Historic
CHARLESTON &
THE *Lowcountry*

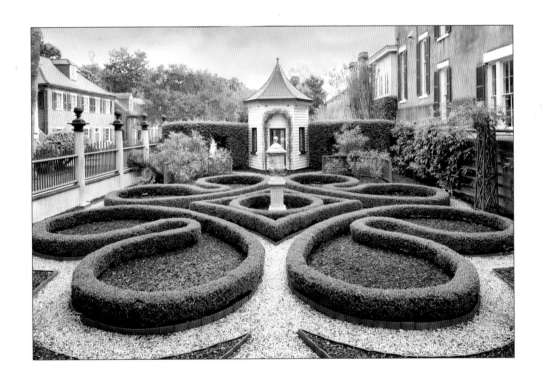

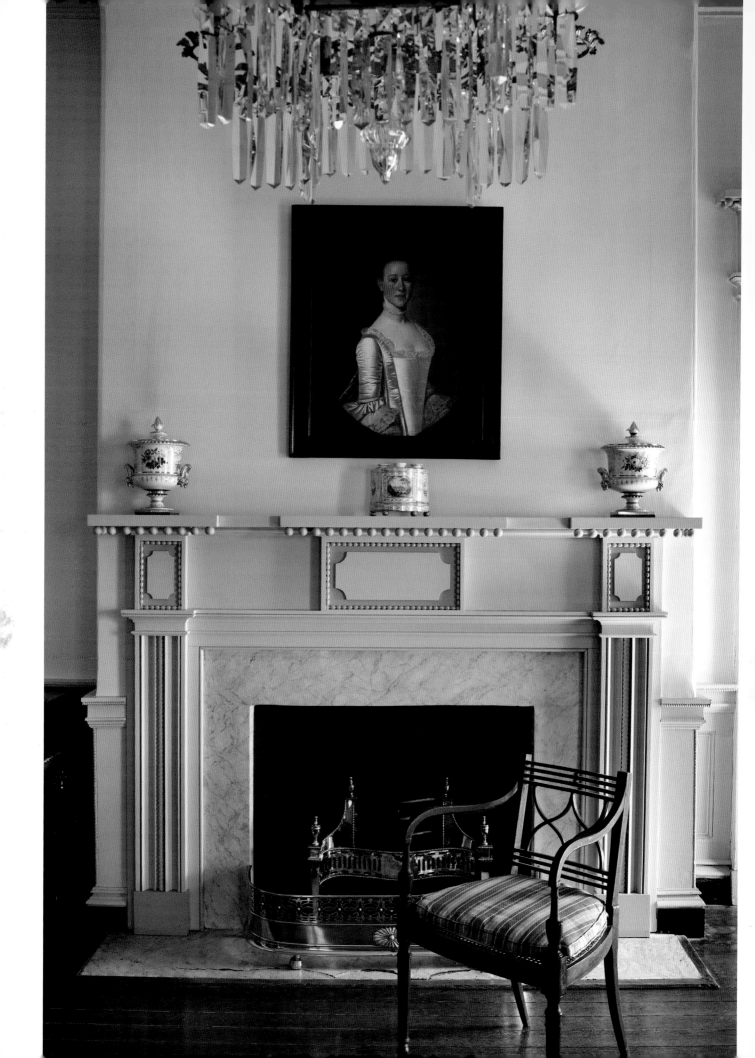

Historic CHARLESTON & THE *Lowcountry*

Steve Gross *and* Susan Daley

GIBBS SMITH
TO ENRICH AND INSPIRE HUMANKIND

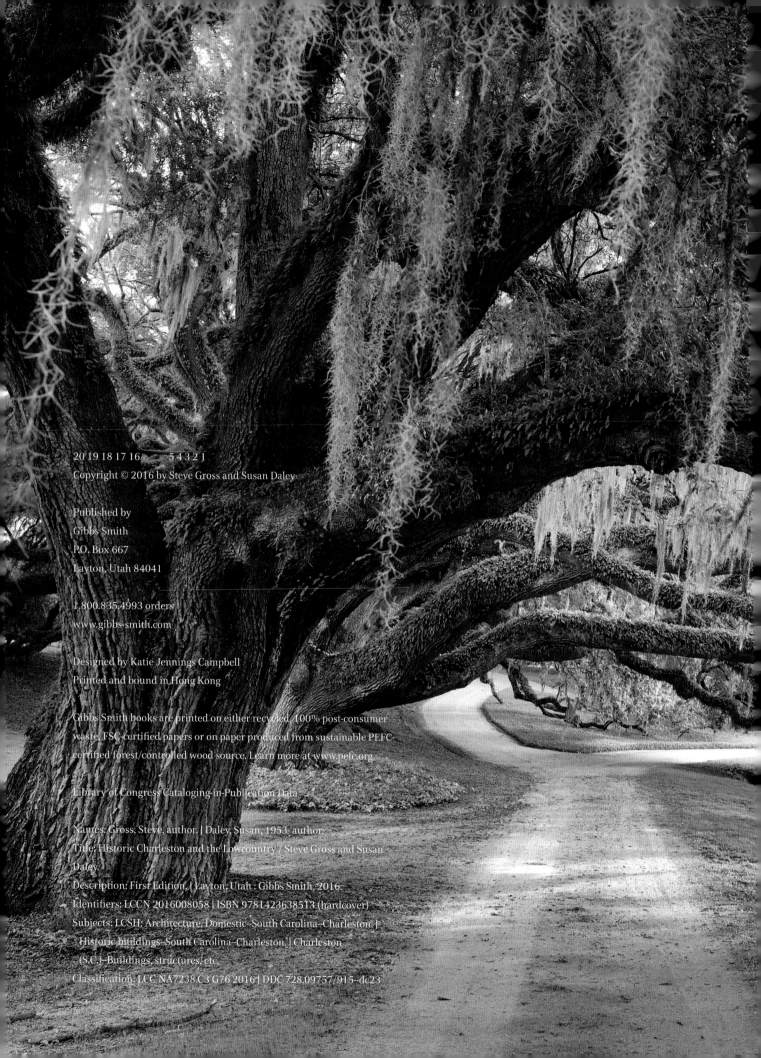

20 19 18 17 16 5 4 3 2 1
Copyright © 2016 by Steve Gross and Susan Daley

Published by
Gibbs Smith
P.O. Box 667
Layton, Utah 84041

1.800.835.4993 orders
www.gibbs-smith.com

Designed by Katie Jennings Campbell
Printed and bound in Hong Kong

Gibbs Smith books are printed on either recycled, 100% post-consumer
waste, FSC-certified papers or on paper produced from sustainable PEFC-
certified forest/controlled wood source. Learn more at www.pefc.org.

Library of Congress Cataloging-in-Publication Data

Names: Gross, Steve, author. | Daley, Susan, 1953- author.
Title: Historic Charleston and the Lowcountry / Steve Gross and Susan
Daley.
Description: First Edition. | Layton, Utah : Gibbs Smith, 2016.
Identifiers: LCCN 2016008058 | ISBN 9781423638513 (hardcover)
Subjects: LCSH: Architecture, Domestic--South Carolina--Charleston. |
 Historic buildings--South Carolina--Charleston. | Charleston
 (S.C.)--Buildings, structures, etc.
Classification: LCC NA7238.C3 G76 2016 | DDC 728.09757/915--dc23

Contents

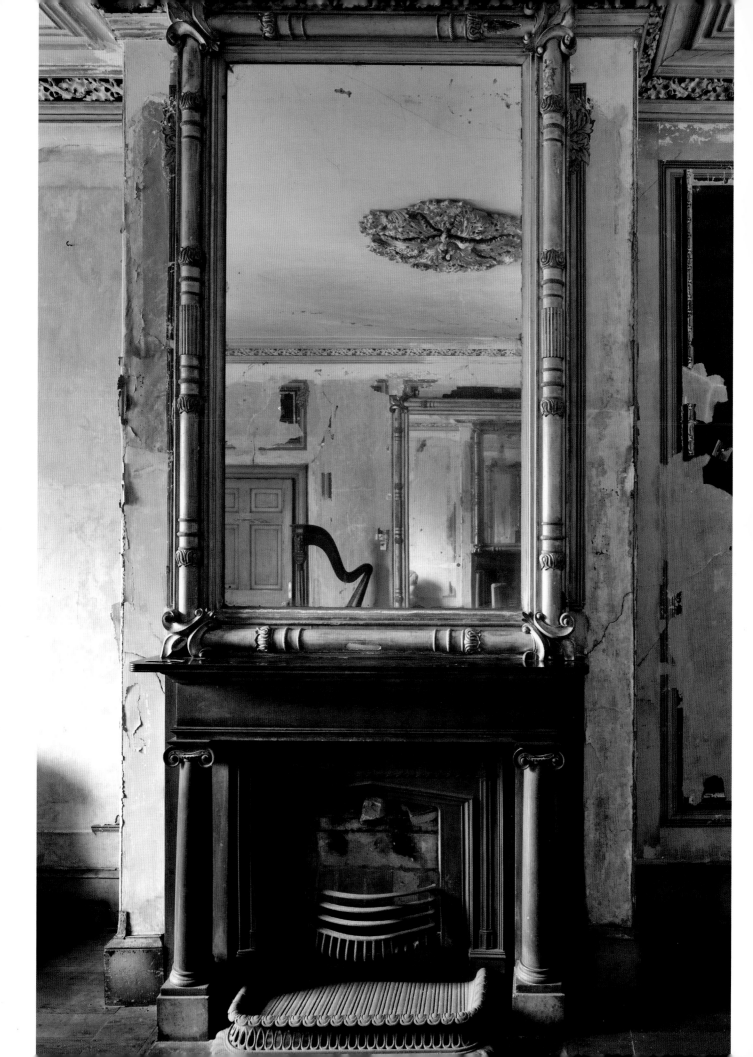

INTRODUCTION

IN 1926 FRANCES BENJAMIN JOHNSTON, a prominent photojournalist with a studio in Manhattan, traveled throughout the South on assignment for *Town & Country Magazine,* photographing a selection of ante-bellum gardens that were undergoing restoration. Johnston, who had been born during the Civil War and given her first camera by George Eastman himself, had been making a living photographing palatial estates and gardens. After her Southern trip, she became increasingly interested in photographing historic places that were falling into neglect and being threatened by modern development.

Years later, and in her seventies, Johnston, along with her assistant and driver, Huntley Ruff, began another excursion. She had been hired to work on a project for the Library of Congress, documenting colonial and antebellum buildings in several Southern states, including the Lowcountry environs of South Carolina. She worked prolifically in Charleston and the surrounding countryside, photographing endangered landscaped gardens and old plantation houses, some of them empty and abandoned. Many of these were published in Samuel G. Stoney's 1938 book *Plantations of the Carolina Low Country.*

Our own fascination with photographing historic architecture also began in the South. While on a driving trip in 1985 from New York City to Florida we stopped in Charleston and happened upon an old decaying mansion, the Aiken-Rhett House Museum. Upon entering the house, we were immediately entranced by the eloquence of sunlight filtering through ancient shutters in the large, sparsely furnished rooms. In musty dilapidated spaces that were once lavishly appointed, we came upon worn, bare floorboards, cracked mirrors and dangling chandeliers, and walls with the remnants of peeling layers of wallpaper still clinging to them.

We spent the next several hours of that first day making photographs, experiencing the flow of the rooms and the echoes of empty space, and later learned the fascinating history of the house; how it had gone from the height of 1850s opulence and luxury to become the threadbare lodgings of the Rhett family's last relations in the 1970s. Those photographs were the beginning of what would become our first book, *Old Houses,* and since that time our work has focused on America's historic houses and gardens.

OPPOSITE: *A harp from the 1820s is reflected in a gilt mirror at the Aiken-Rhett House.*

To walk into a three-hundred-year-old house and feel the resonance of past lives, to make photographs using the same geometry of sunlight coming through windows and doors as generations of inhabitants have experienced it, is to glimpse into history and to be provided with a way to read the past.

For this current book, we photographed some of the same illustrious locations that Frances Johnston visited, including Medway and Mulberry Plantations, Magnolia and Middleton Place gardens, and the austere and classic Pompion Hill Chapel. We went into elegant townhouses in Charleston and took similar photos of the same decorated mantels, walls, and ceilings that still had their 1800s delicate plasterwork intact. Many of the places we found had been newly restored, and some contained the same furnishings that had been there in Johnston's time, and even before that. But other important historic places had been changed or destroyed, with photos now the only remaining record to serve as resources for conservationists, architects, landscapers, and historians.

Charleston today seems hardly threatened by neglect or indifference; the city's architectural riches of Georgian, Federal, and Greek Revival houses, historic churches, and lush gardens are well cared for and the site of a burgeoning tourist trade. Despite fires, earthquakes, floods, and wars, a remarkable number of colonial and antebellum houses remain. The city is fortunate to have long had a strong preservation movement; it was one of the first in the country, started in the 1920s by concerned citizens and artists. The character of the city is changing as is inevitable, but due to the work of the Historic Charleston Foundation and other community groups, Charleston remains one of America's most historic and well-preserved cities and a place of great beauty because of it.

OPPOSITE: *Statuary of classical figures evoke the lost past of Greek and Roman times.*

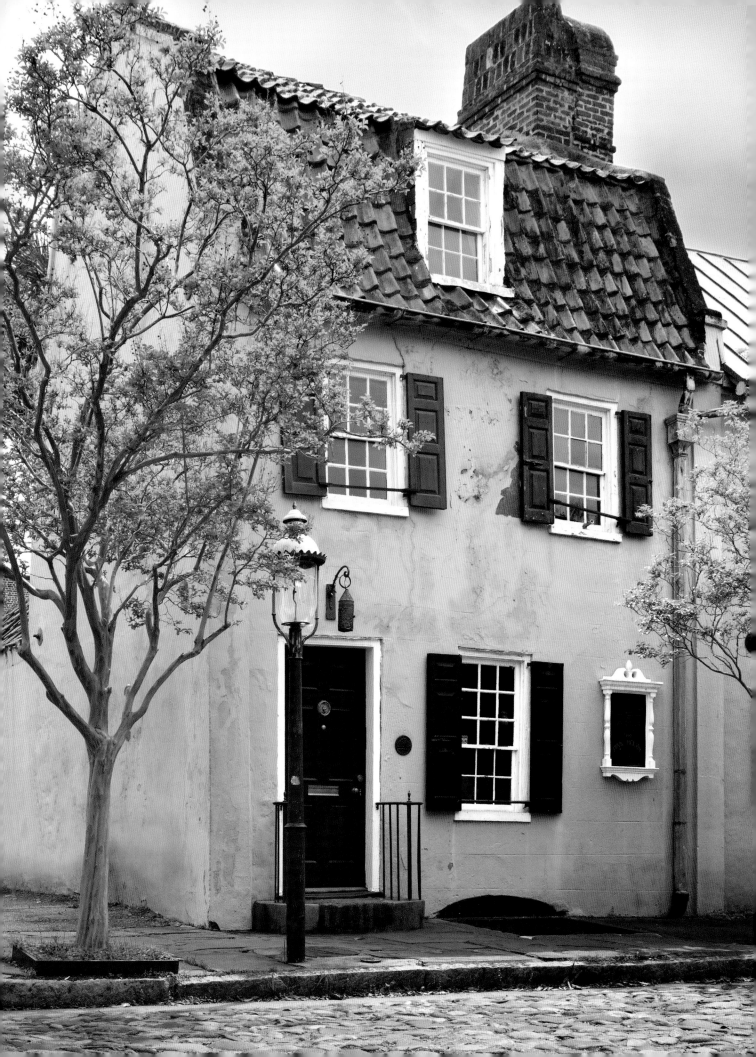

THE
Old City

TWICE OCCUPIED BY INVADING ARMIES, the historic city of Charleston has survived bombardment, fires, epidemics, floods, hurricanes, and a major earthquake in 1886.

The port city, sited on a peninsula between two rivers, was from its beginnings in 1670 vulnerable to attack from sea and land. Initially called Charles Town for the British king who granted its charter to his eight followers known as the Lords Proprietors, the early colony was built within a wall that defended against Indians, French, Spanish, and pirates.

In the oldest part of the town, close to the harbor, warehouses lined the wharfs and streets, and artisans and suppliers such as coopers, rope makers, and chandlers kept shops and taverns on cobblestoned streets and alleys. This historic district, now called the French Quarter, was named for the French Huguenot exiles who built European-style row houses with shops or counting houses on their first floors and living quarters above.

By the 1730s colonial Charleston was said to have reached a "Golden Age" which lasted to the 1820s. Much mercantile wealth had been created, starting from humble beginnings in the deerskin trade. Fortunes were further amassed with the successful cultivation of indigo, rice, and Sea Island cotton on plantations worked by slaves in the surrounding environs of the Lowcountry.

With these profits, scores of fine townhouses in the Georgian, Adam, and Federal styles were built in Charleston. Planters enjoyed the city's winter social season and escaped to town when the summer "miasma," bringing fever and disease, was rampant in the swampy countryside. Many of these houses, with their elaborate interior architectural detailing and high wide piazzas built to catch prevailing sea breezes, still remain. After the Civil War, genteel poverty helped to conserve many historic homes and buildings. Houses were passed down in the old families; continuity and kinship with the past was revered.

Beginning in 1920, houses were also protected from change with the creation of the Preservation Society of Charleston, the oldest community-based historic preservation organization in America. Ordinances were enacted to protect structures of historic and aesthetic significance, ensuring the remarkably rich and enduring architectural legacy of Charleston and the Lowcountry.

The "Pink House" on Chalmers Street was a tavern in colonial days; in the 1920s it served as an art gallery. Constructed of coral Bermuda stone with a tiled gambrel roof, it is one of the oldest houses in Charleston.

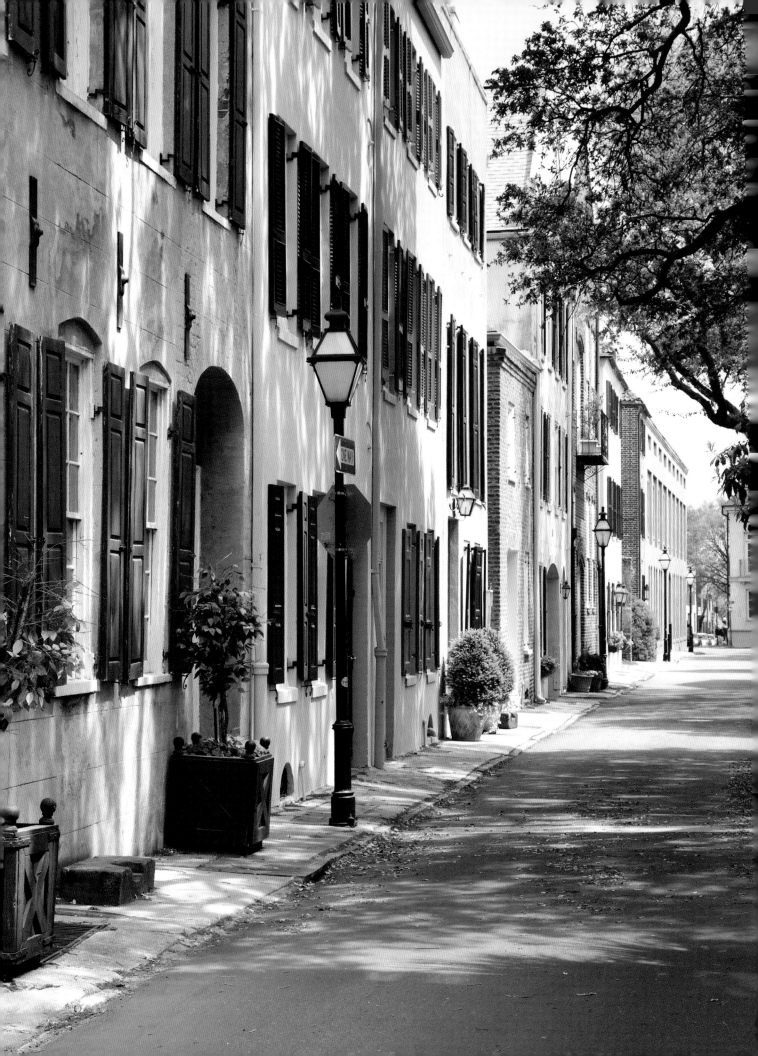

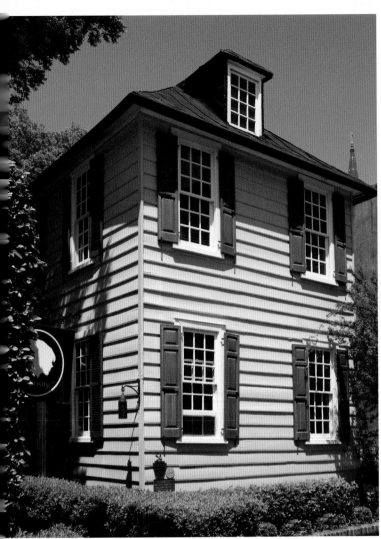

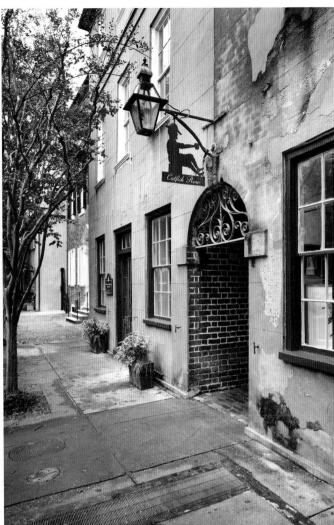

OPPOSITE: *Elliott Street, once populated mainly by French Huguenots, was laid out as a narrow thoroughfare in 1683. During the late eighteenth and early nineteenth centuries the street was a major retail shopping area.*

ABOVE LEFT: *Thomas Elfe, a cabinetmaker who is considered one of the finest furniture craftsmen of eighteenth-century Charleston, built his wooden "single house" on Queen Street some years before the Revolution.*

ABOVE RIGHT: *In 1925 DuBose Heyward wrote his novel* Porgy, *setting it on Cabbage Row, which he renamed Catfish Row. The "double tenement," or apartment building, on Church Street was home to African American families and has an interior courtyard.*

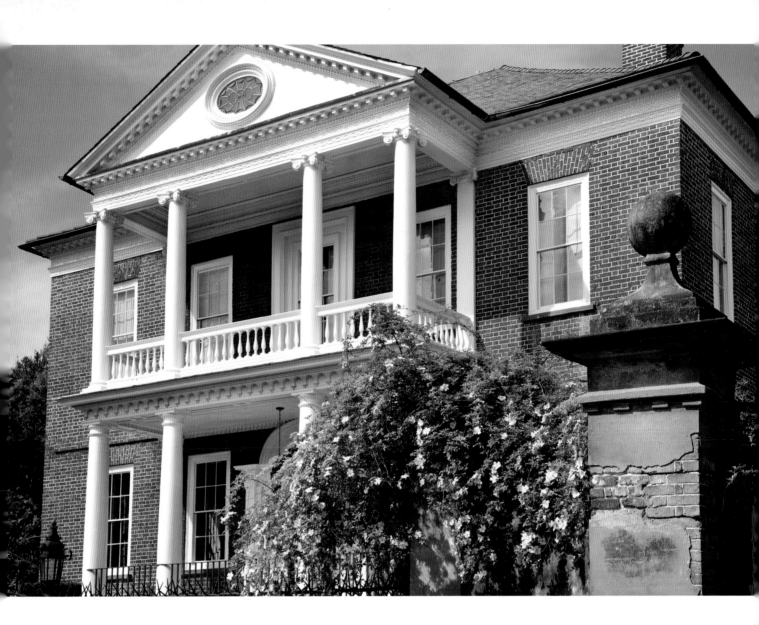

OPPOSITE: *Cobblestoned Chalmers Street was part of the old walled city. Jane Wightman, a free black woman, built two houses here in 1835. In the 1930s, author Josephine Pinckney lived at No. 36, while Laura Bragg, the first woman in the U.S. to head a public museum, lived at No. 38.*

ABOVE: *The stately Miles Brewton House was built in 1769 by a leading rice planter and slave merchant who was lost at sea with his family ten years later. The Georgian "double house" has a two-story portico with Ionic columns.*

RIGHT: *The carriage house of the Miles Brewton House was remodeled in Gothic Revival style by the Pringle family in the 1840s. A descendant of Miles Brewton, Susan Pringle Frost began the Society for the Preservation of Old Dwellings in 1920.*

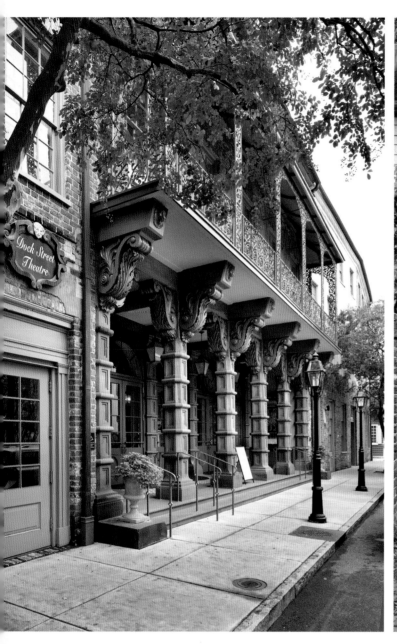

ABOVE LEFT: *The ornate facade of the Dock Street Theatre dates to the early 1800s when it was the fashionable Planter's Hotel. The original theatre, which began on the site on Church Street in 1736, was one of the first buildings in America designed specifically as a theatre.*

ABOVE RIGHT: *The quaint brick-paved passage called Stoll's Alley was named for Justinus Stoll, a blacksmith who owned a large part of the Battery and is thought to have built his home at No. 7 in 1745.*

OPPOSITE: *The German Fire Company Engine House at 8 Chalmers Street was built as the engine house of a private engine company in 1851; later it became the meeting place of an African American "Good Samaritan" society.*

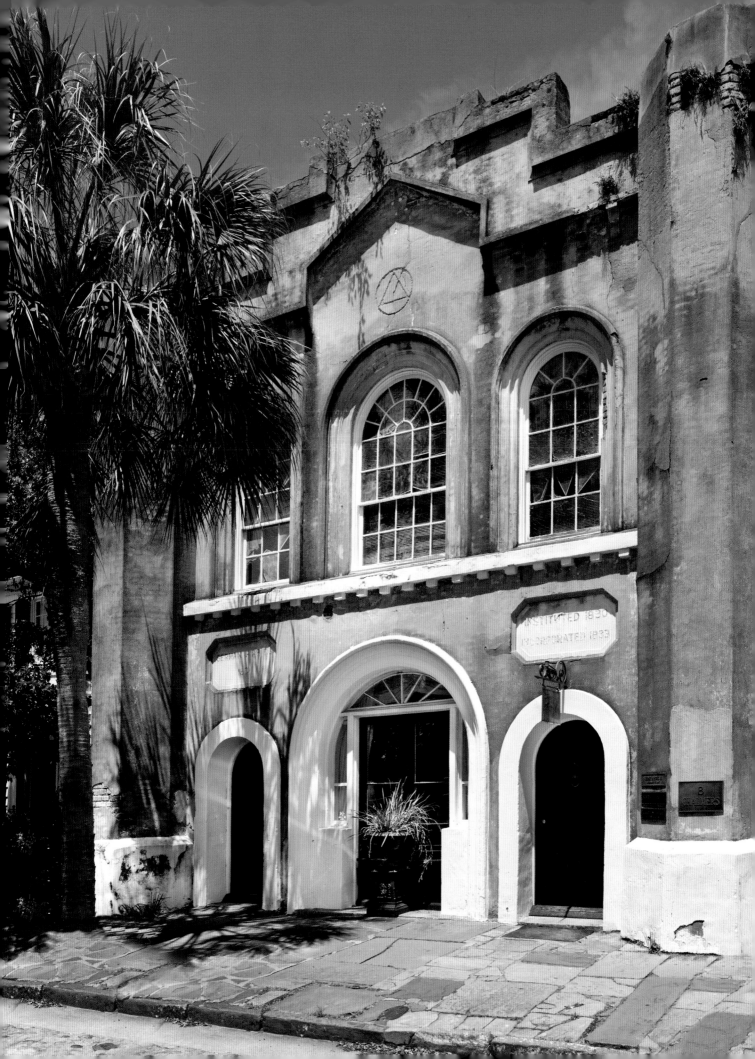

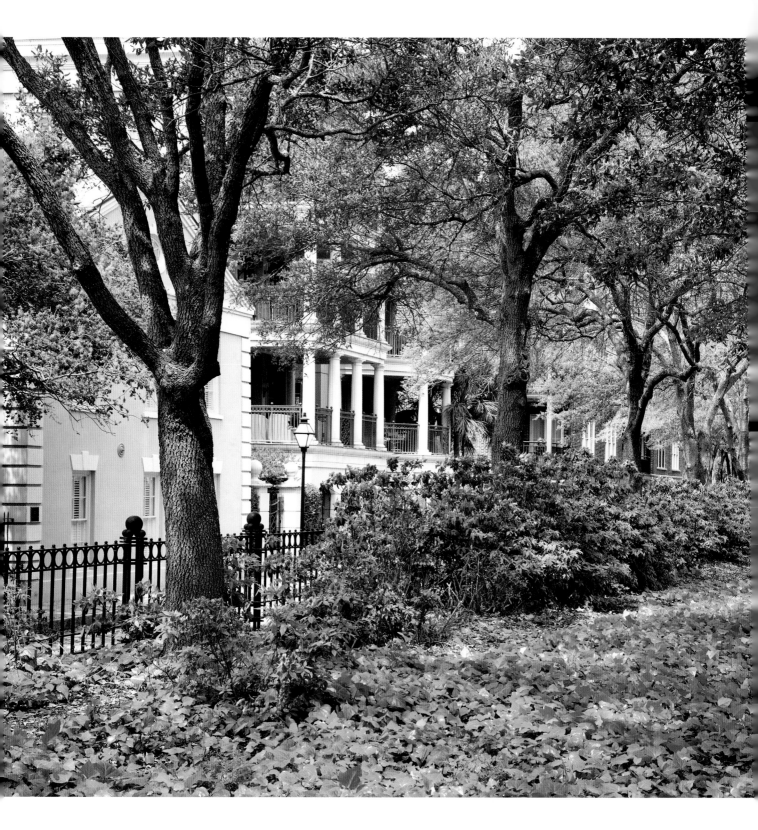

Waterfront Park is a twelve-acre public park built along the Cooper River in an area of former wharves and shipping terminals.

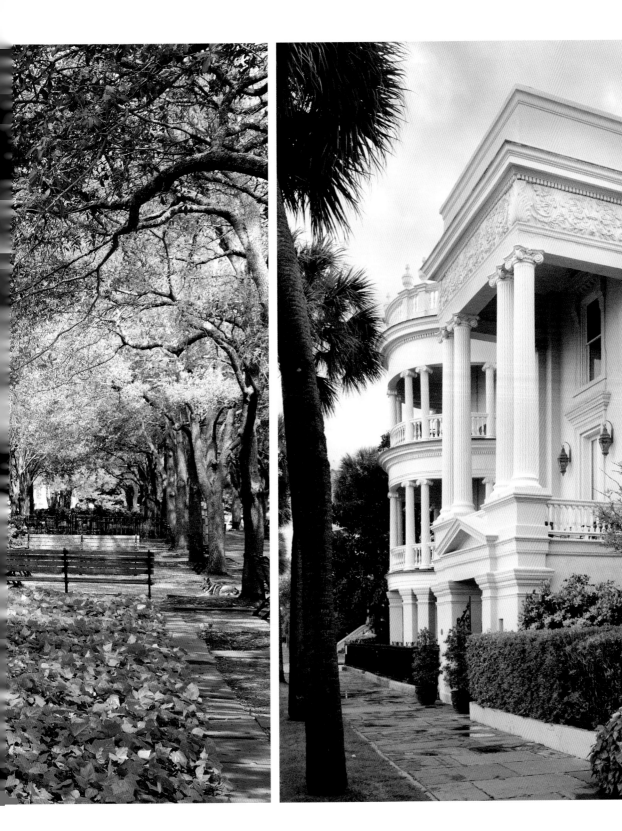

The Porcher-Simonds House on the East Battery was built by cotton broker Francis Porcher in 1856 in the Greek Revival style. It was later remodeled by John Simonds with a mix of Beaux Arts and Renaissance Revival details.

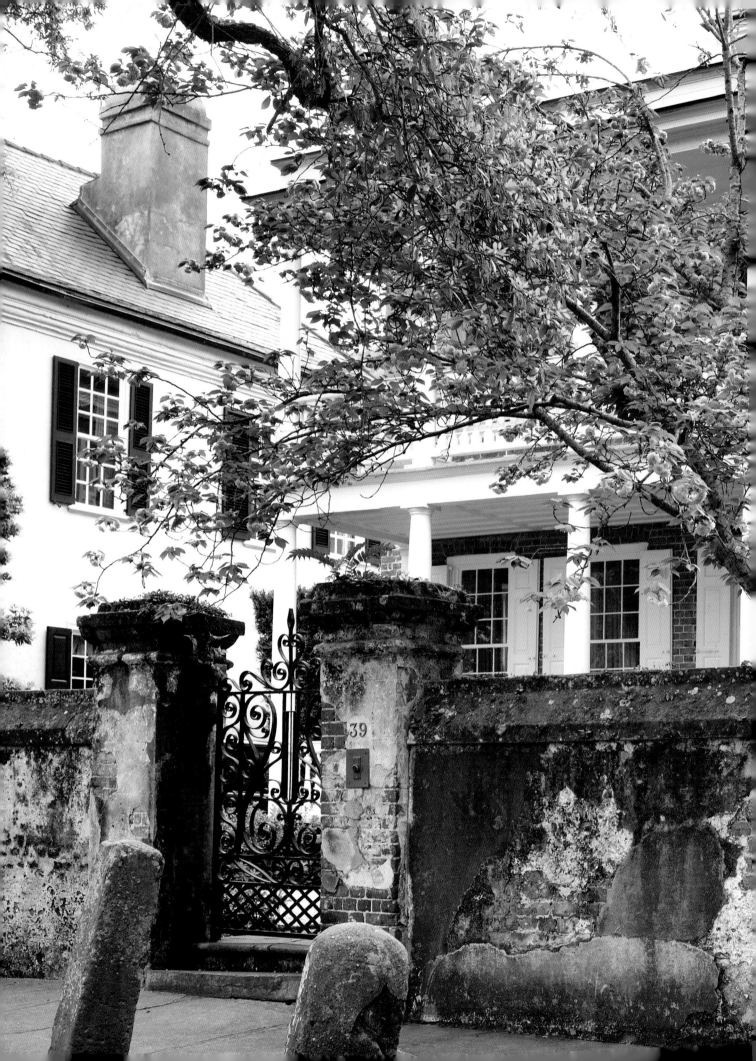

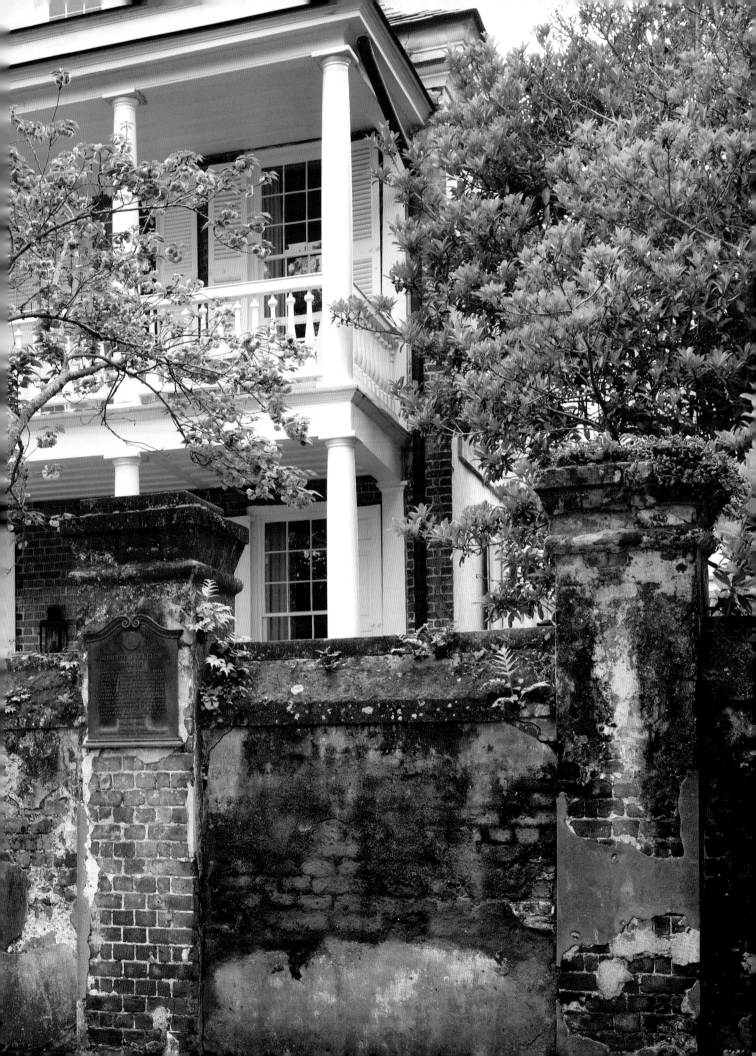

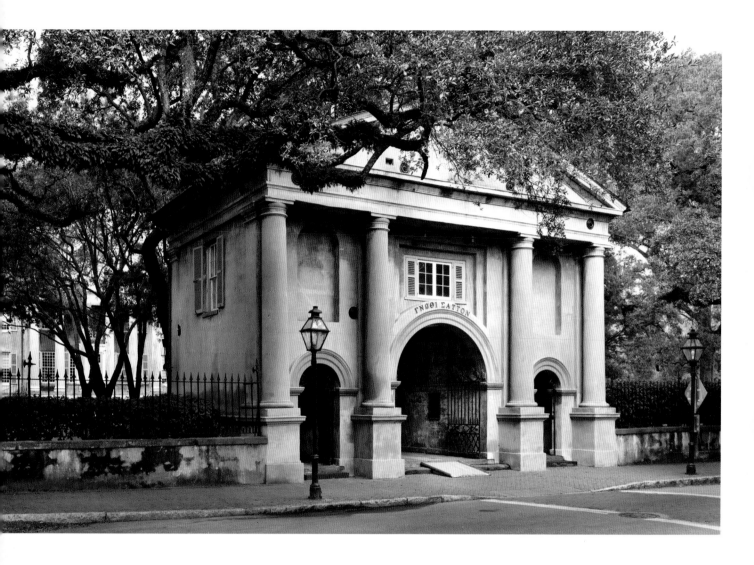

ABOVE: *In 1852, architect E. B. White designed the Roman Revival style gatehouse known as Porter's Lodge on the campus of Charleston College. The Greek inscription above the arch translates as "Know Thyself."*

OPPOSITE: *"Rainbow Row" is a series of early 1700s Georgian row houses along East Bay Street that were once the dwellings of merchants. Falling into dilapidation, they were restored in the 1930s, beginning with preservationist Dorothy Porcher Legge who painted hers in Caribbean pink.*

PRECEDING OVERLEAF: *Set behind a brick wall on the picturesque "Bend" of Church Street, the George Eveleigh house was built in 1743 by a prosperous deerskin trader. The "Bend," with its leaning bollards that were barriers against wagons, is often painted by artists.*

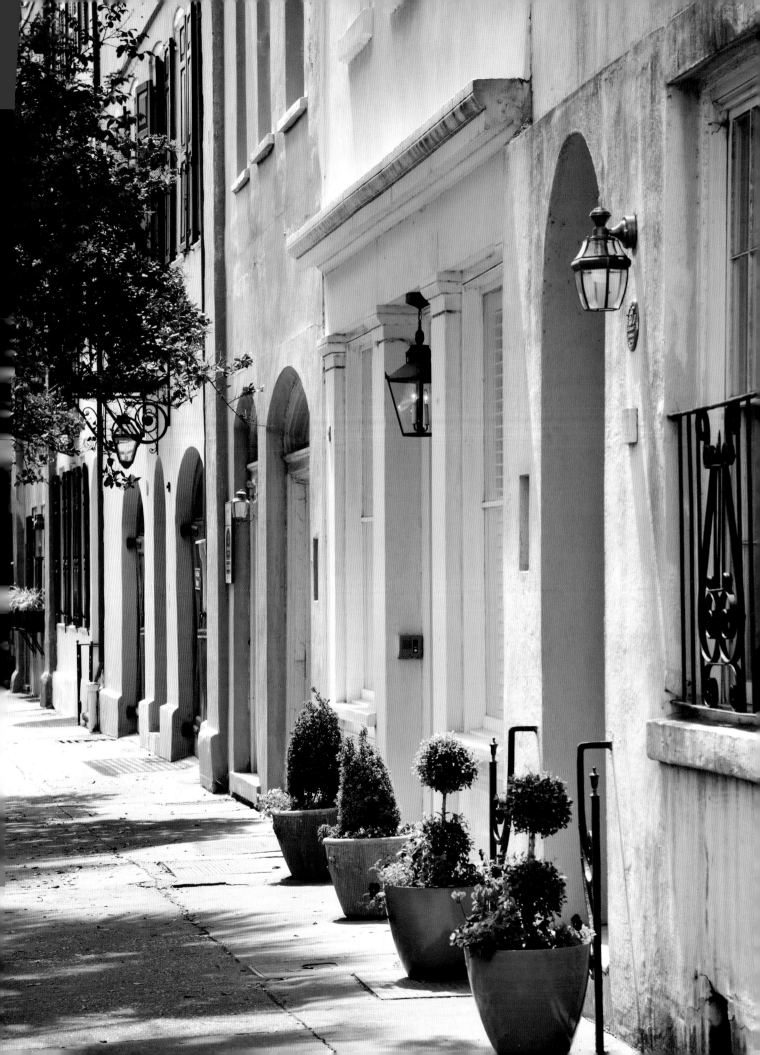

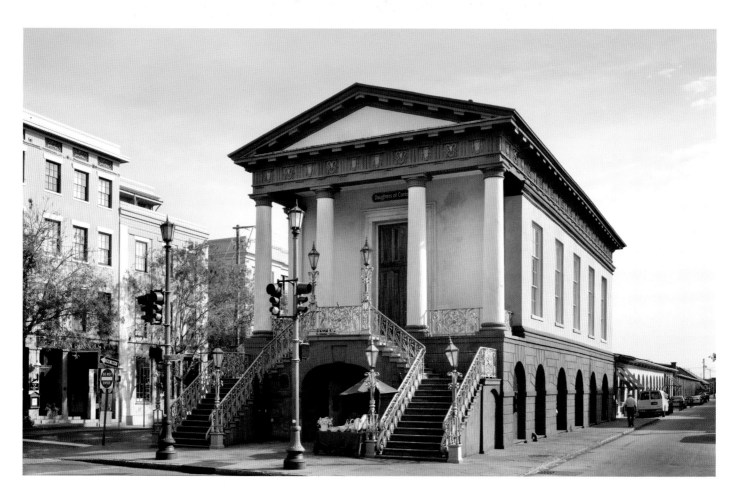

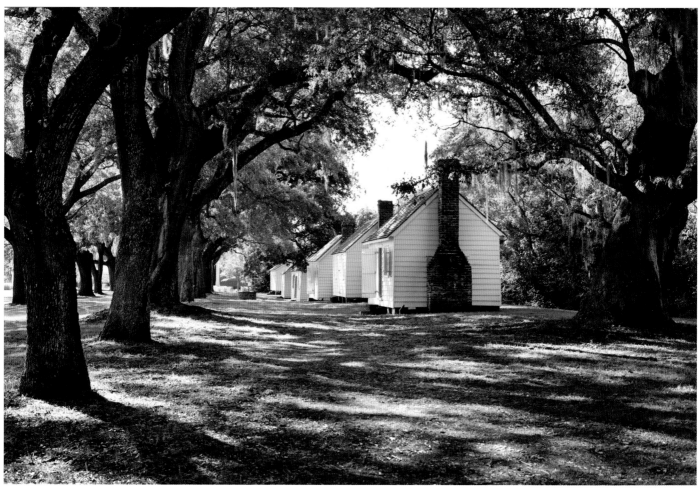

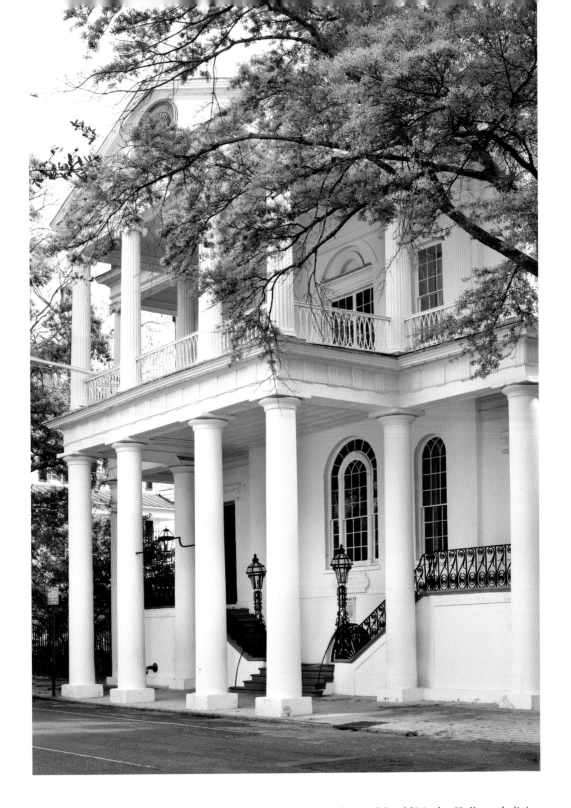

OPPOSITE ABOVE: *"Bucrania" and rams' heads decorate the frieze of the old Market Hall, symbolizing the presence of the meat market that was once located within. Since 1899, the United Daughters of the Confederacy and their Confederate Museum has occupied the upper floor.*

OPPOSITE BELOW: *Five remaining slave cabins at McLeod Plantation on James Island were built in the early 1800s and were occupied until the 1990s. The plantation was originally a beef plantation, with slaves from Gambia who were expert horsemen and cattle herders.*

ABOVE: *The South Carolina Society Hall was designed in 1804 by "gentleman architect" Gabriel Manigault for the Huguenot fraternal society known as the "Two-Bit Club." It contained a billiards room, classrooms, and a large ballroom for the businessmen who met there.*

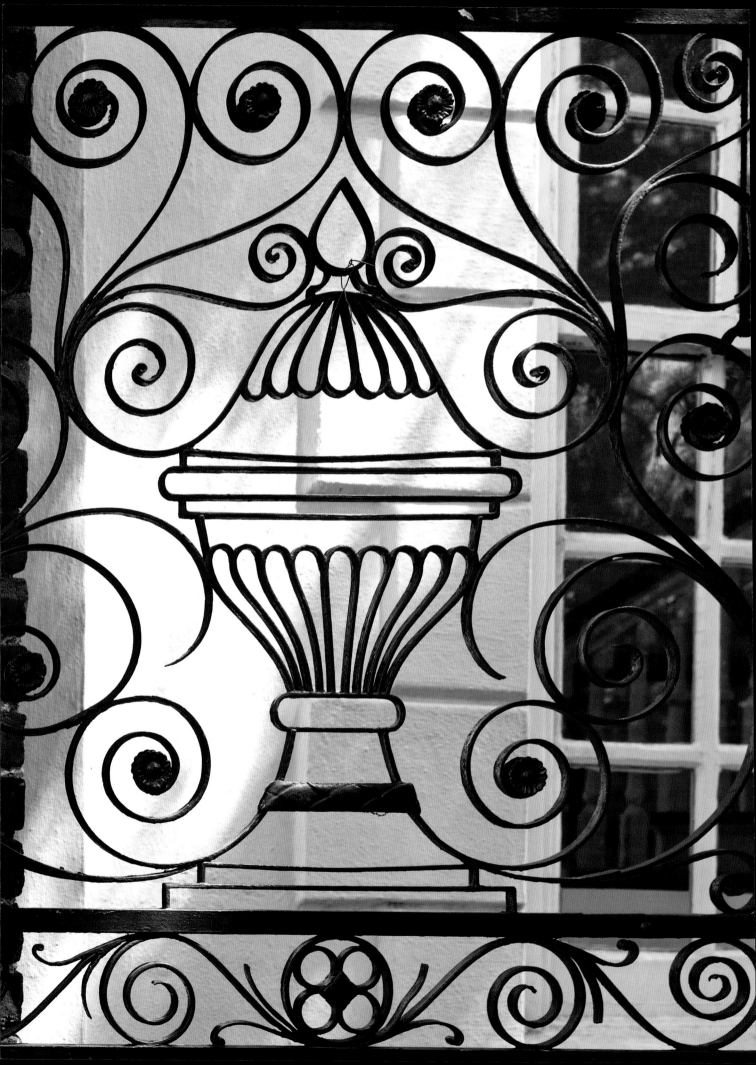

Wrought Iron

A wealth of old ironwork gives character and grace to Charleston, enriching the city and providing a theme that unifies its architecture. Ornamented iron gates that "half reveal, half conceal" the gardens hidden behind them are part of the allure of the town.

The wrought iron tradition began in the 1730s when Charleston houses began to feature iron balconies, typically added on to replace wooden ones that tended to rot. In addition to balconies and balustrades, many other iron artifacts were made including lanterns, grilles, gates, and fences, all wrought by hand by artisans and blacksmiths. The ornamental patterns of the colonial era were hammered out in smiths' shops with designs taken from British plan books, using symbolic motifs such as the lyre, heart, spear, urn, and star.

Another functional need for ironwork became evident after the unsuccessful Denmark Vesey slave uprising plot of 1822 and the fear of slave insurrection. Sharp iron spikes were added to gates and fences, known as a "chevaux-de-frise." Although many early examples of wrought iron were destroyed in fires or melted down for military purposes, some survived intact; other pieces were salvaged and added on to existing houses in the twentieth century by historical preservationists.

Today, much of the old wrought iron still in existence is the work of three nineteenth-century German immigrants: J. A. W. Iusti, Christopher Werner, and Frederick Ortmann, all master workers who designed in the ornate manner of their native land.

German-born master ironworker J. A. W. Iusti is known for his creation of the wrought iron gates leading to St. Michael's Cemetery. Funerary urns are surrounded by scrolls that taper off, becoming thinner at their ends, the sign of expert work.

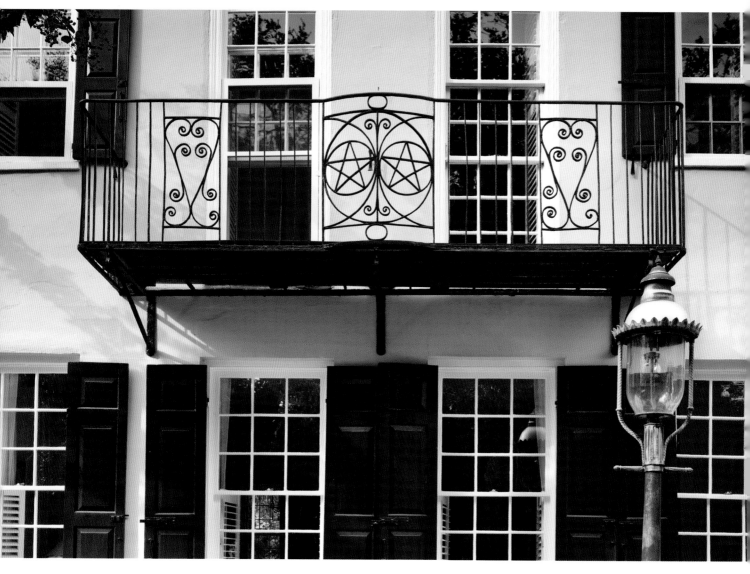

ABOVE: *A house built by Jane Prevost Wightman in 1844 had a salvaged wrought iron balcony added during a renovation by writer Josephine Pinckney in the 1930s. Pinckney started a Poetry Society during "Charleston's Renaissance," entertaining Gertrude Stein and Robert Frost here.*

RIGHT: *Ironwork gates with a lyre motif open onto the 1857 Italianate Maybank house. Wrought iron was sometimes embellished with cast iron elements, such as the rosettes capping the ends of the scrolls.*

OPPOSITE: *One of a handful of houses built of Bermuda stone, the c. 1740 Perronneau tenement house on Church Street is legendary for a "Pirate's Courtyard" located behind it. Shutters were added during a restoration by Thomas Pinckney, an African American preservationist.*

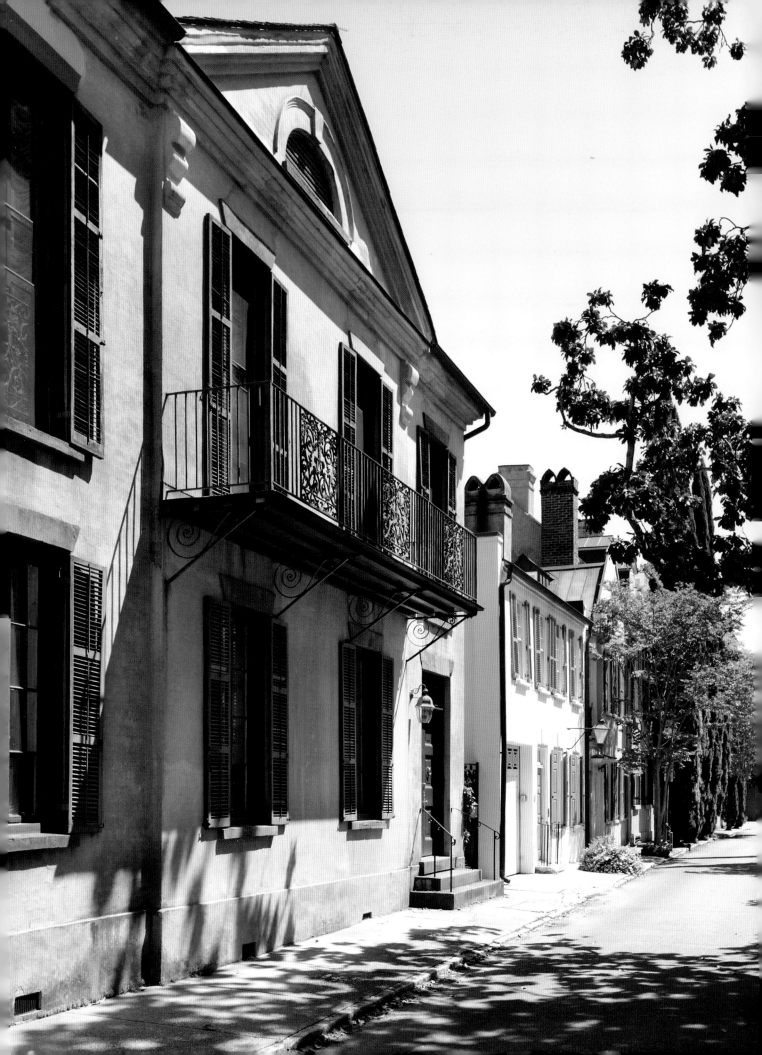

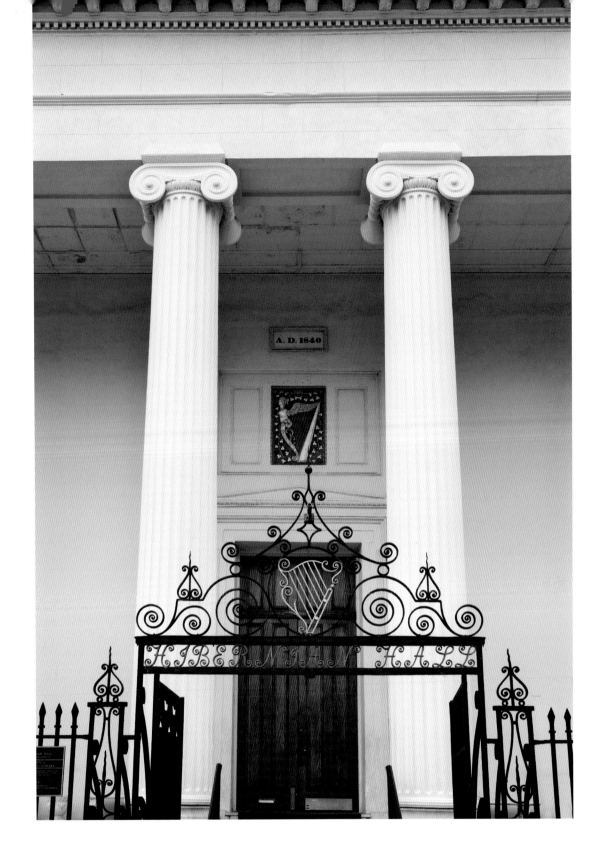

OPPOSITE: *A wrought iron balcony was salvaged by preservationist Susan Pringle Frost and added to the former James L. Petigru's law office. Petigru, an outspoken Unionist, famously said in 1861, "South Carolina is too small for a republic and too large for an insane asylum."*

ABOVE: *The Hibernian Hall was built in 1839 for members of an Irish social and charitable institution. Its iron gate by Christopher Werner displays lettering, as well as the harp of Ireland enameled in gold. The building was designed by Thomas U. Walter, who also designed the dome of the U.S. Capitol.*

ABOVE: *A medieval looking "chevaux-de-frise" barrier of metal spikes was placed atop the iron fence of the Miles Brewton House. Behind the fence was a pleasure garden, as well as a work yard with slave quarters, kitchen, and cistern.*

LEFT: *A circle of feathered arrows forms part of an ironwork gate leading into a brick-paved courtyard at the William Rhett House on Hasell Street. The elegant garden was designed by Umberto Innocenti in the 1940s.*

OPPOSITE: *A wrought iron balcony extends across the front of the narrow Geyer House. The house was originally part of the wealthy mariner Isaac Holmes' property and was built by the Geyer family in the 1780s.*

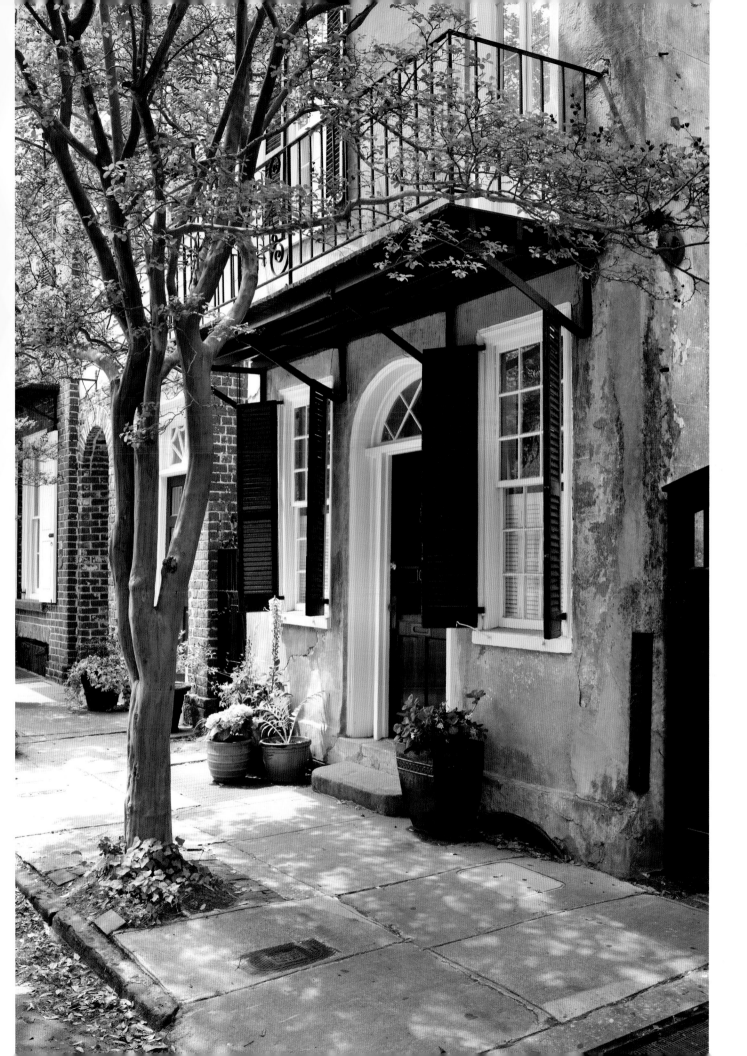

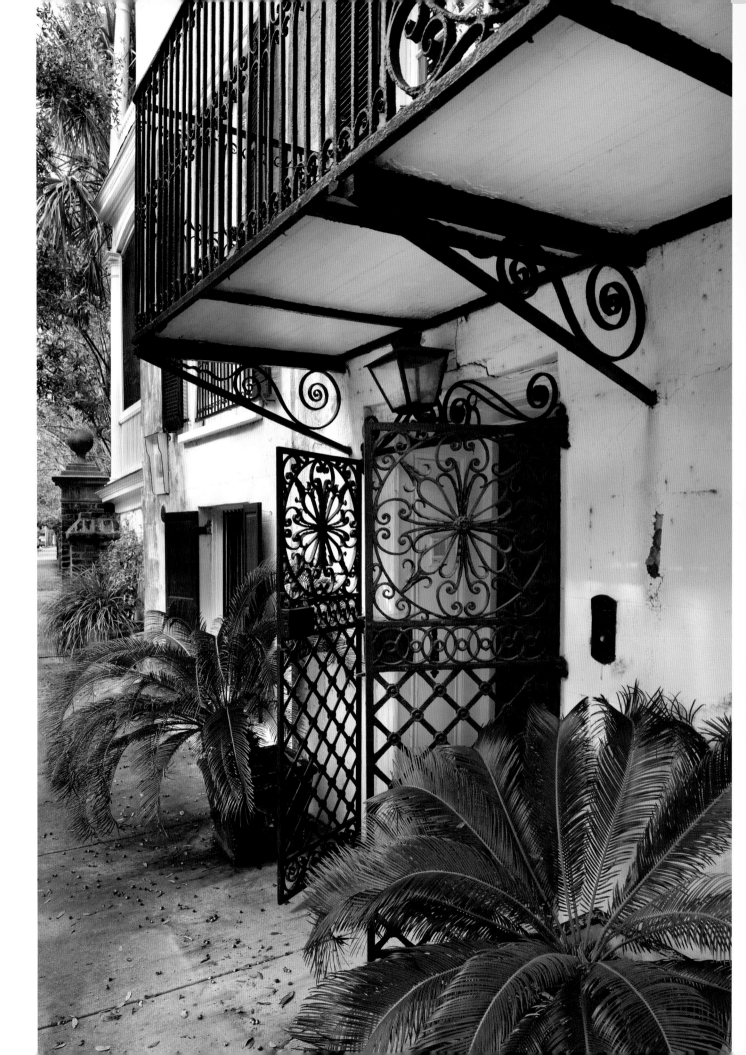

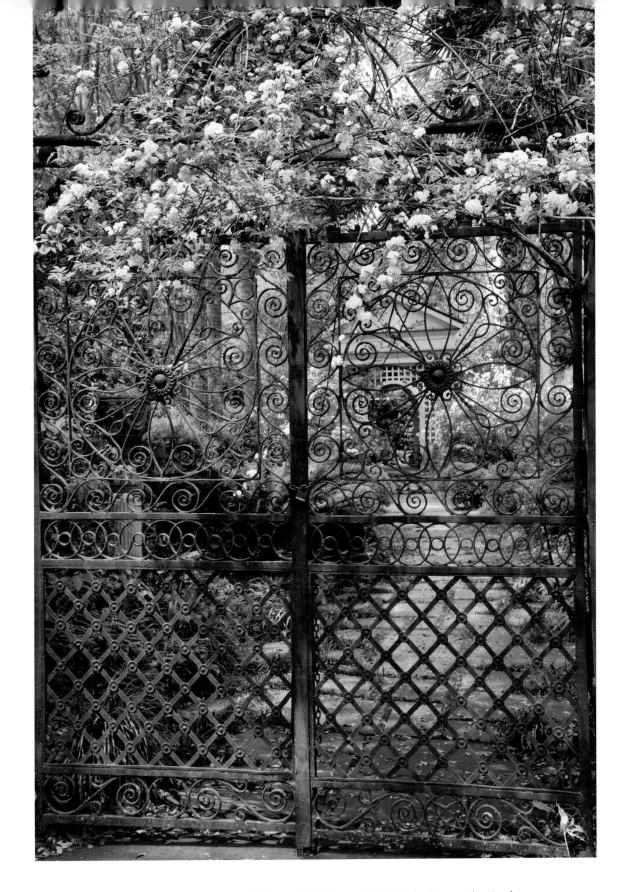

OPPOSITE: *Unlike most Charleston "single houses" with side piazzas, the Harth-Middleton House is entered directly from the street through a front door.*

ABOVE: *A garden designed by Loutrel Briggs in the 1920s can be viewed through the rose-covered wrought iron gates of the Harth-Middleton House on South Battery.*

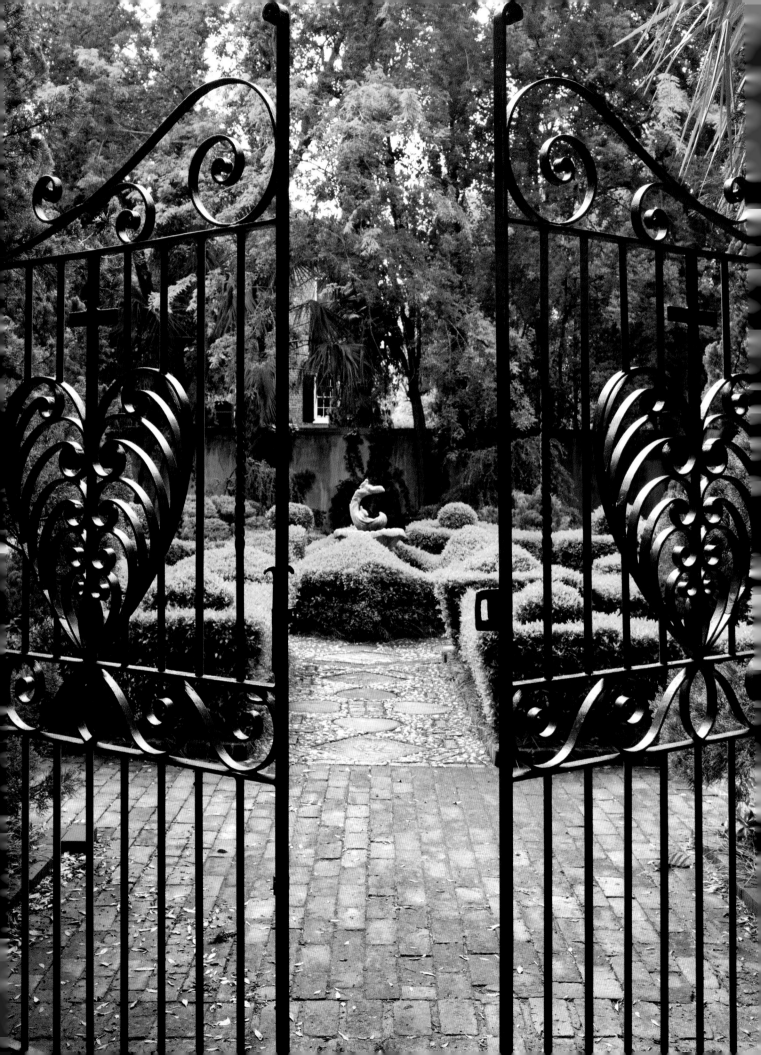

Hidden Gardens

The well-loved Charleston urban garden is a small private world unto itself. Enclosed by high, vine-covered, brick walls with wrought iron gates and grilles, intriguing glimpses can be caught by peering through fences and doors. As local author Harry Hervey wrote, "Charleston, behold it–through a peephole."

The "single house" plans of Charleston have long been well integrated with their adjacent, enclosed gardens. Walled courtyards were built as the work places of the house, where vegetable gardens shared space with outbuildings, including the stables and kitchens where slaves lived and worked, along with privies, chicken coops, and sheds. Behind the sheltering walls, pomegranates, figs, and "double and treble rows of orange trees" grew, along with oleanders, saw palmetto, and flowering shrubs. Jasmine, honeysuckle, and Cherokee rose spread over the brick walls and twined up the columns of the piazzas.

Early British formal gardens in the old town were of the Elizabethan type; geometric in design with topiary work, box parterres and knots, walks, statuary, and closely clipped trees. The French Huguenot settlers were noted for their "fine small gardens with plantings in good taste" found hidden behind their row houses. The French added to the British-derived garden culture, bringing with them seeds and bulbs from their stay in Holland.

After the ravages of the Civil War, Charleston was "a city of ruins, of desolation, rotting wharves and deserted warehouses. Gardens were full of weeds, grass grew in the streets." By the early 1900s, small gardens began to emerge from the wreckage, with some of the original patterns unearthed and re-created. Landscape architect Loutrel Briggs moved to Charleston in the 1920s and began creating his iconic, neocolonial gardens throughout the city and at plantation houses in the Lowcountry. Following the national Colonial Revival trend, Briggs's designs recalled a mythic past, of chaste white picket fences, a preponderance of clipped box and holly, and a recycling of old world elements such as red clay bricks and crushed oyster shell paths that can still be seen and enjoyed today.

The "Heart Garden" at St. John's Episcopal Church is an artistic collaboration between two South Carolina artists, master blacksmith Philip Simmons and renowned topiary artist Pearl Fryar. Double heart gates were designed by Simmons and crafted by his nephew.

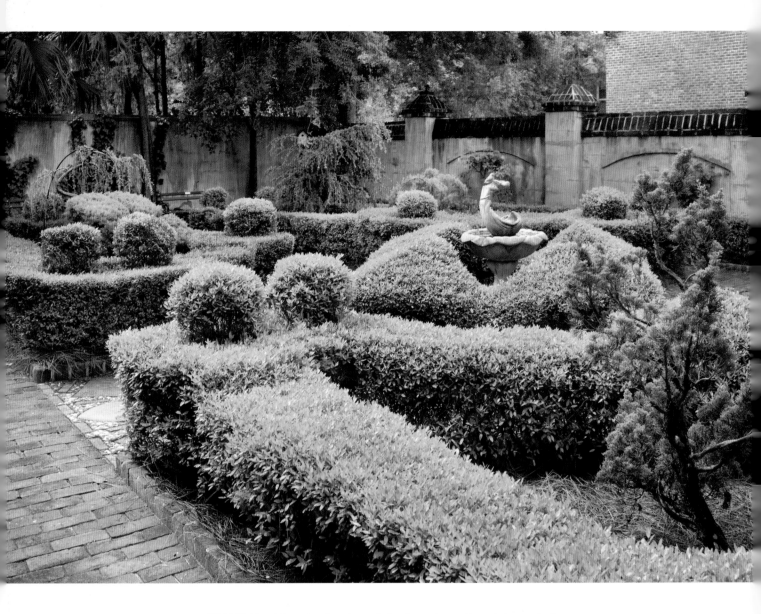

ABOVE: *Pearl Fryar's trimmings of shrubs and trees into waves, spirals, cones, and spheres are recognized as artworks in themselves. Fryar added the central birdbath feature from his own garden in Bishopville, South Carolina.*

OPPOSITE: *Expanding upon the heart theme, Pearl Fryar laid a stone walkway patterned with hearts, intending to "spread a message of love, peace, and goodwill" through his horticultural design.*

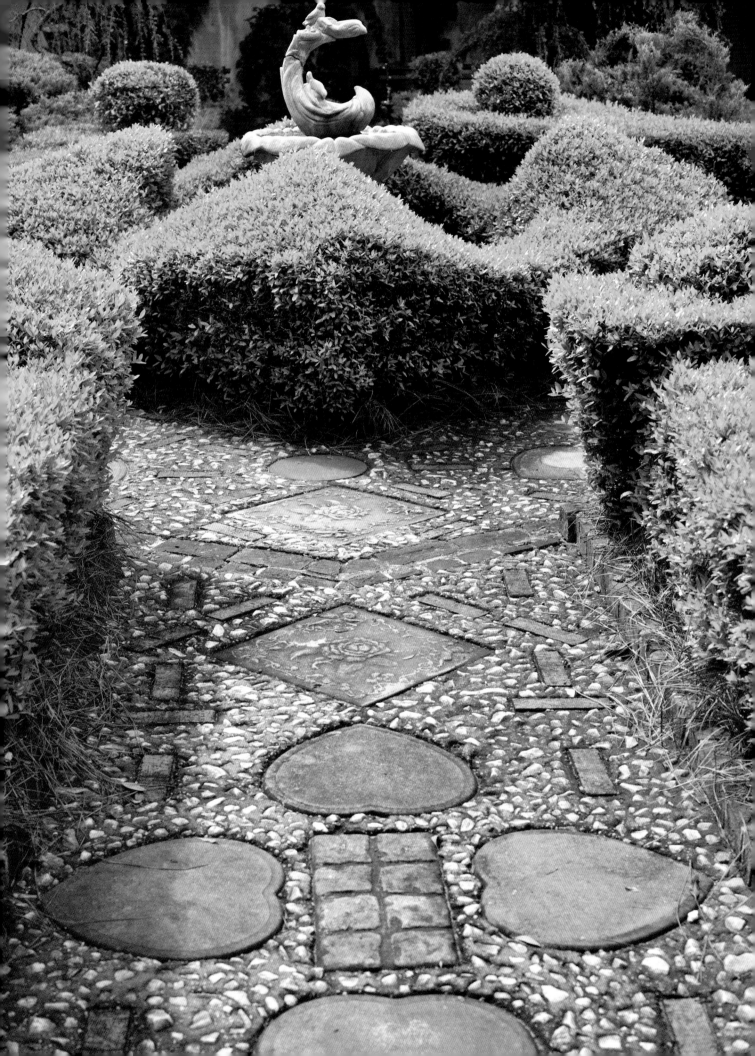

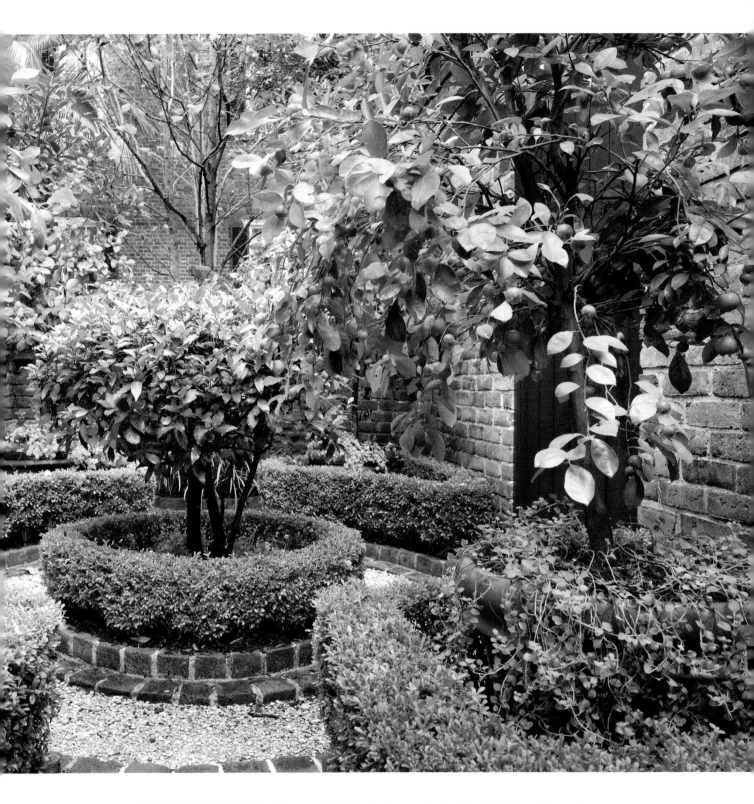

OPPOSITE ABOVE: *Elias Horry added Greek piazzas to the Branford-Horry House in the early nineteenth century. They are unique in that they cover the sidewalk of Meeting Street, providing shade for passersby.*

OPPOSITE BELOW: *Next to the Branford-Horry House, an ornamental grille, known as a "clairvoyee," is set into a brick wall offering a glimpse of a sheltered parterre garden within.*

ABOVE: *In the courtyard of the Branford-Horry House, a small herb garden was designed by Sheila Wertimer as a four-square parterre. A bay laurel and kumquat trees flourish, protected by the brick walls.*

ABOVE: *One of the oldest wisteria vines in Charleston cascades over the iron fence of the c. 1800 Timothy Ford House on Meeting Street. The ancient vine has been painted by many artists over the years, including Childe Hassam.*

OPPOSITE: *Japanese cherry trees in full bloom meet over the garden of the Timothy Ford House. The garden, designed by the ubiquitous Loutrel Briggs, was once "Ford's Court" where John Bartlam, a noted colonial era potter, operated a kiln.*

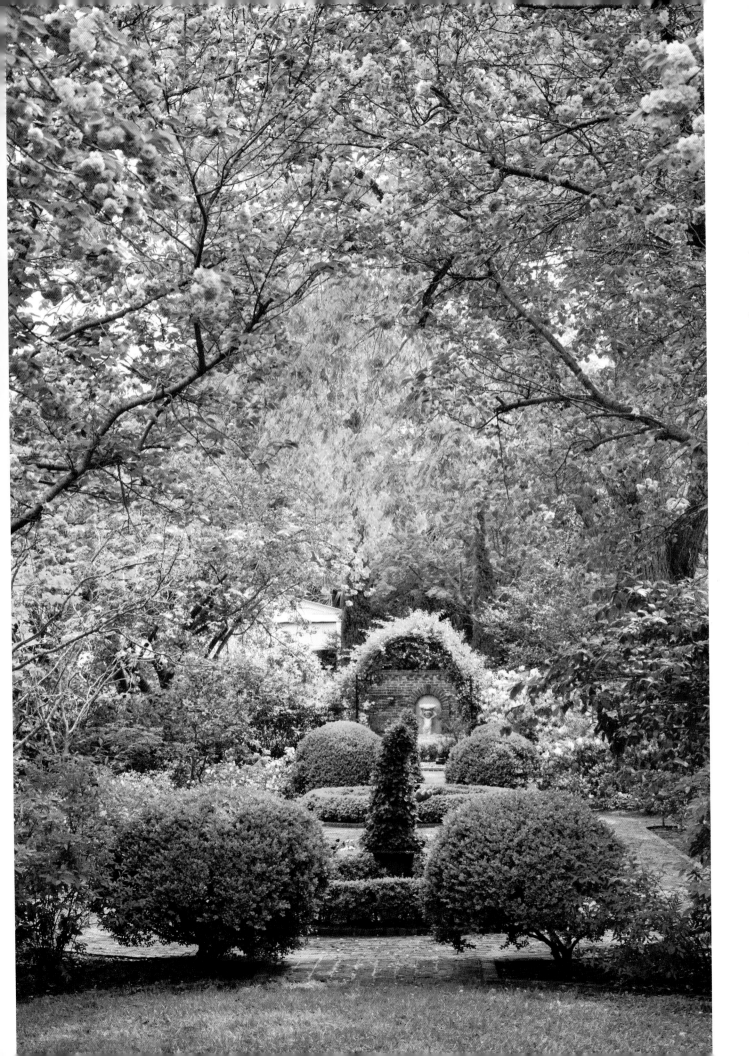

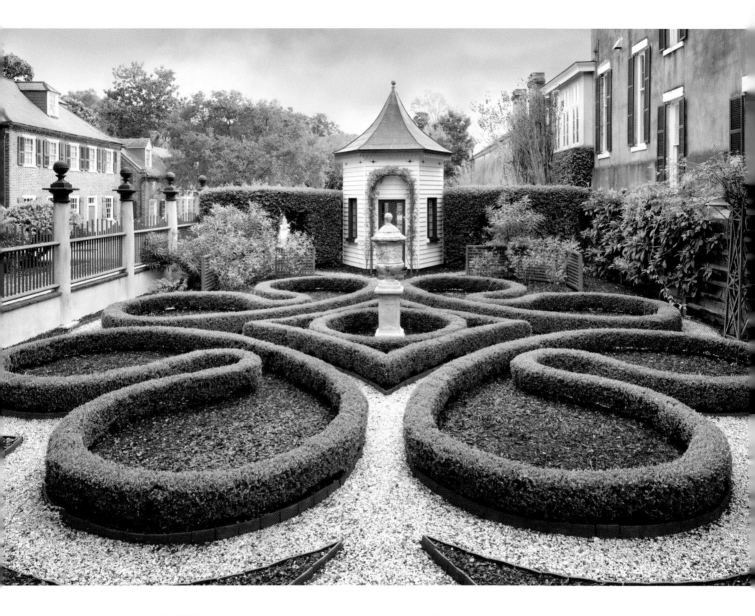

ABOVE: *A c. 1818 formal garden design was unearthed at the Simmons-Edwards House and has been restored with crushed oyster shell paths, a folly, and boxwood parterres in a swirling "rosary" pattern. The excavation also uncovered cannonballs and a slave tag from 1803.*

OPPOSITE: *The brick and wrought iron fence of the Simmons-Edwards House on Legare Street is known for its ornamental marble finials carved to resemble Italian pinecones, frequently referred to as pineapples.*

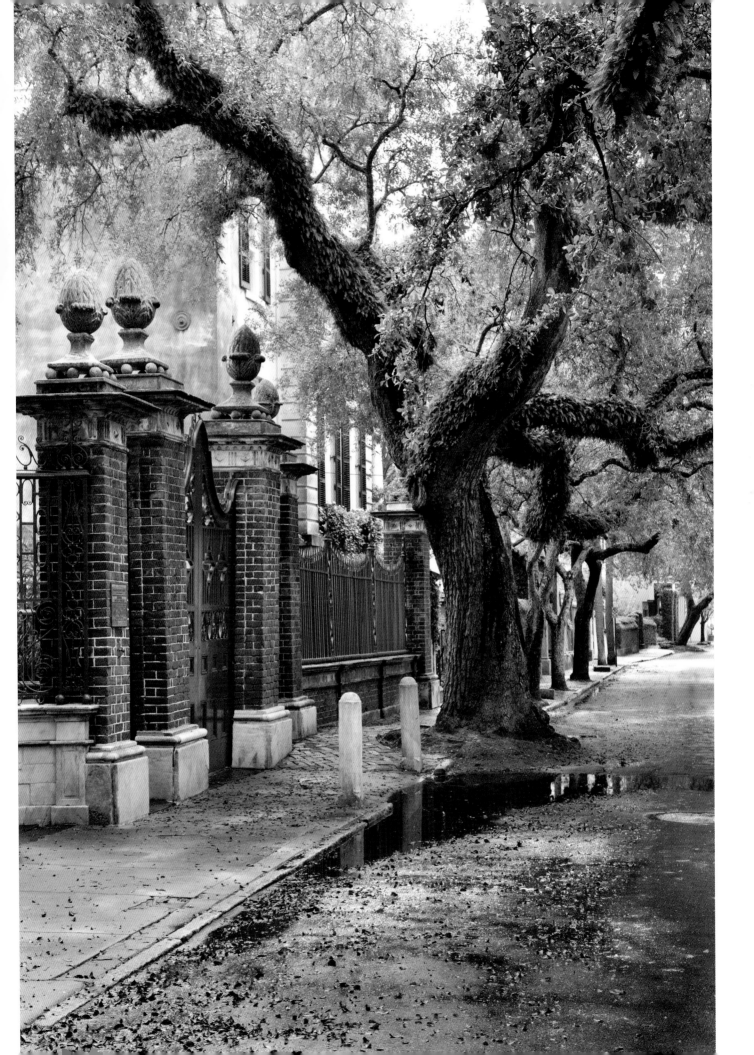

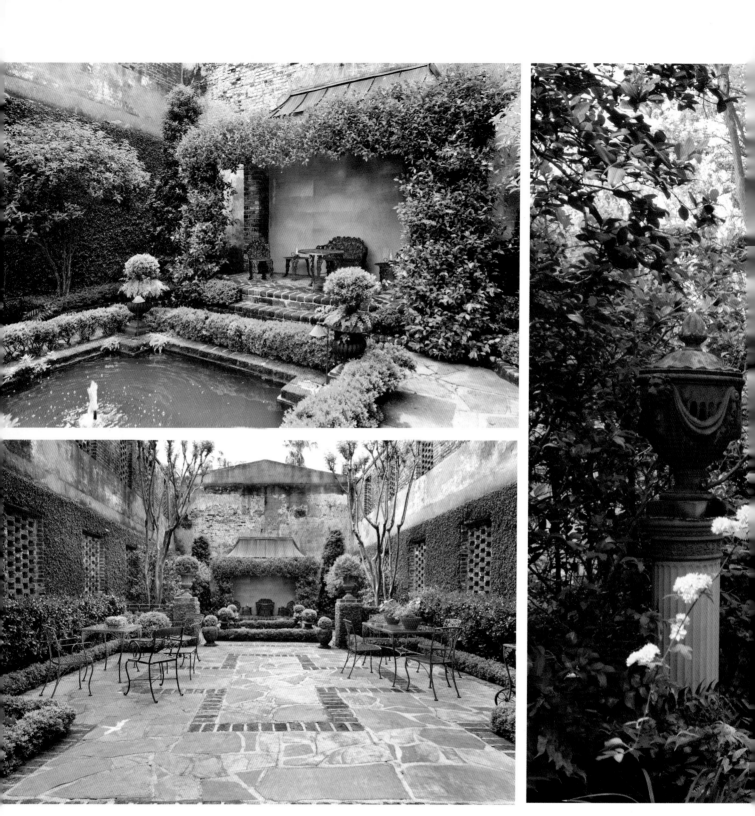

ABOVE: *A seating area of cast iron garden furniture in a canopied vestibule was created at the back of the garden of the 1784 William Stone House on "Rainbow Row."*

BELOW: *Loutrel Briggs used the remaining brick walls of a former cotton warehouse to create the courtyard behind the William Stone House.*

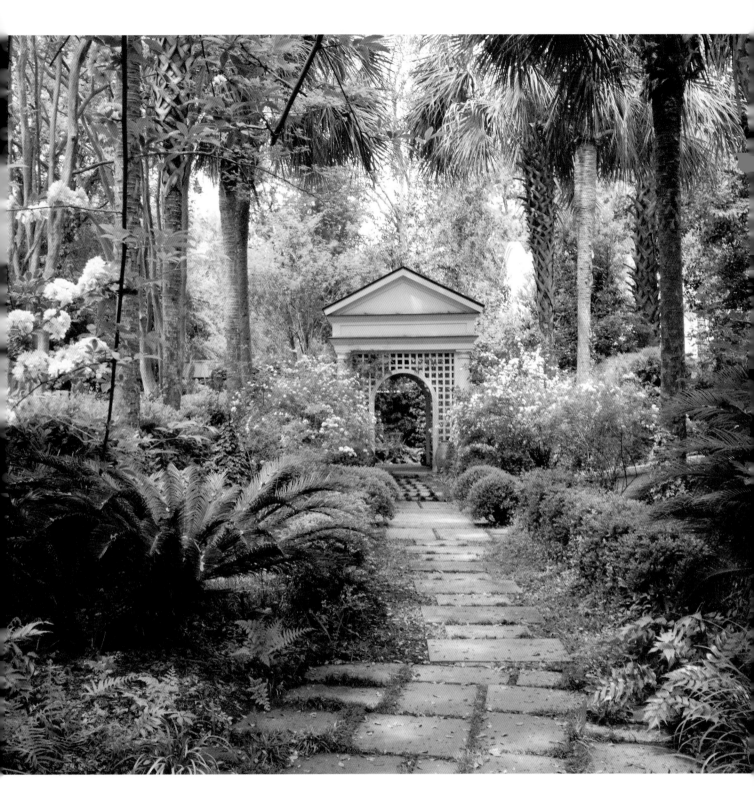

A neocolonial gazebo with latticed walls provides a focal point in a garden Loutrel Briggs designed for the Harth-Middleton House in the 1920s. The large garden was built on filled-in marshland along the South Battery.

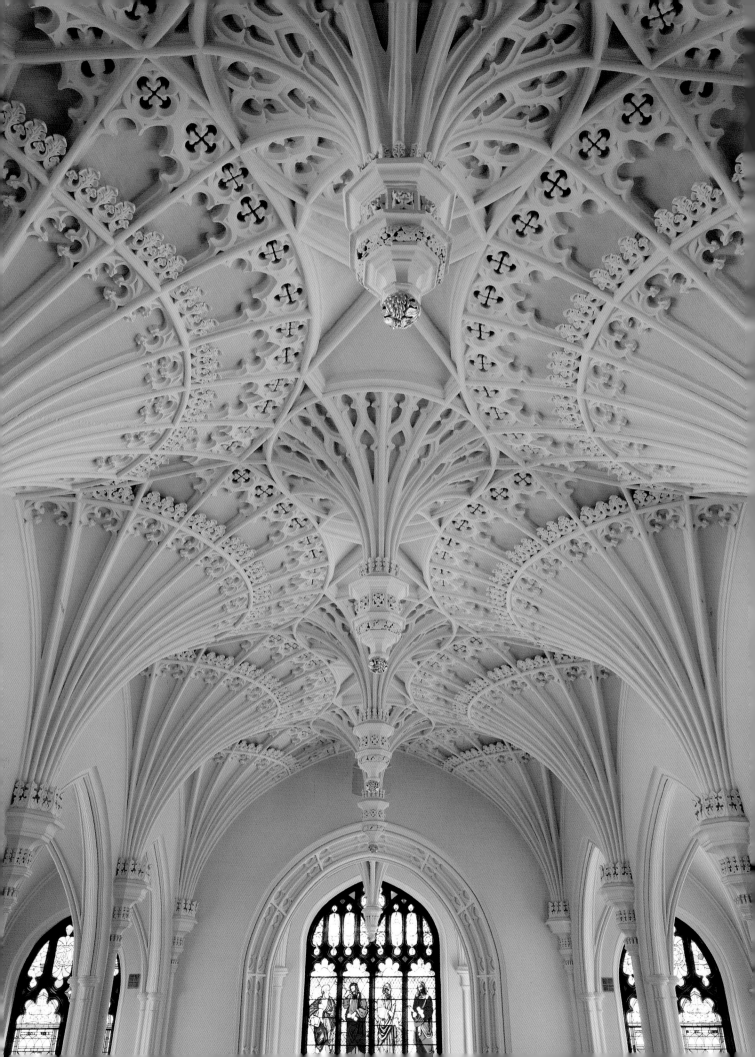

THE
Holy City

Charleston is sometimes called the "Holy City" due to its wide assortment of churches, with their towering steeples that once served as useful landmarks for sailors guiding ships into harbor. Advocating religious tolerance (with the exception of Catholics), the early Carolina colony was able to attract many religious groups including Sephardic Jews, French Huguenots, Scots Presbyterians, Quakers, and Dissenters. The number of ecclesiastical buildings in the city continue to reflect that diversity.

The architecture of Charleston's colonial-era churches was mainly of the Georgian style, drawing on the designs of Christopher Wren and James Gibbs. When fires in 1835 and 1838 destroyed hundreds of buildings, entire sections of the city had to be rebuilt, including dozens of churches. This led to a variety of different building styles and types, many designed by noted architects of the day.

The oldest surviving church building in the city remains St. Michael's, designed by Irish architect Samuel Cardy with a "tall, well-proportioned steeple." Built in the 1750s, it has been called the most beautiful colonial church in America. The church houses a tower clock that is the oldest in North America and is famous for its ringing bells that date from colonial times.

Charleston's oldest congregation, St. Philip's, was the first Anglican church established south of Virginia. Their small wooden building of black cypress built in 1681 was replaced in the early 1700s by a second brick one, "partially funded by duties on rum and slaves." After this church burned in 1835, the present one was constructed by architect Joseph Hyde.

Also destroyed in a fire was the Kahal Kadosh Beth Elohim synagogue that dated from 1794. This congregation was founded by Sephardic Jews from Spain and Portugal who came to Charleston as early as 1695. The present synagogue is a stately Greek Revival temple, built in 1840 by David Lopez from a design by Tappan and Noble with work plans drawn by Cyrus Warner of New York. It is the second-oldest synagogue in the nation and the oldest one in continuous use.

Other notable buildings that grace the city are the French Huguenot Church, rebuilt in 1845 as the first Gothic Revival style building of Charleston and the First Baptist Church, designed by Robert Mills, one of the first Federal architects in the nation and the designer of the Washington Monument.

Begun in 1772 by the Society of Dissenters, what is now the Unitarian Church was remodeled by the architect Francis D. Lee in the 1850s into its present English Gothic style. Lee added the decorative fan-vaulted ceiling and stained glass windows adorning the interior.

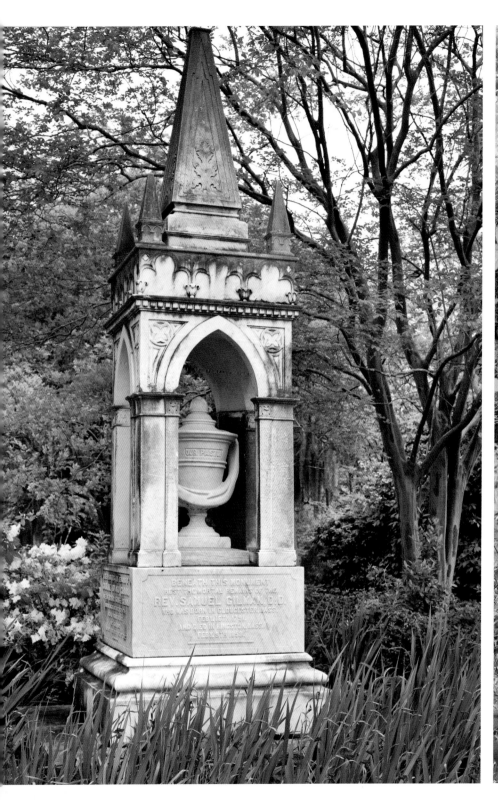

In the graveyard of the Unitarian Church is a monument to Samuel Gilman who came from Boston and served as minister in the 1800s. His wife, Caroline, published the national magazine The Southern Rose, *a forum for writers such as Nathaniel Hawthorne and Harriet Beecher Stowe.*

The Unitarian Church has an overgrown graveyard on Archdale Street where native plants, roses, and wildflowers are left to roam freely, as envisioned by Caroline Gilman in the 1820s. It provides a welcome contrast to the manicured gardens of many Charleston gardens.

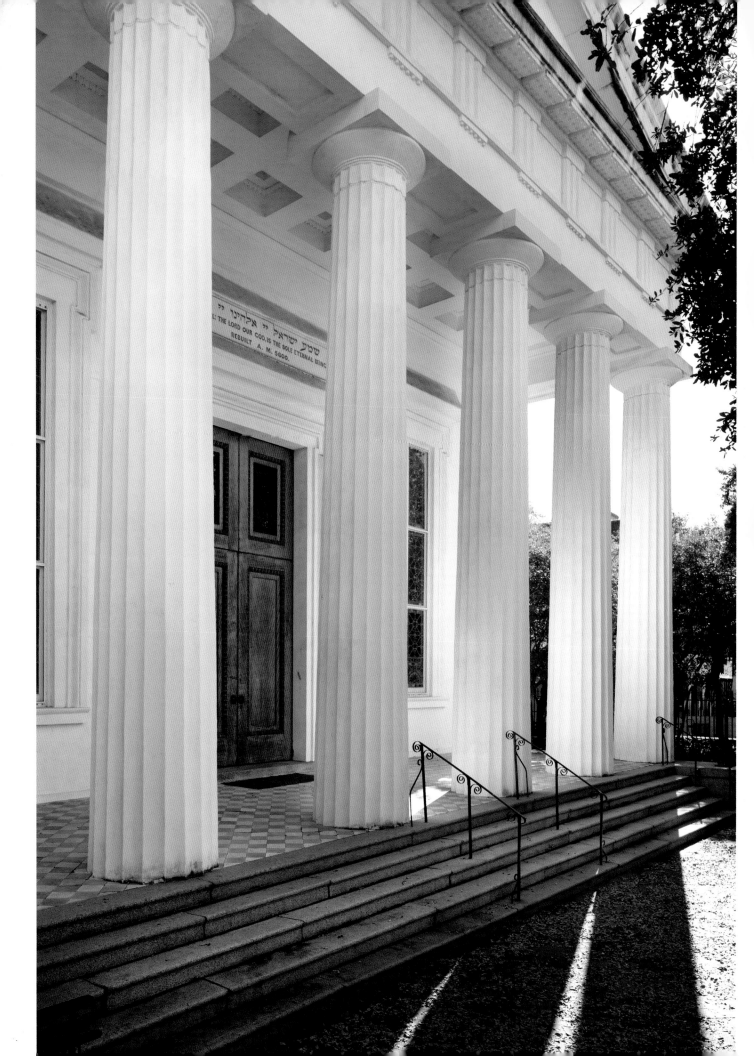

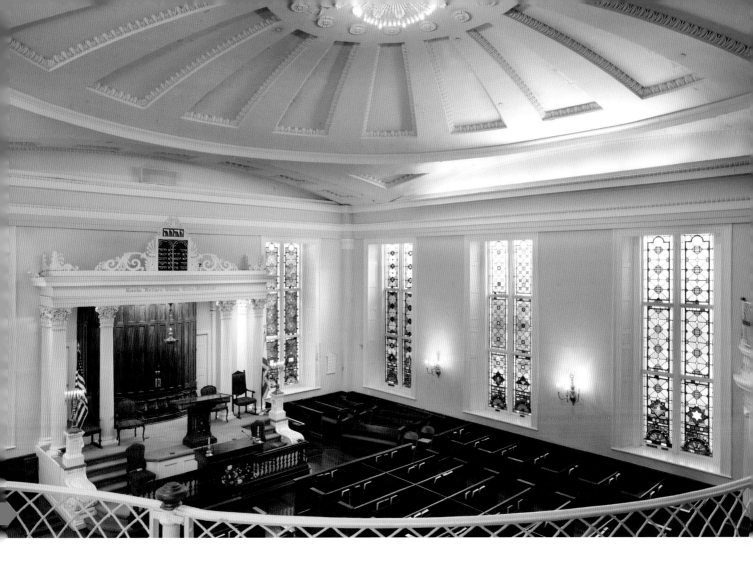

OPPOSITE: *One of the first buildings in Charleston to be built in the Greek Revival style, the synagogue Kahul Kadosh Beth Elohim on Hasell Street was constructed in 1840-41. It is considered one of the country's finest examples of the Greek Revival.*

ABOVE: *The large sanctuary of KKBE has a coffered dome set into a vaulted ceiling and ark doors of Santo Domingo mahogany. It is the oldest continually used synagogue in the U.S., as well as the second-oldest synagogue building in the country.*

RIGHT: *The Jewish community in Charleston dates to the seventeenth century and was composed primarily of Sephardic Jews from Portugal and Spain, coming by way of the West Indies. Stained glass windows of the KKBE temple were replaced after the 1886 earthquake.*

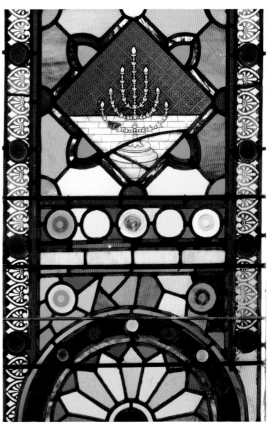

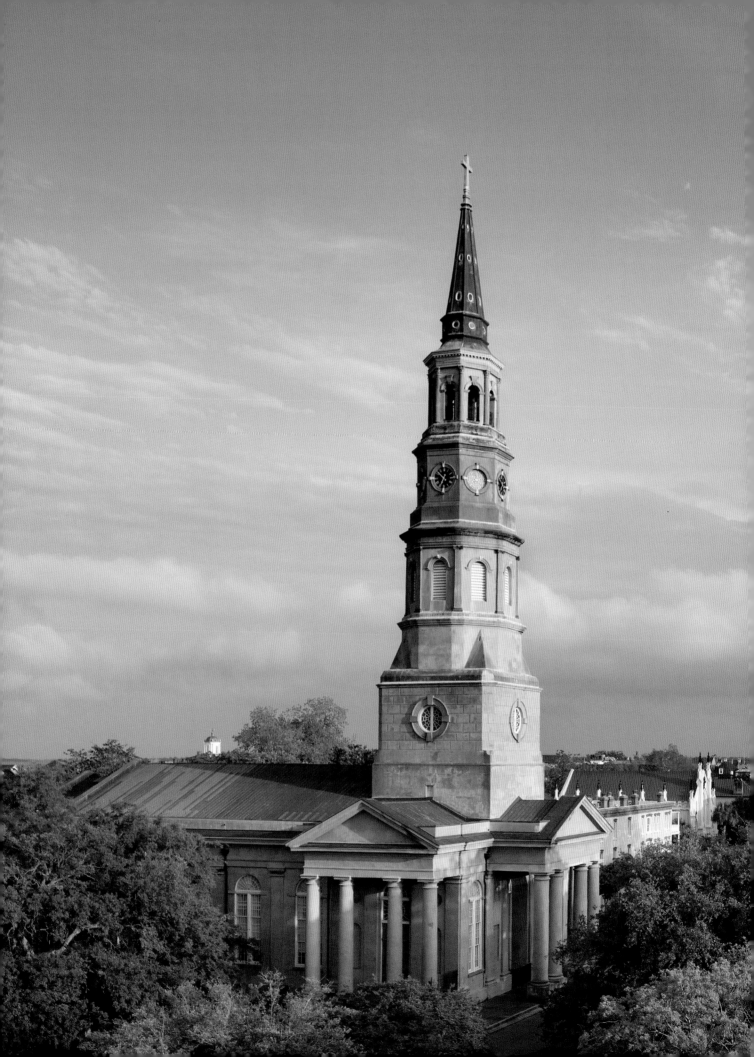

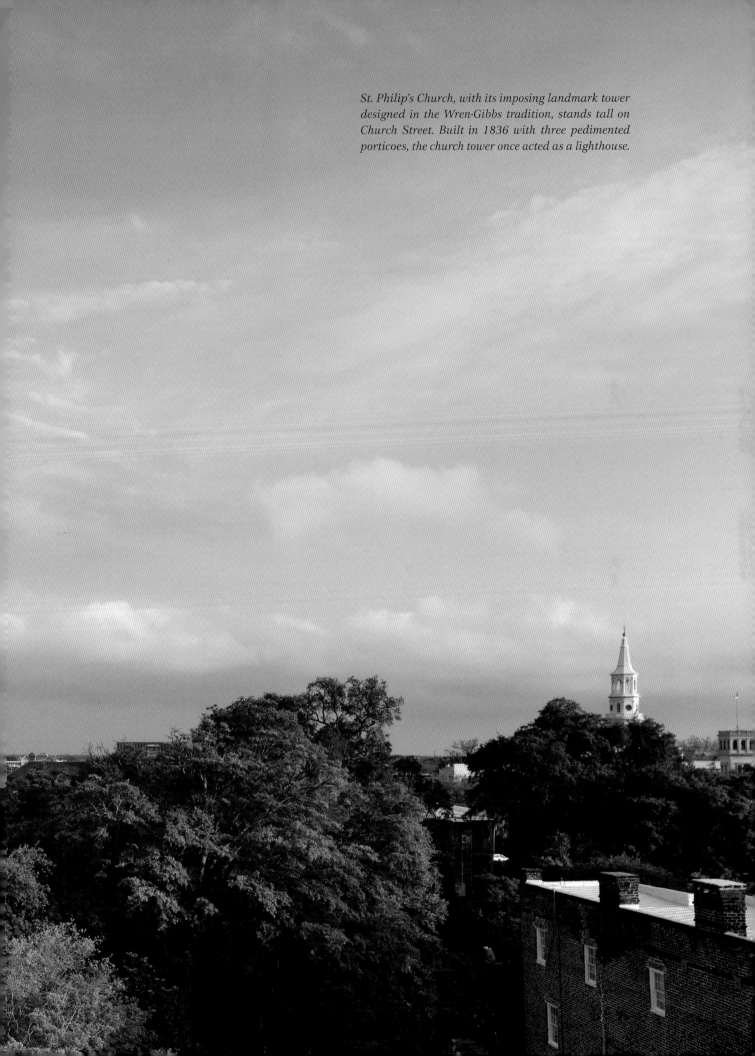

St. Philip's Church, with its imposing landmark tower designed in the Wren-Gibbs tradition, stands tall on Church Street. Built in 1836 with three pedimented porticoes, the church tower once acted as a lighthouse.

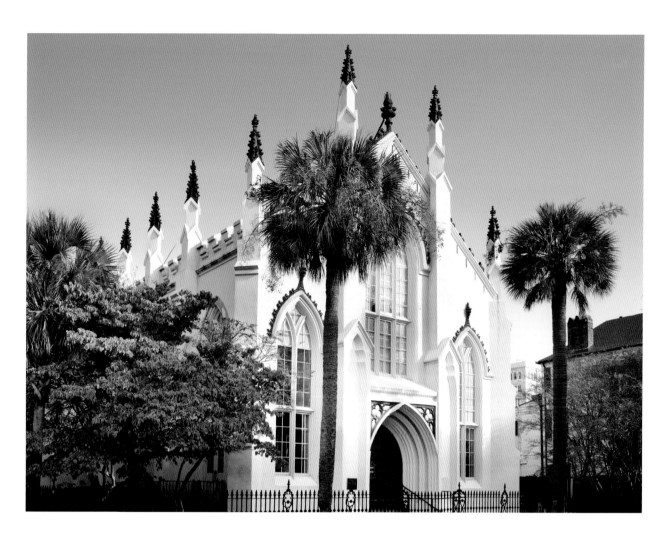

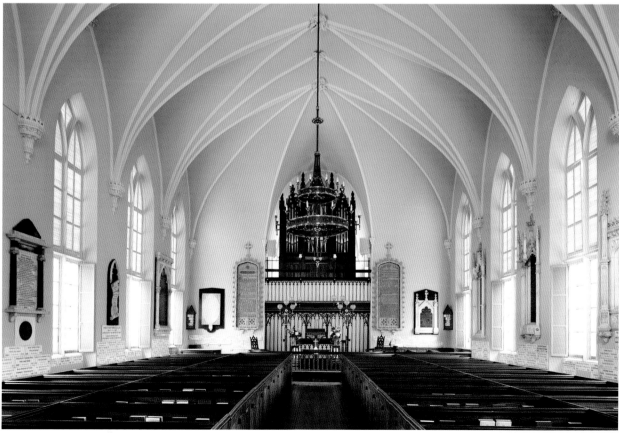

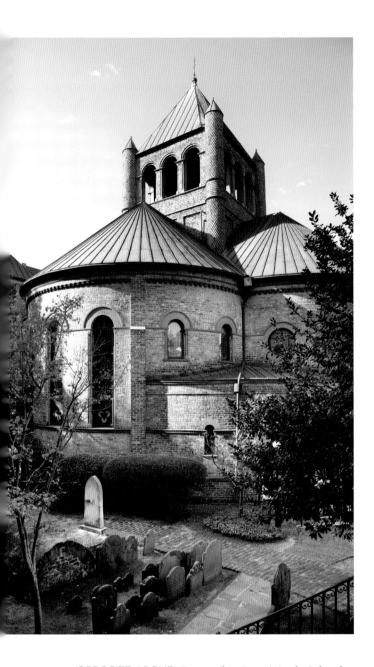

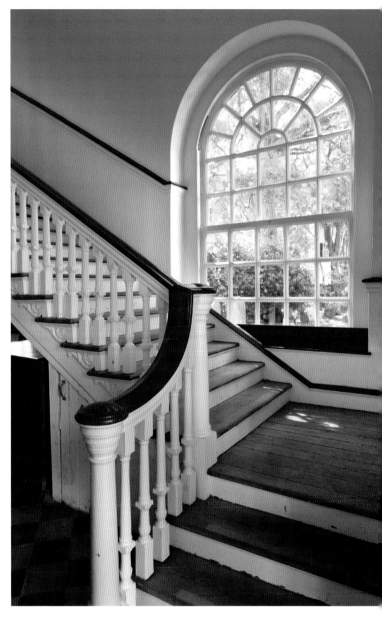

OPPOSITE ABOVE: *Restored to its original pink color, the stuccoed brick French Huguenot Church was completed in 1845 by architect E. B. White. The first church in South Carolina built in the Gothic Revival style, it is distinguished by fanciful pinnacle-topped buttresses.*

OPPOSITE BELOW: *The interior of the French Huguenot Church has walls with plaster-ribbed grained vaulting and marble tablets carved with the names of Huguenot families. Still in working condition, the large "tracker" organ was purchased in 1845.*

ABOVE LEFT: *The Congregationalist Church stood in ruins after the 1886 earthquake and was replaced by the present Romanesque structure in 1892. The oldest slate markers in its surrounding graveyard were shipped from carvers in New England and date back to the early 1700s.*

ABOVE RIGHT: *A Palladian window of St. Michael's Church overlooks its graveyard. St. Michael's was built from 1751-61 by architect Samuel Cardy; it's been called "one of America's most sophisticated colonial church buildings."*

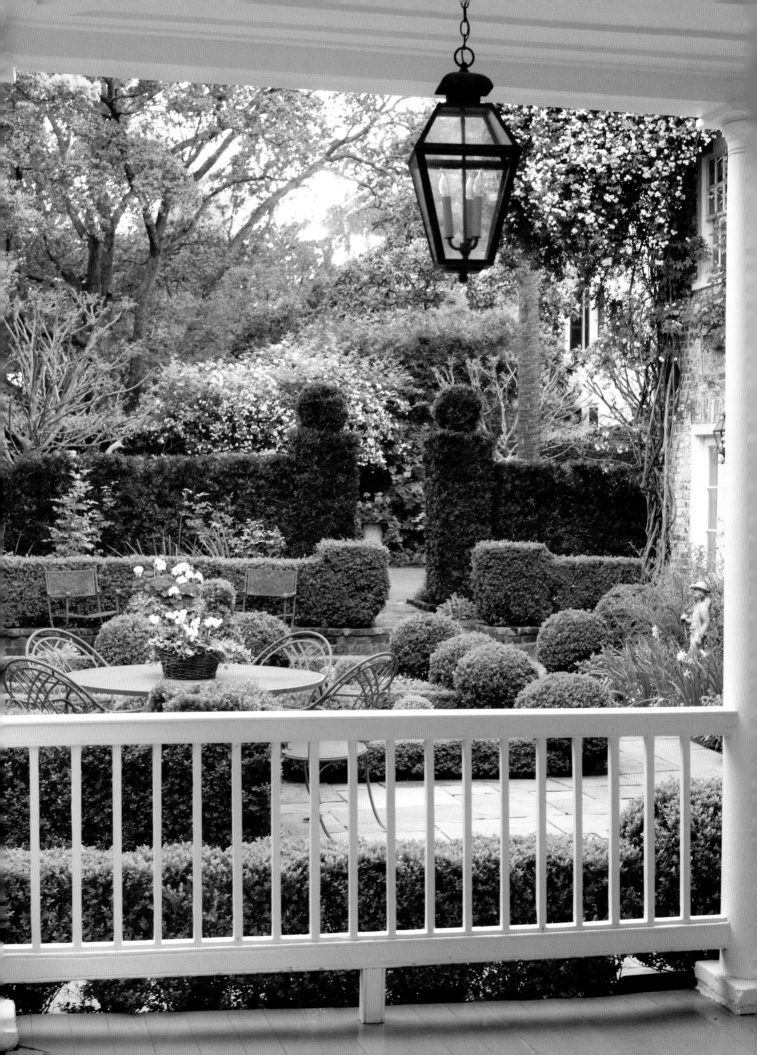

THE
Piazzas

"What gives Charleston its particular character is the verandah, or piazza, which embraces most of the houses on their southern sides," wrote the British traveler Sir Basil Hall on his visit to the city in 1828. Called porches, verandahs, galleries, or porticoes elsewhere, these covered additions to houses are known as "piazzas" in Charleston.

Piazzas began appearing on Charleston houses in the early 1700s, when it was realized how much more comfortable they might make life in the sultry climate. The porch form itself is age-old; the ones in Charleston are believed to have originated from the Creole vernacular style of the Caribbean Islands.

The typical house built in Charleston became the "single house," with its narrow, gable end facing the street and wide piazzas, often a double tier of them, extending sideways alongside the courtyards. Piazzas, which faced the south and west to catch any sea breezes, were supplied with hammocks, palmetto chairs, or the long benches called "joggling boards." On the piazzas everything from breakfasting, sewing, sleeping, and playing music took place.

The presence of so many piazzas, each overlooking their courtyard gardens filled with trees, foliage, and flowers, makes Charleston seem "like a great assemblage of country villas" and contributes enormously to the unique beauty of the place.

Piazzas served as outdoor rooms from which the layouts of geometrically patterned parterre gardens could be viewed and enjoyed.

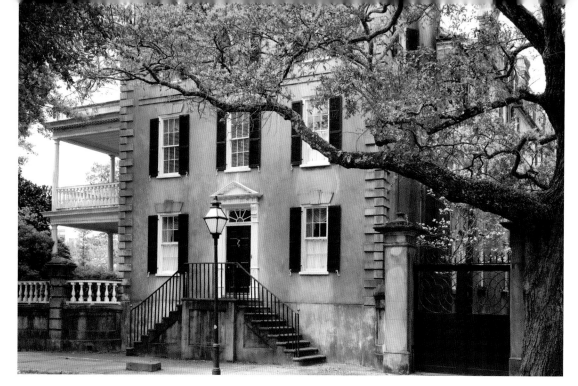

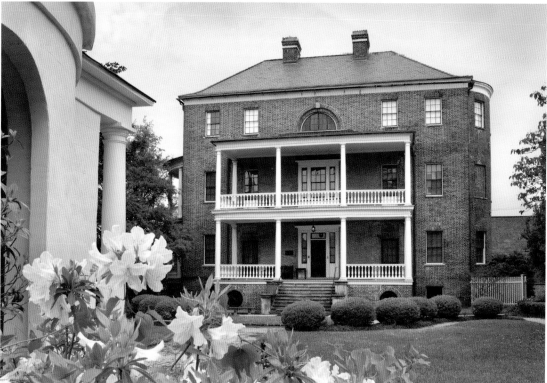

ABOVE: *Sitting over a high basement, the William Bull House on Meeting Street has a flight of steps leading up to its front entrance, lending it an air of elevated status. The house has side piazzas but no door from the street entering onto them.*

BELOW: *The southern façade of the neoclassical villa known as the Joseph Manigault House has a rectangular piazza overlooking a large garden. The grounds of the house include a small temple pavilion that was used as a rest room for a gas station before the property was restored by preservationists.*

OPPOSITE: *The John Poyas House shows the features of a Charleston "single house" type; it is one room deep, with its gable end facing the street and large piazzas overlooking a side garden. Entry is through a door that opens not into the house, but into the piazza.*

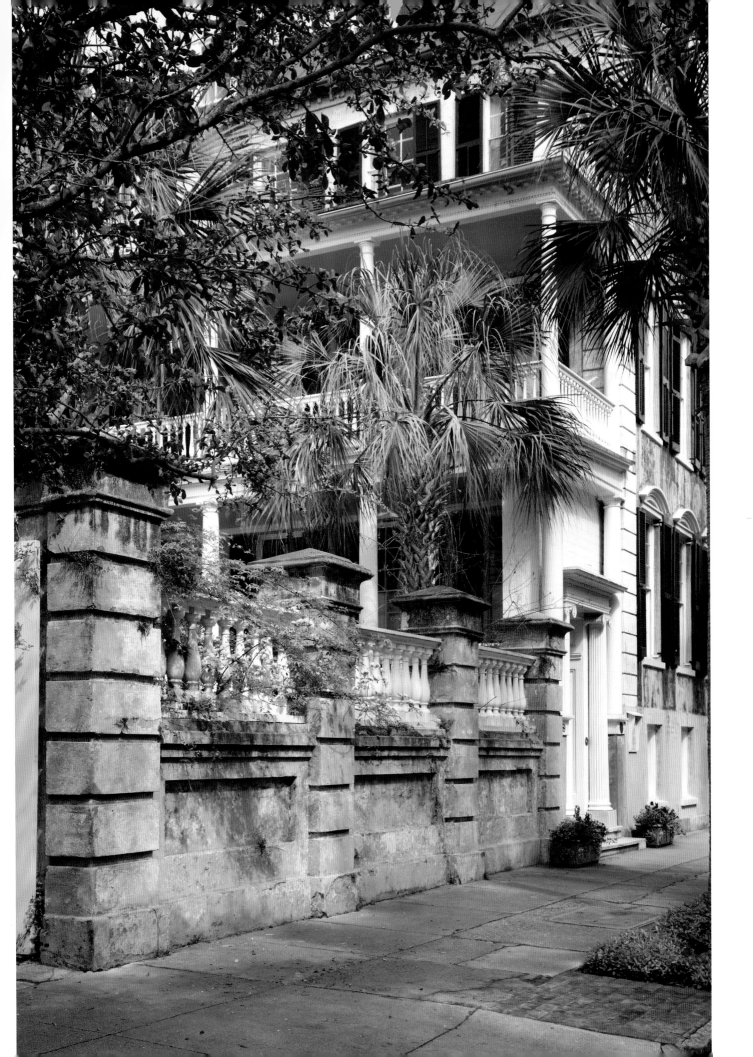

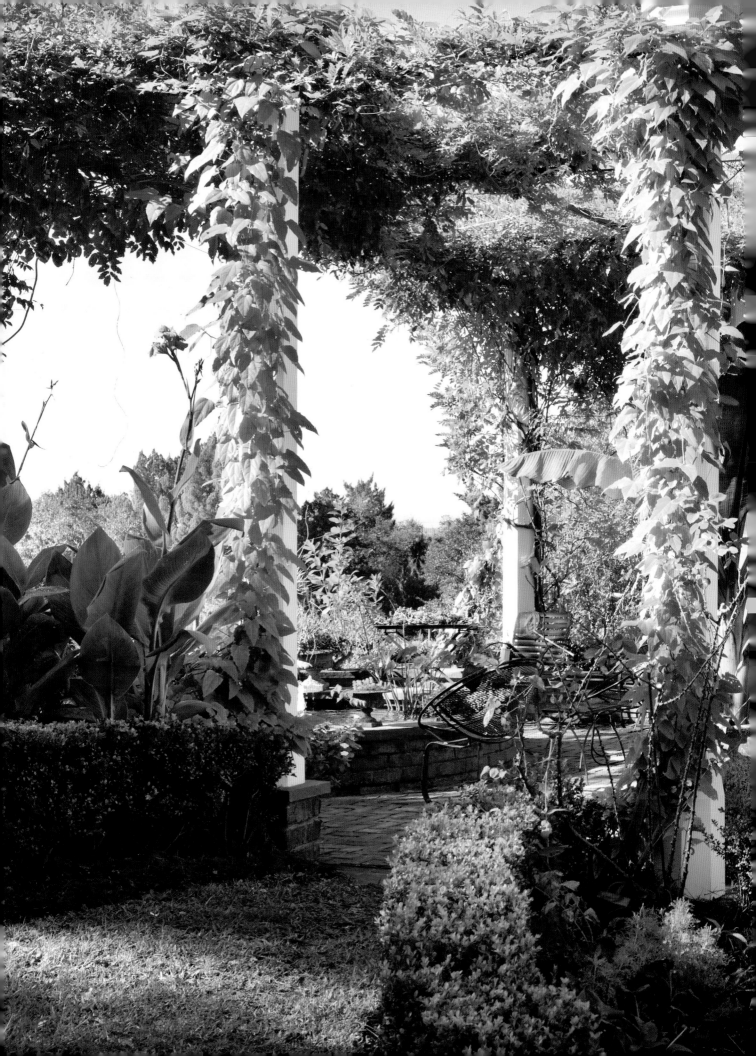

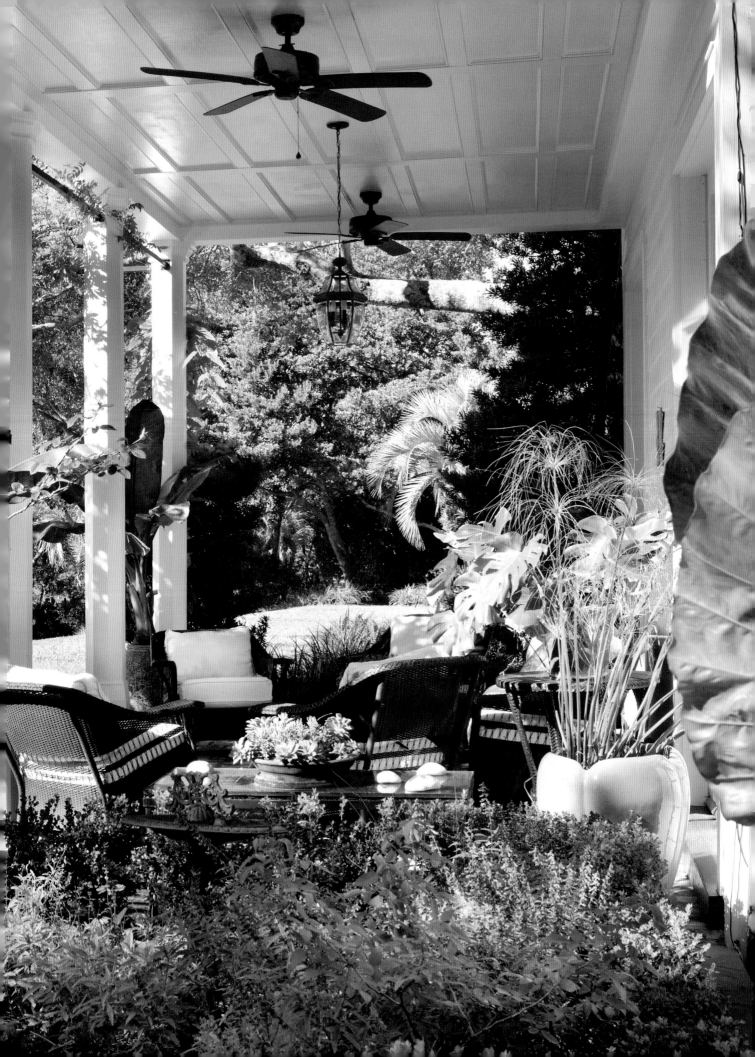

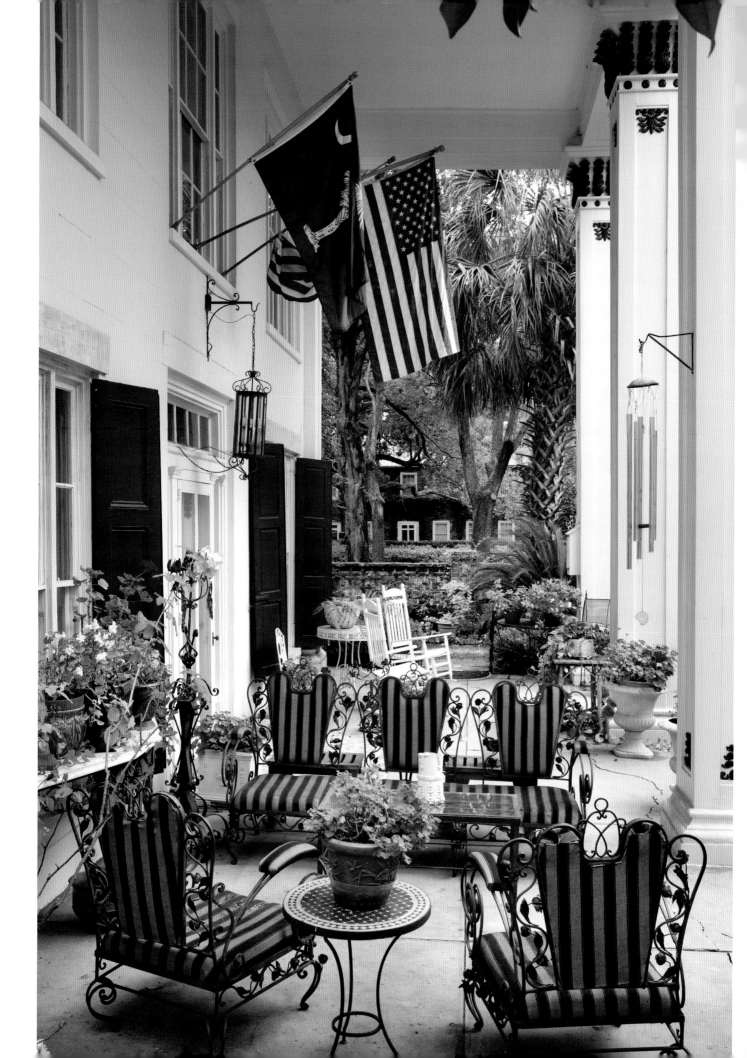

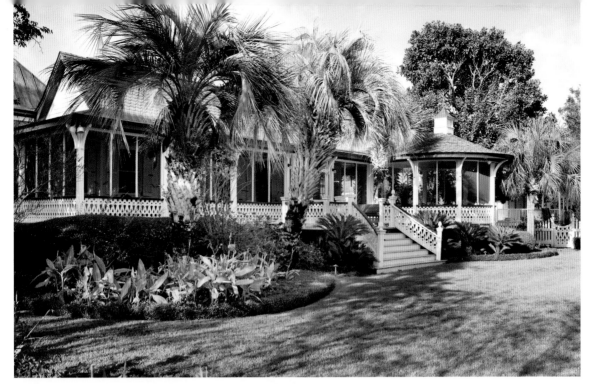

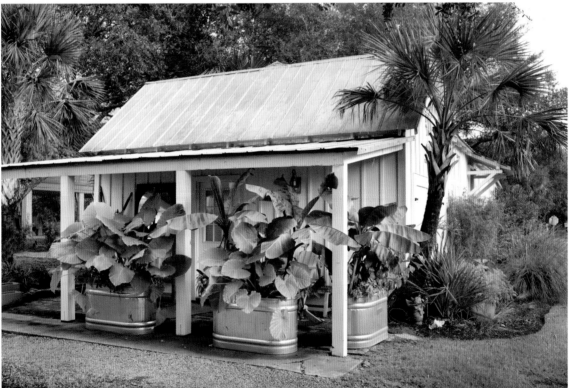

OPPOSITE: *Tall, square Tuscan columns dressed with black iron palm leaves add dignity to the portico of the George Reynolds House on Hasell Street.*

ABOVE: *A summer refuge, Sullivan's Island with its beaches was said to be a place "where guests grow young in the embrace of the ocean." The wraparound porch of a Victorian house is designed to catch as many salubrious breezes as possible.*

BELOW: *Large containers filled with banana tree and elephant's ear plants provide a screen for the porch of a small vernacular beach cottage on Sullivan's Island.*

PRECEDING OVERLEAF: *At Southwinds, the porch ceiling is painted in "haint blue," the name given by local folklore to the celestial color used to imitate the sky.*

Charleston

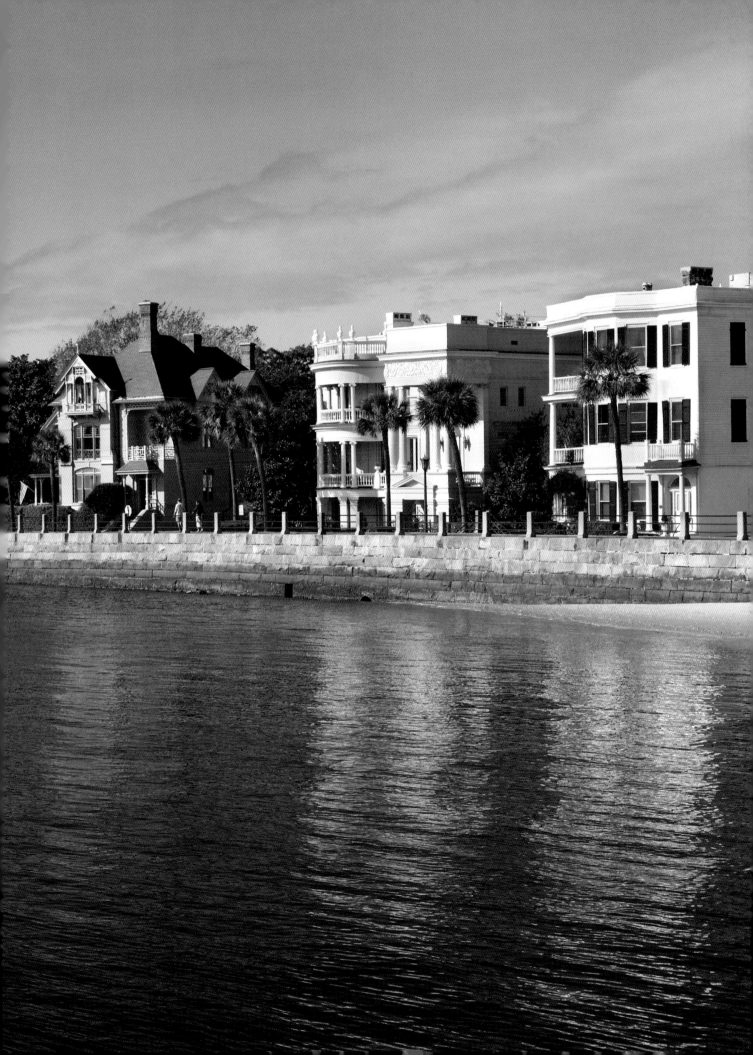

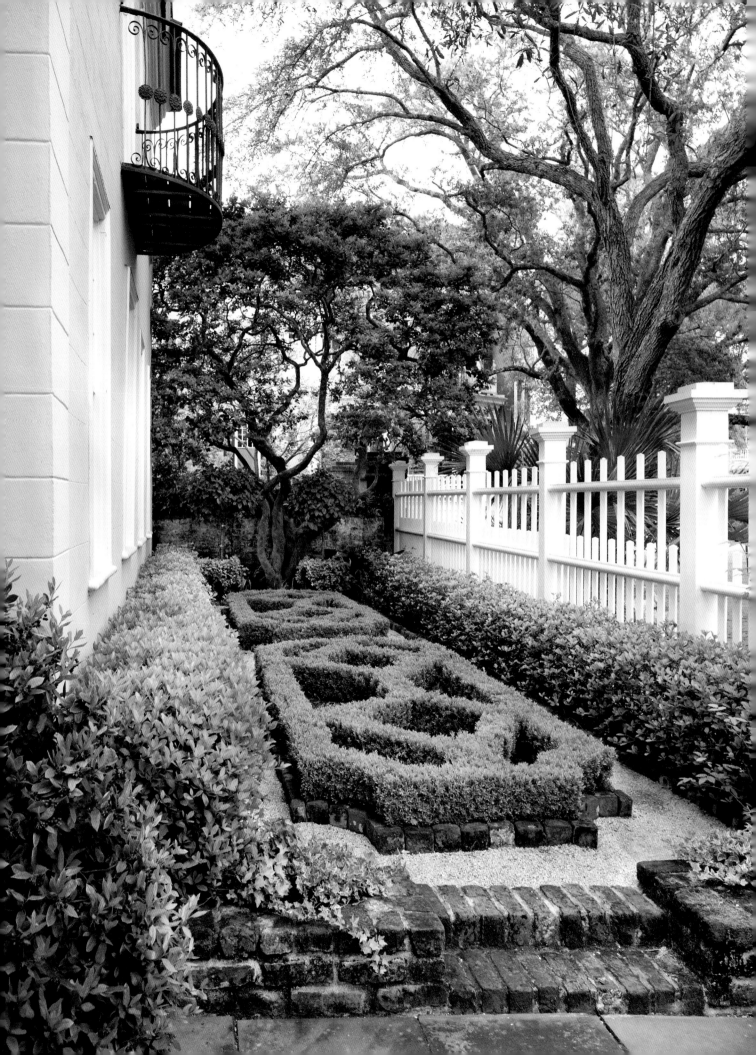

GEORGE MATHEWS HOUSE GARDEN

Known as the George Mathews House, the refined Georgian-style house with a small wrought iron balcony and double-tiered piazzas is one of the earliest homes in Charleston and was constructed in 1743 in what is the picturesque "Bend" of Church Street, a spot that is often painted by artists.

Recently, the house was meticulously restored by Ben and Cindy Lenhardt; in the process the couple also created a sophisticated, elegant garden consisting of a series of outdoor "rooms" made of hedges and walls, all planted in a prevailing palette of green and white. The garden, while compact, has several different levels and private spaces that create visual interest. Lenhardt has filled the garden with classic plantings of box, yew, and white roses, as well as exotic specimens such as white ginger lilies, papyrus, fig-leafed palm, and rice paper plants.

Chairman of the national Garden Conservancy, Ben Lenhardt designed the garden himself. Drawing on the neocolonial, iconic gardens designed by Loutrel Briggs in the 1930s, Lenhardt created the urban garden in similar fashion to be compatible with early Charlestonian architecture and the hot southern climate.

The driveway was paved with tabby, an oyster shell concrete that was historically used in colonial America, and stone and bricks were utilized to make and edge paths. An ancient mooring post was discovered while digging in the garden and resurrected to become a focal point. And a large eighteenth-century-style parterre was created that could be viewed from the upper piazza, from which its intricate pattern may be enjoyed.

OPPOSITE: *Tucked behind the picket fence is a small "pocket garden" with crushed oyster shell paths and a parterre of Japanese boxwood and Indian hawthorn.*

ABOVE: *Climbing white "Lace Cascade" and "Iceberg" roses bloom on the white-painted neocolonial fence and gate in front of the George Mathews House.*

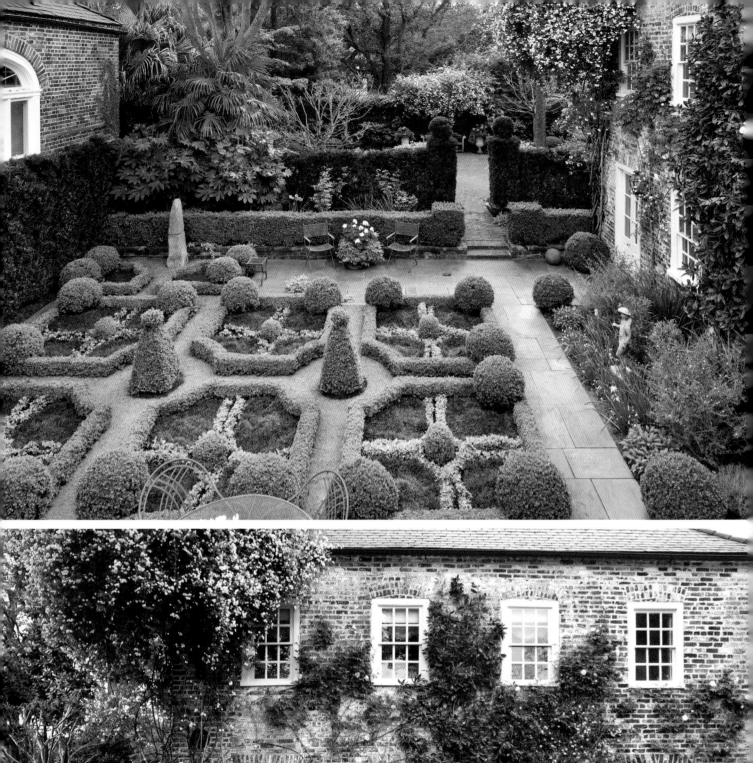
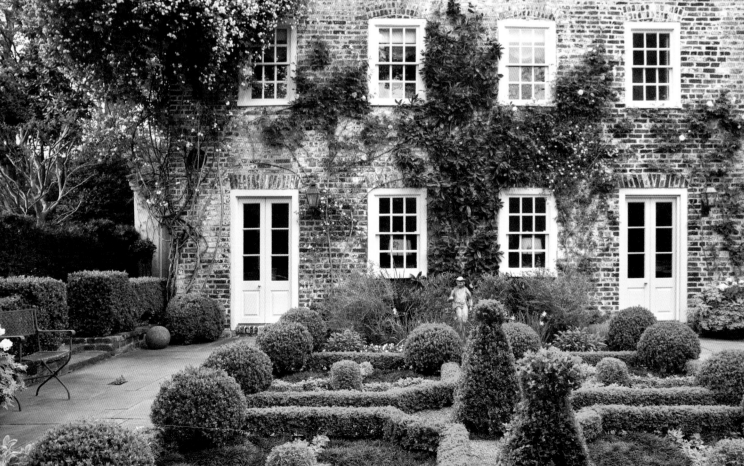

OPPOSITE ABOVE: *A large garden "room" contains an early eighteenth-century-style parterre of box, needlepoint ivy, and dwarf mondo grass.*

OPPOSITE BELOW: *White roses and lantana climb the walls of an old brick kitchen dependency, along with a deep green 'Magnolia grandiflora' that Lenhardt espaliered against the wall.*

RIGHT ABOVE: *A small garden shed with a tile roof was once a double privy. In front of it, beds of variegated English ivy mix with seasonal annuals.*

RIGHT BELOW: *A room at the end of the garden is entered by going up two steps through a hedge, which has a "gate" shaped with entry posts and finials. Inside the walled room, a teak bench is flanked by English urns and surrounded with white climbing roses.*

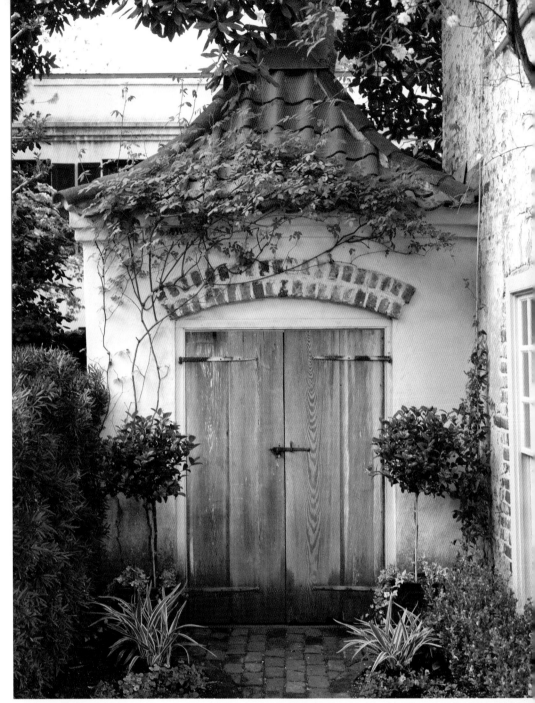

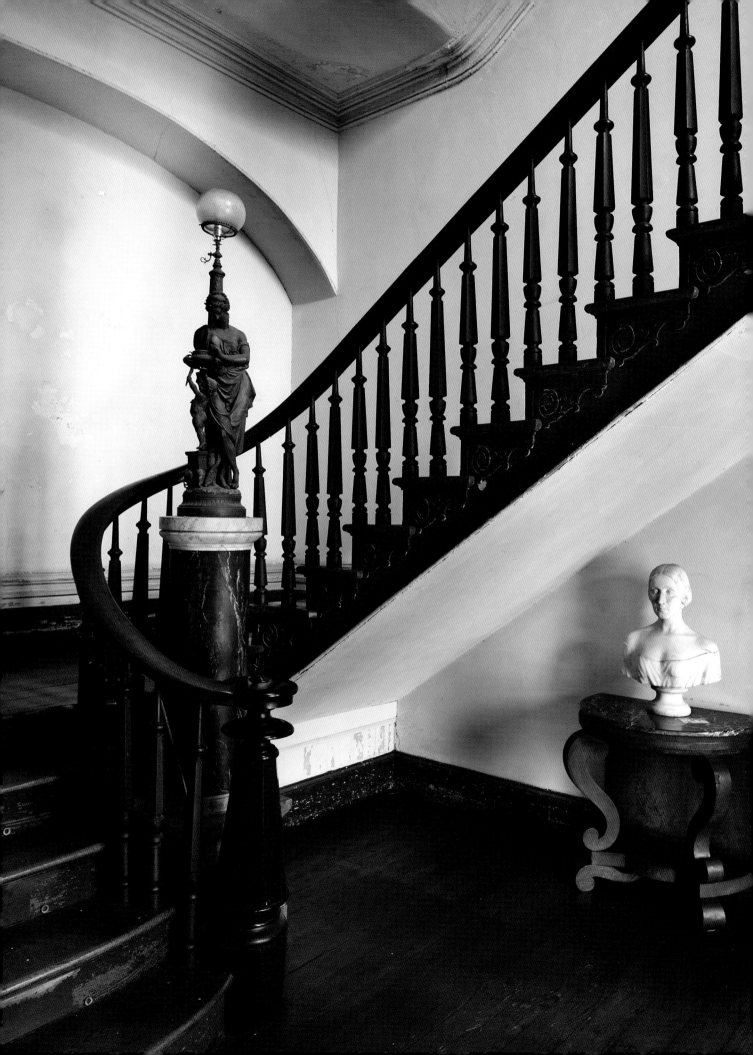

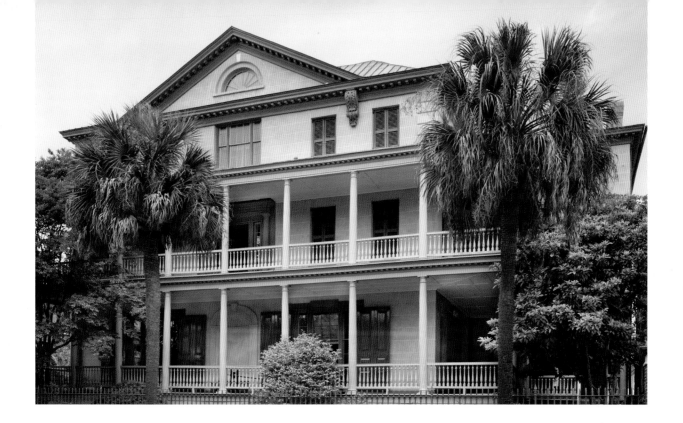

AIKEN-RHETT HOUSE MUSEUM

The Aiken-Rhett House was once one of Charleston's grandest mansions. Originally designed circa 1818 as a Federal-style building for cotton factor John Robinson, it was remodeled in 1833 and again in1858 by owners William and Harriet Aiken. The Aikens altered the original floor plans, adding an impressive marble entrance foyer, a capacious art gallery, and a wing with a large dining room and ladies' withdrawing room above it for extravagant entertaining.

Like other wealthy antebellum Charlestonians, the Aikens sought to identify themselves with aristocratic European tastes and culture. They traveled extensively in Europe, acquiring paintings, statues, chandeliers, marble mantels, and other objects with which to ornament their twenty-three–room mansion.

After the Civil War, generations of Aiken and Rhett families continued to live in the house until 1972, gradually closing off rooms they could no longer afford to keep up. Over the passage of time, paint and wallpaper peeled off the walls, glass fanlights shattered, elaborate draperies and silk upholstery rotted, and heavy black dust covered the French crystal chandeliers.

Today the house is in the same condition as the last family member left it, in a state of elegant dilapidation, preserved but not restored. In its disheveled state it conveys a poignant sense of changing fortuncs and the history of the South. Operated as a museum by the Historic Charleston Foundation, there are also a number of outbuildings in the enclosed courtyard in their original condition, including the living quarters of former slaves and a Gothic Revival stable.

OPPOSITE: *In the stairway is a bust of Ellen Martin Aiken done by her husband the artist Joseph Daniel Aiken, who also designed the art gallery of the house for his cousin.*

ABOVE: *Built as a Federal "double house," the Aiken-Rhett House was restyled as a Greek Revival showplace by William and Harriet Aiken.*

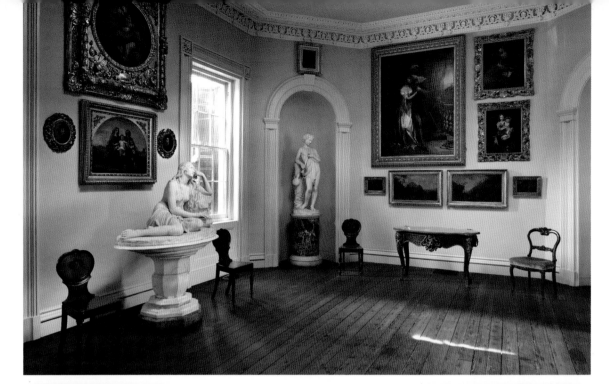

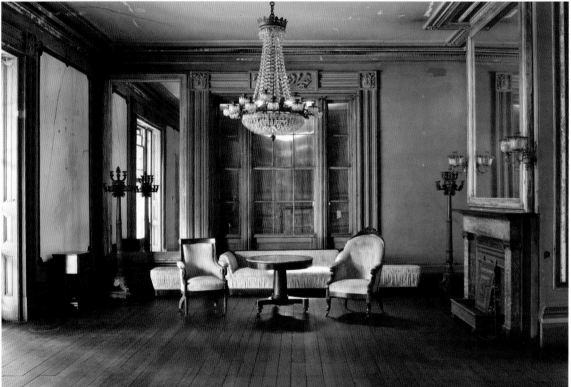

ABOVE: *After a European tour in 1857, the Aikens redecorated the house in the Italianate style, adding an art gallery wing with curved wall niches in which to place their marble statues.*

BELOW: *The vast, double drawing room has mahogany pocket doors and Greek Revival moldings. Many pieces of furniture came from the New York firm of Deming and Bulkley, who offered Charlestonians "beautiful furniture which will not suffer in comparison with the best specimens ever imported from Europe."*

OPPOSITE: *In the dining room, beneath a robust ceiling medallion with interlocking rings and rosettes, hangs an oil-burning Argand lamp.*

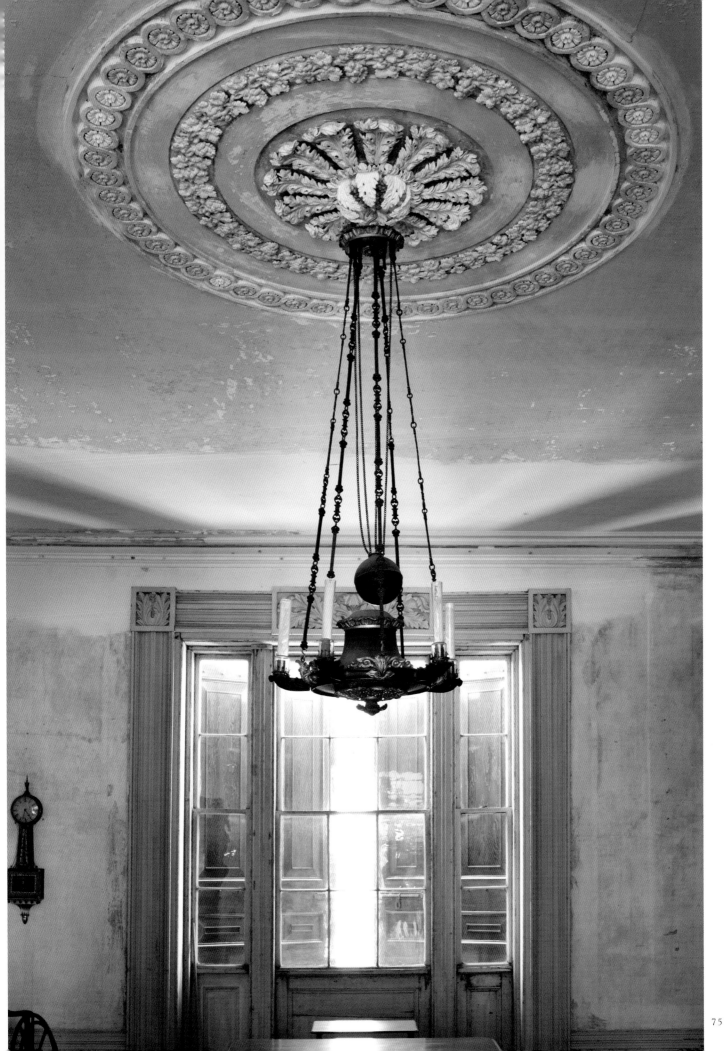

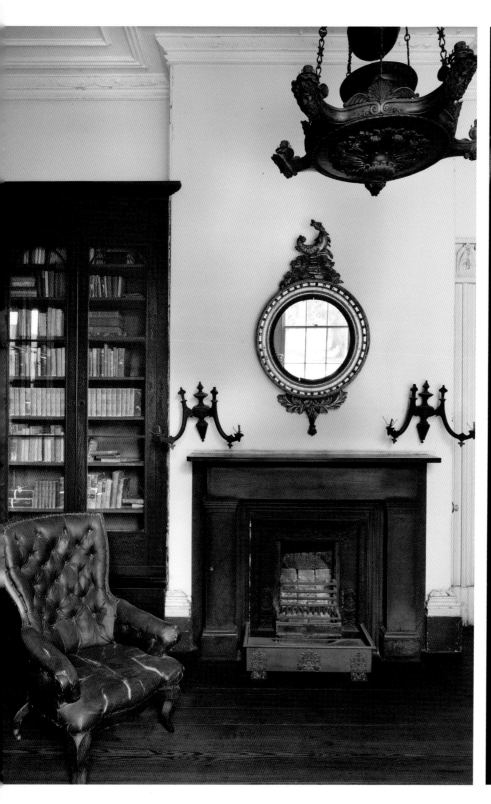

The library of the house still contains some of the family's books. A larger collection of more than two thousand volumes is on loan to the Charleston Library Society.

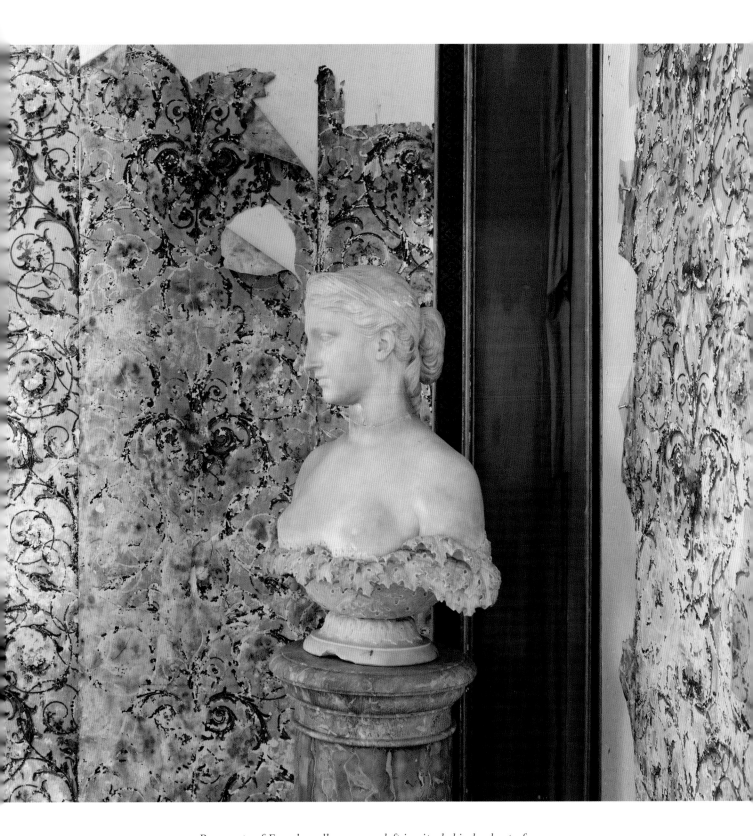

Remnants of French wallpaper are left in situ behind a bust of Proserpine by Hiram Powers. Renowned as one of the great sculptors of the nineteenth century, "Proserpine" was one of Powers' most popular sculptures.

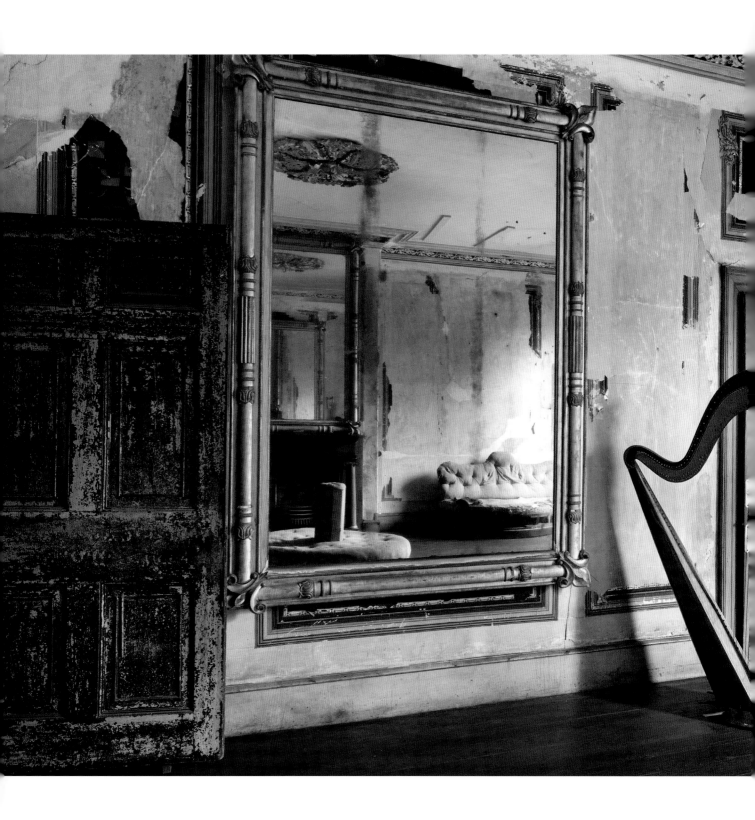

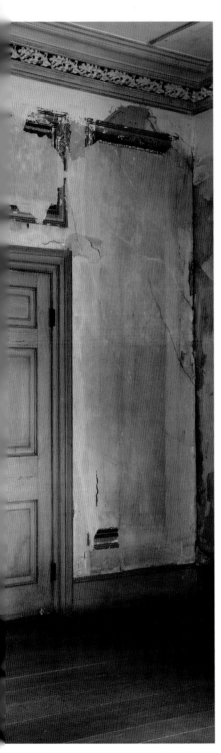

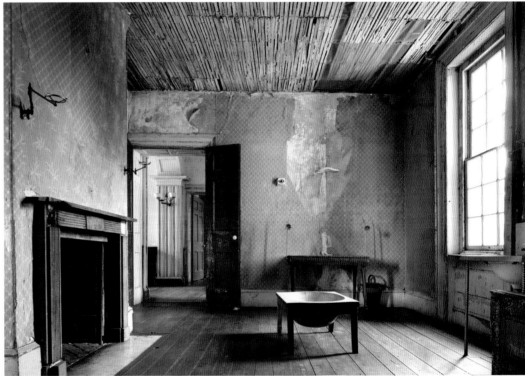

LEFT: *After her husband died in 1887, Harriet Aiken turned the grand ladies' withdrawing room on the second floor into her bedroom. Upon her death five years later, the room was shut up for the next seventy-nine years.*

ABOVE: *A Victorian-era footbath and a twentieth-century sink are left in a second story dressing room.*

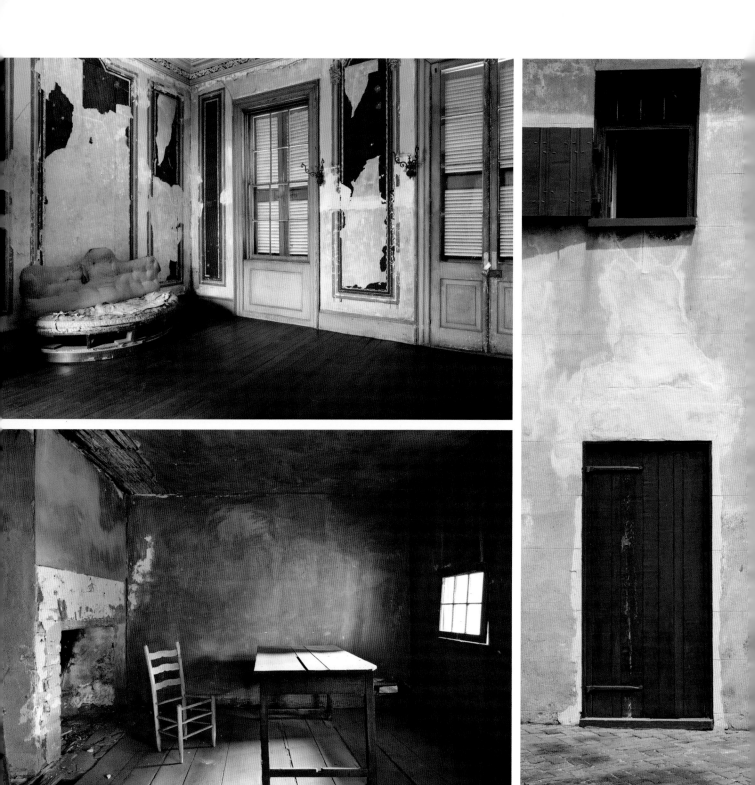

ABOVE: *Light slants in through the broken louvers of old shutters. Shreds of flocked wallpaper put up in the 1830s still cling to the walls over a tattered demi-lune sofa.*

BELOW: *In the kitchen and laundry house, slaves lived upstairs in five rooms. Leftover paint from the main house was used by slaves and servants to brighten the walls of the rooms.*

Nineteen skilled enslaved African Americans were confined behind walls on the prem-ises, including carriage drivers, cooks, butlers, carpenters, gardeners, laundresses, nursemaids, and seamstresses.

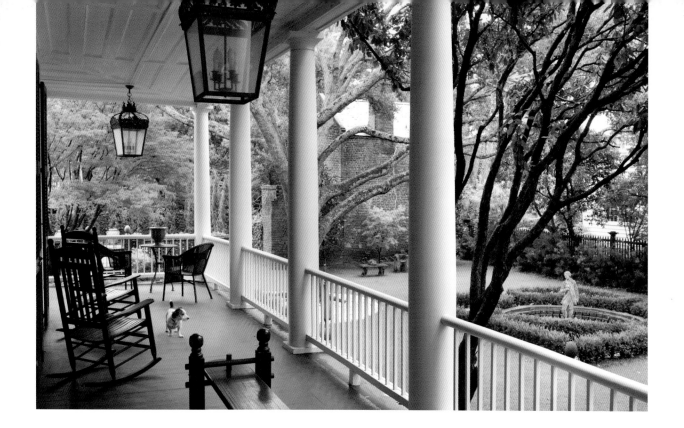

AUGUSTUS TAFT HOUSE

Sitting in stately beauty on a quiet street in Ansonborough, the Greek Revival "single house" was built in 1836 by Augustus Taft, a member of the New England family that included a president. Taft's daughter, who married into an old Charleston family, the Stoneys, inherited the house and it remained in the Stoney family for more than a century, with the exception of the six months in 1865 when it was confiscated by the Freedman's Bureau to house freed slaves.

Along with thirty pages of conservation easement rules, the house came with its original doorknobs, black marble mantels, plaster cornices, and ceiling medallions, and even a few chandeliers. According to the easement rules, details such as these may never be changed, but that was not a problem for the current owners Donatella Cappelletti and Giulio della Porta , who met in their native Italy before coming to Charleston, and are both avid preservationists.

In the era when the house was built, it was fashionable among the sons of wealthy Charlestonians to take the Grand Tour of Europe, with Italy as a primary destination. They traveled in order to be schooled in the language of classical Greek and Roman architecture, painting, and sculpture. Busts, Renaissance oil paintings, marble fireplaces, and portraits of themselves were brought back from their Italian tours in order to tastefully furnish their townhouses in Charleston.

Today, the della Porta home is furnished in similar manner with fine Italian pieces reflecting the couple's artistic sensitivities. The house contains an ancient stone bust of a Roman commander, old lanterns from Florence, landscape views of Italy done by painters in the 1700s, and a fountain statue that was once in their garden in Umbria. Like many old Charleston homes, it contains portraits of illustrious ancestors, including one of a Cardinal, and heirloom pieces, such as inlaid marble tables, hand-painted doors, and silver that have all been passed down in the family.

OPPOSITE: *Removing the low ceiling tiles revealed the black cypress roof beams and "gives a feeling of kitchens in the Umbrian countryside."*

ABOVE: *Double piazzas offer views of the additional lot Augustus Taft purchased so that Mrs. Taft could have a large garden.*

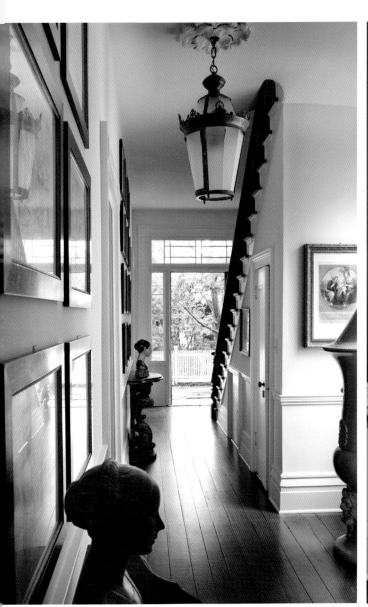

ABOVE LEFT: *In a variation of the usual Charleston "single house" plan, the hallway is placed on the side in order to accommodate wide double parlors. Prints by a High Renaissance artist from Florence line the walls.*

ABOVE RIGHT: *In the dining room, a "pietre dure" table from Florence is of black marble inlaid with semi-precious stones, alabaster, and colored marble. The hand-carved mirror is from Umbria; cutlery has the della Porta coat of arms engraved on each piece.*

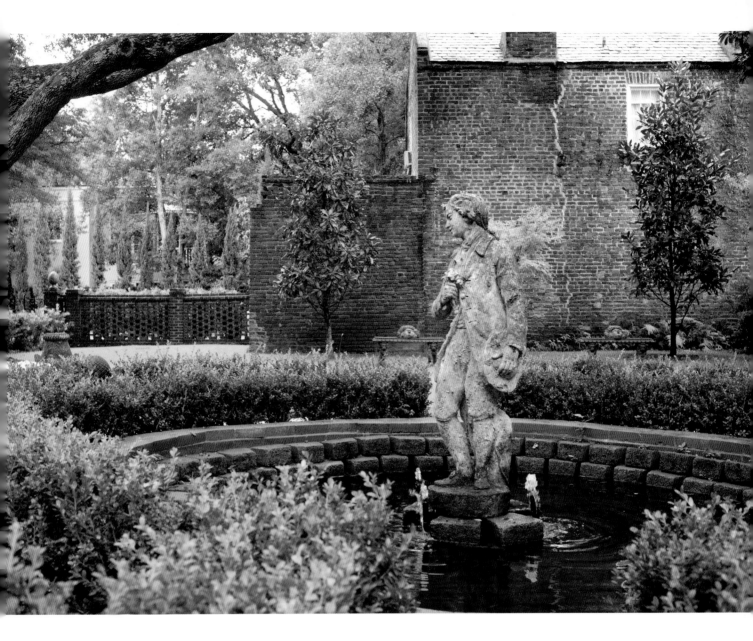

A c. 1800 statue from the della Porta's garden in Umbria has been placed in the center of a fountain that is lined with old brick and surrounded by a circular hedge.

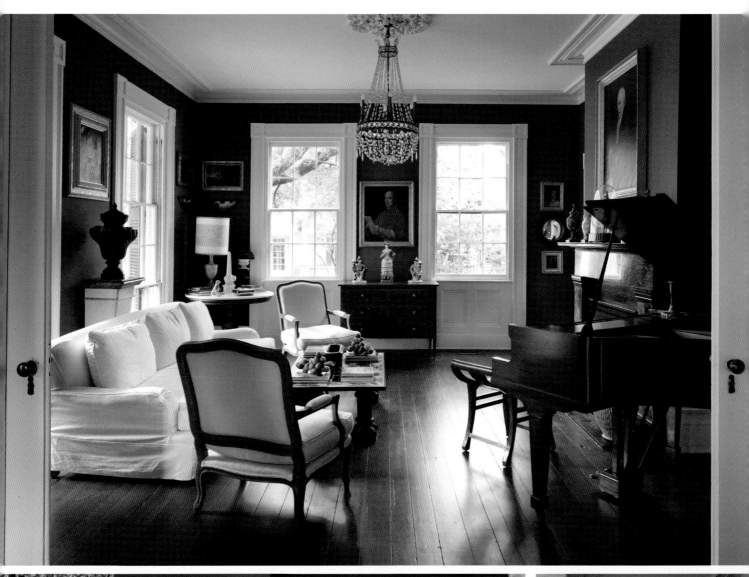

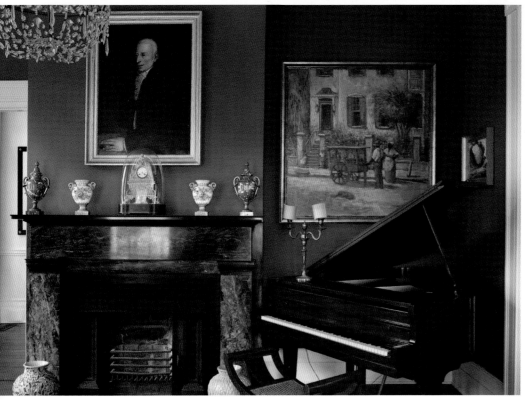

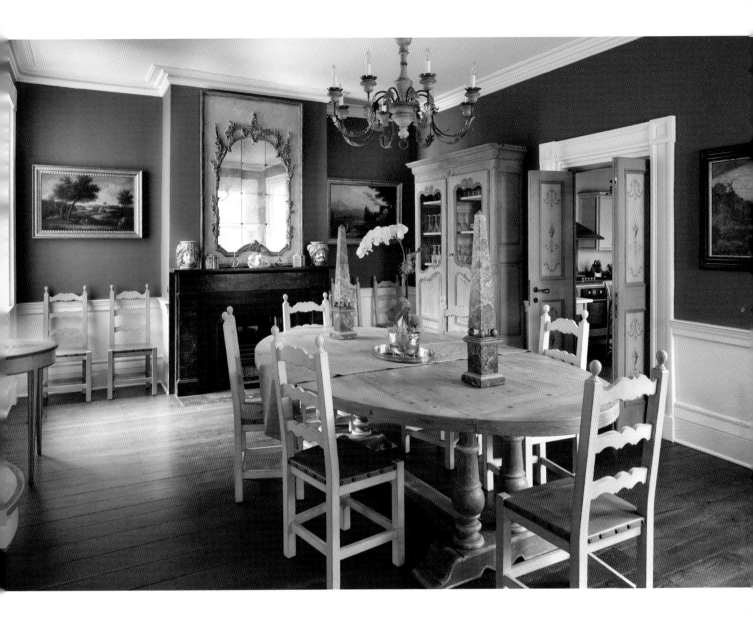

OPPOSITE ABOVE: *Between the windows in the pine-floored front parlor hangs an ancestral portrait of Girolamo della Porta, a Cardinal and the head of the Vatican's archaeological department in the late 1700s.*

OPPOSITE LEFT: *Mantels of black Portoro marble with gold veining were installed by the Tafts in the 1830s. Black marble, sometimes called "mourning marble," was a newly fashionable color for fireplaces at the time.*

OPPOSITE RIGHT: *A full-length portrait of General Robert E. Lee, done by Charleston painter John Carroll Doyle, hangs on the wall of the back parlor which has walls painted in Confederate gray.*

ABOVE: *A hand-painted dining table was designed in the manner of fourteenth century Tuscan furniture; the doors leading to the kitchen are also hand-painted. Landscapes, all from Italy, offer views of Rome through the eyes of painters of the sixteenth century.*

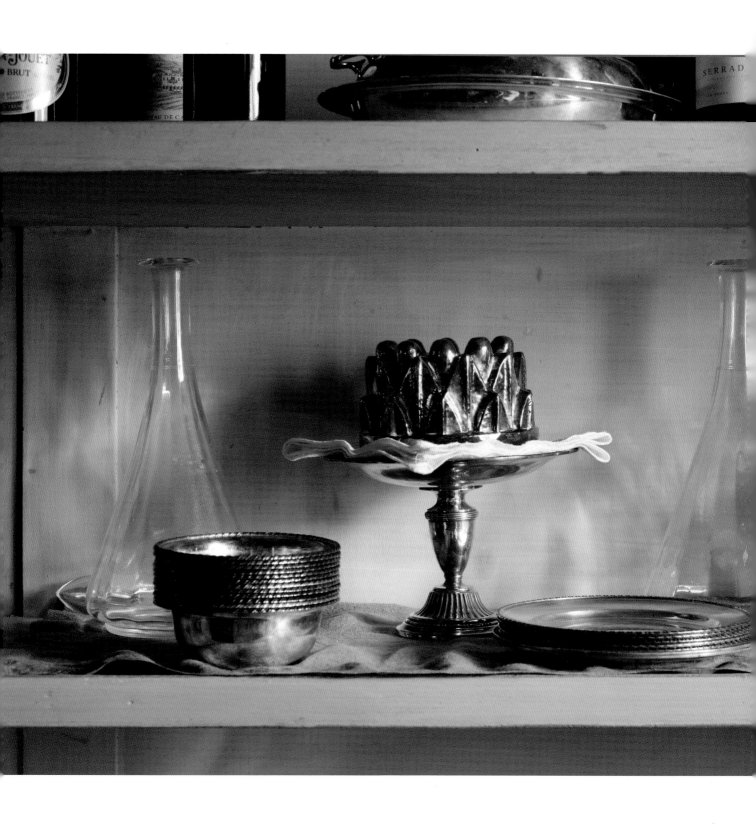

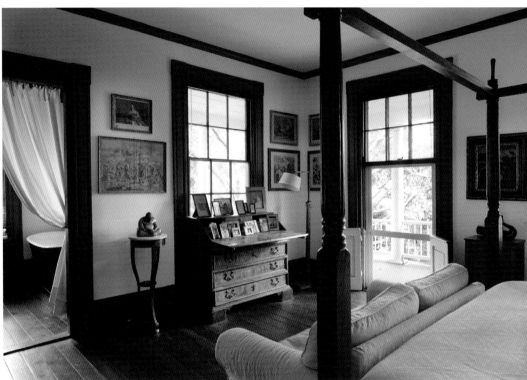

LEFT: *A hand-painted antique Italian wine cabinet placed in the kitchen displays silver from Tuscany and lovely glass pieces from Florence.*

ABOVE: *In a second-floor bedroom, triple sash windows have a wooden bottom section that opens like a door, providing access to the upper piazza. The desk is Italian, made of walnut wood inlaid with rosewood.*

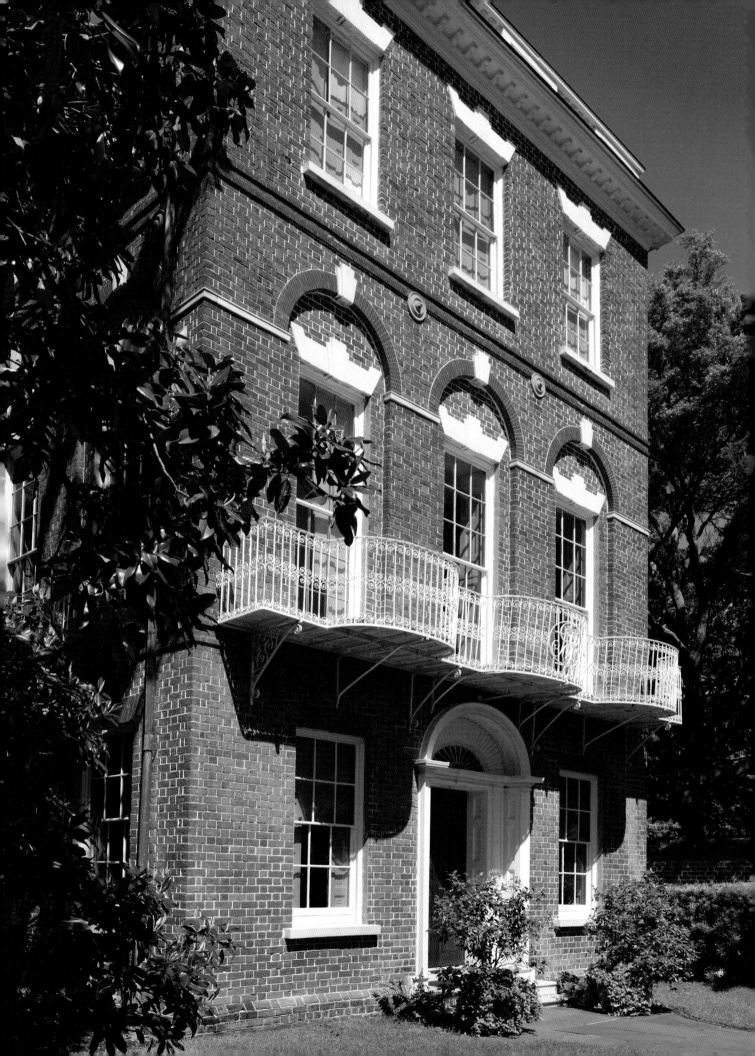

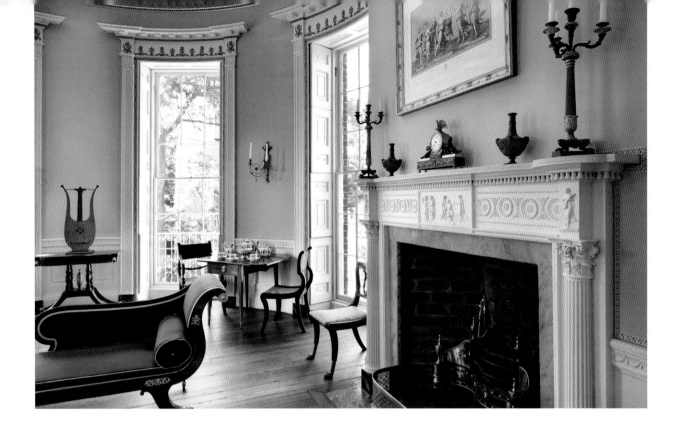

THE NATHANIEL RUSSELL HOUSE MUSEUM

The Nathaniel Russell House was completed in 1809 by a wealthy shipping merchant from Rhode Island whose international trade in tobacco, rice, indigo, cotton, and slaves allowed him to live in a lavish style. The Federal-style house, made of Carolina gray brick, has a projecting four-sided bay on one side, which allows for oval rooms within. Its white-painted wrought iron balconies wrap around the house and flamboyantly display Russell's monogram above the front door. The architect of the house is unknown, but it has been attributed to Russell Warren, a kinsman of the Russells from Rhode Island and one of the most prominent architects in New England.

Nathaniel Russell went to great lengths to decorate the interior of his house with fine craftsmanship, hiring highly skilled carpenters and plasterers who used the designs of Robert Adam, the Scottish architect whose plans were popular at the time among the elite. One of the most stunning architectural features in Charleston, the elliptical, free-flying staircase is the centerpiece of the house. A number of lavishly embellished rooms were created for formal entertaining, while Mrs. Russell, an amateur gardener, grew "a wilderness of flowers, bowers of myrtles, and orange, lemon, and grapefruit trees" around her house.

The Russell heirs sold the house in 1857 to Governor Robert Francis Withers Allston and his family, who were forced to evacuate it during the five-hundred-day bombardment of Charleston by Union troops. After the Civil War, the building housed boarders of Miss Kelly's "rigorous but genteel academy" for girls. In 1870 it was purchased by the Sisters of Charity of Our Lady of Mercy, who also used the house for instructing young ladies on the premises in their convent school. Since 1955, the restored house and garden have been open to the public as a museum of the Historic Charleston Foundation.

OPPOSITE: *The neoclassical Nathaniel Russell House has been called "an exercise in ellipses" for its curving rooms and balconies and its swirling cantilevered stair.*

ABOVE: *An oval drawing room was used for dancing and musical entertainments. The mantel is adorned with carved wood tassels, rosettes, and a Grecian lute player done in plaster composition.*

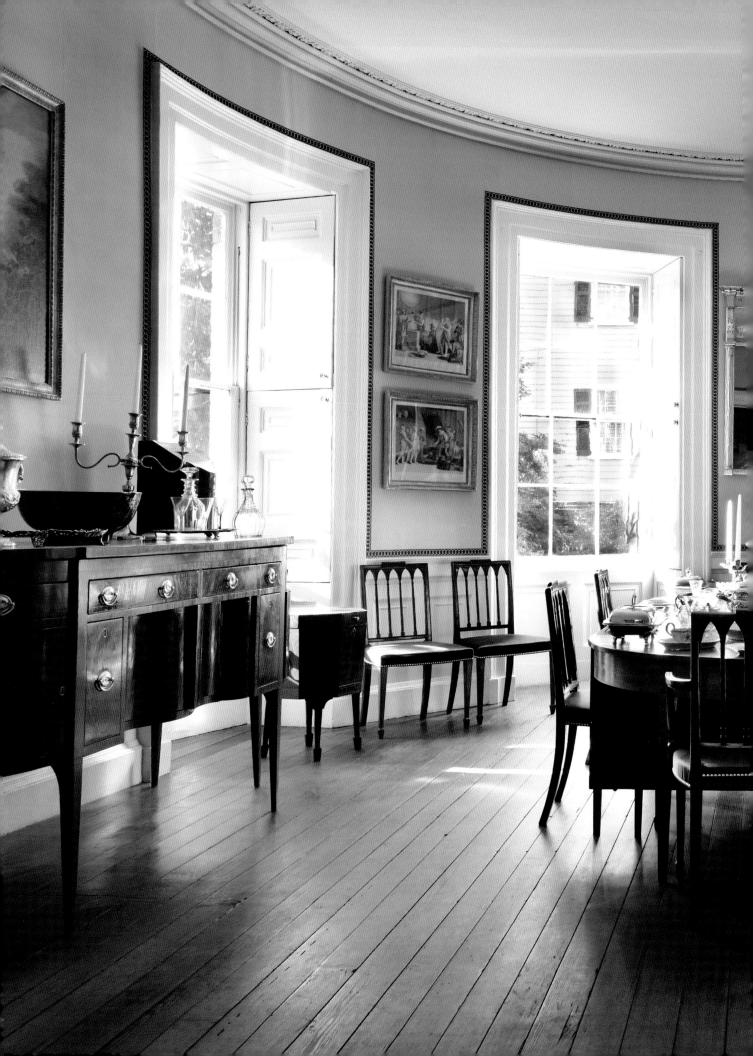

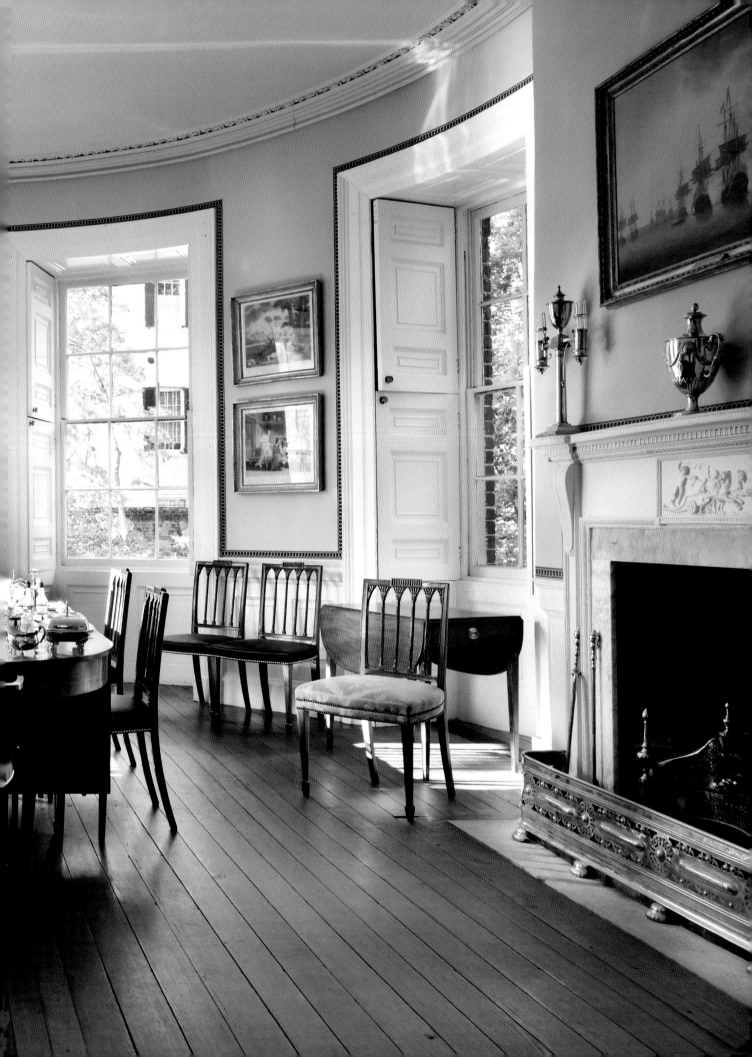

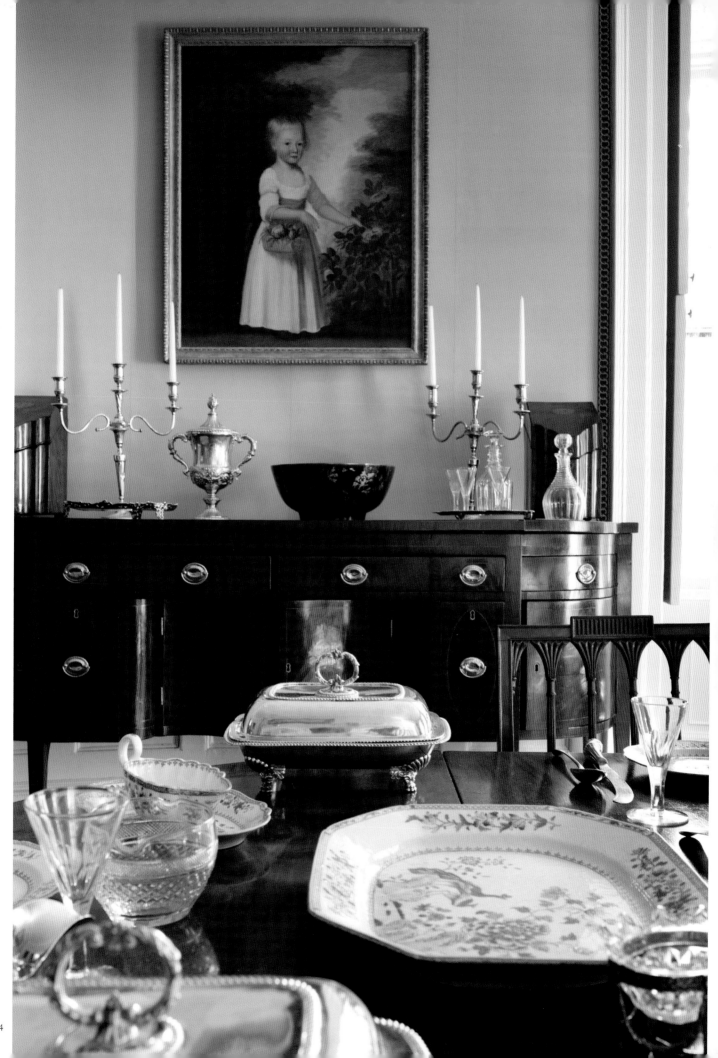

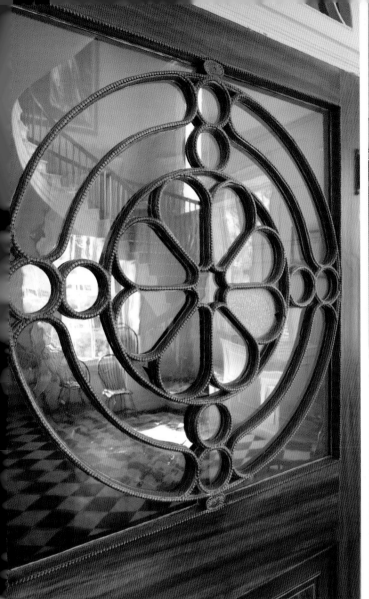

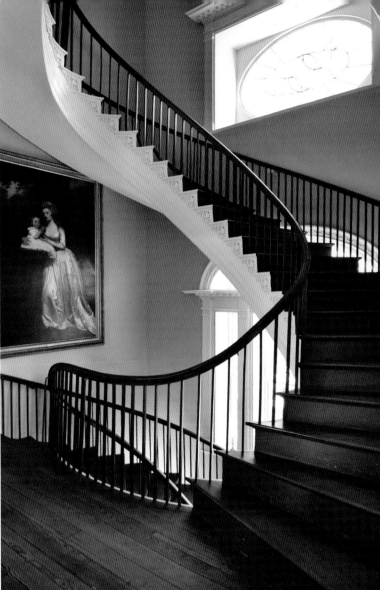

OPPOSITE: *The dining room table is laden with Chinese export porcelain and silver, much of it passed down through generations of Charlestonians. The portrait is of Alicia Russell, the eldest daughter of Nathaniel and Sarah Russell.*

ABOVE LEFT: *Painted, burled wood grain doors on the first floor open to the stair hall. The wood decorating the window glass was first soaked in seawater to make it pliable enough to bend into a rosette pattern.*

ABOVE RIGHT: *A large Palladian window illuminates the famous spiraling stair and a portrait of Mary Rutledge Smith and her son, painted in 1786 by British society painter George Romney.*

PRECEDING OVERLEAF: *On the first floor, an oval-shaped dining room has vivid turquoise wallpaper along with Charleston-made furniture, including Sheraton-style chairs with Gothic arch-patterned backs.*

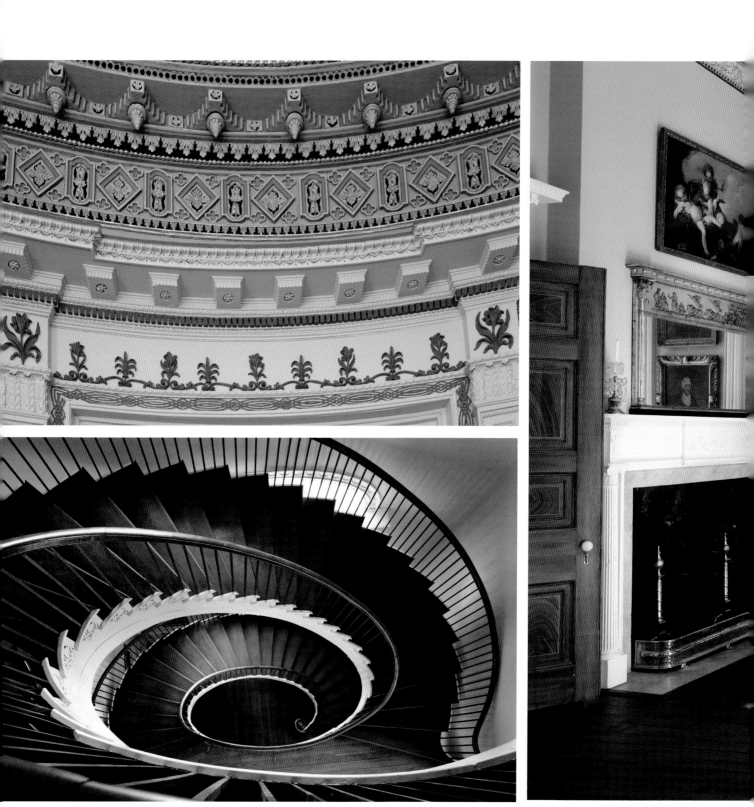

ABOVE: *The cornice in the music room contains a circus of colorations, bits of gold leaf, and dangling pendants.*

BELOW: *The center staircase rises dramatically up three floors without touching any walls and is the architectural highlight of the house.*

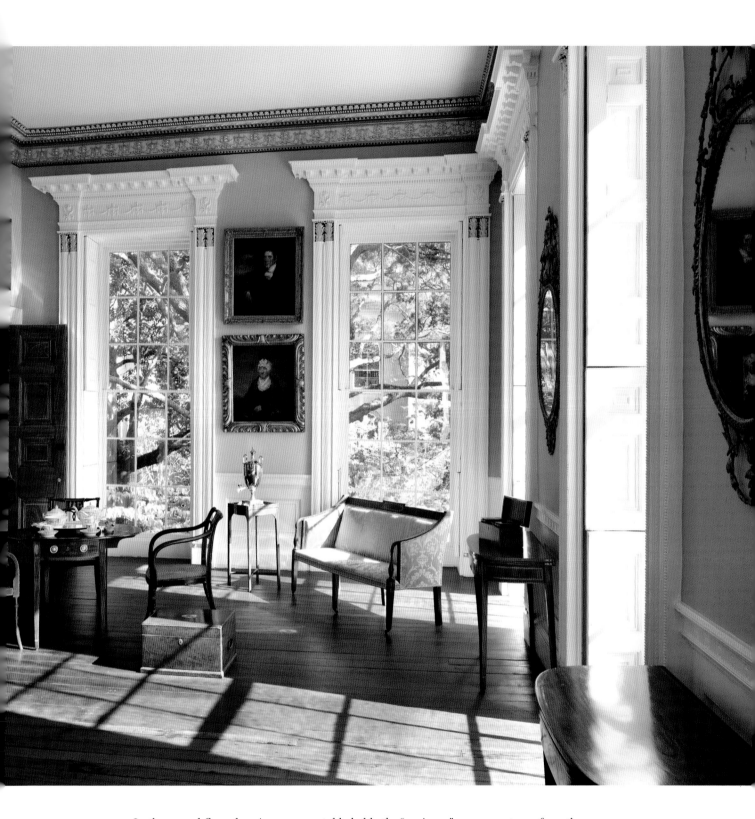

In the second floor drawing room, a table holds the "equipage" necessary to perform the afternoon tea ritual. Black lacquered Regency armchairs made in England belonged to Governor R. F. W. Allston.

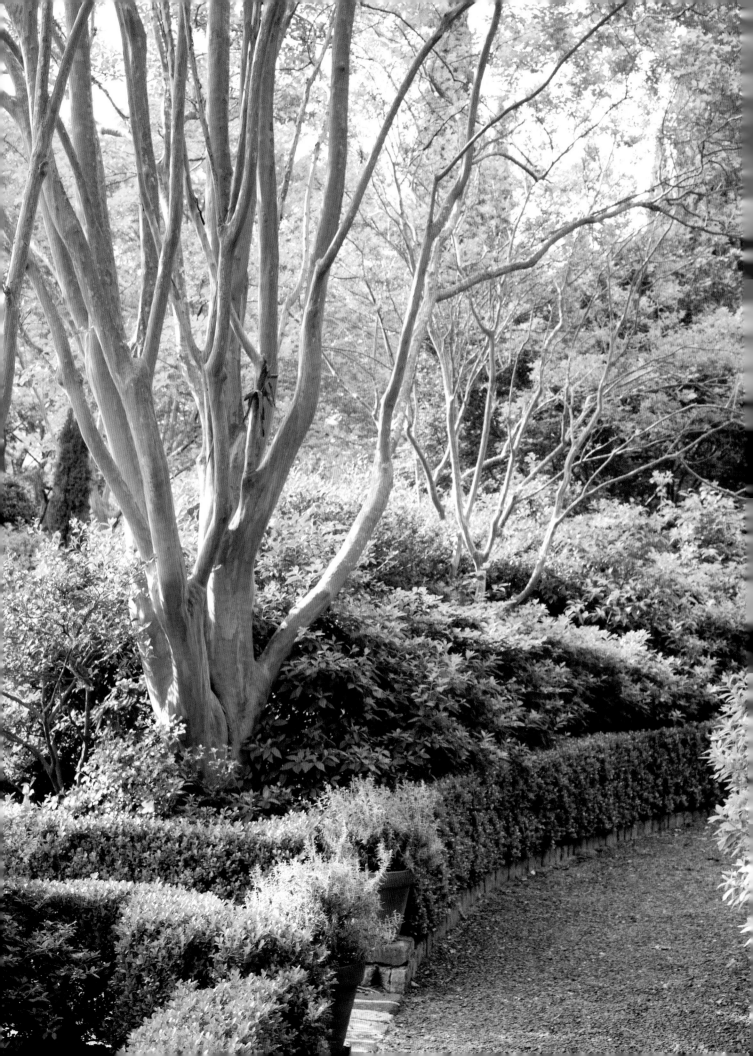

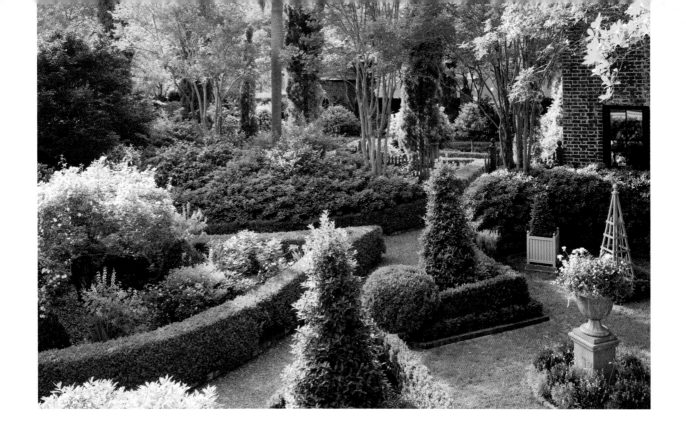

ISAAC MOTTE DART HOUSE GARDEN

The Italianate garden at the 1806 Isaac Motte Dart House was designed by its current owner, Doctor Gene Johnson, who has lived in the historic house since 1994. When Doctor Johnson and his wife, Betsy, purchased the Dart House there was no garden surrounding it, just an overgrown back yard with a black asphalt parking lot and a derelict 1823 Gothic Revival carriage house covered with vines.

Having become intrigued with the art of gardening when city officials ordered him to clear out the weeds in front of his former home on Chalmers Street, Johnson began studying books on garden design and taking notes while touring European gardens. Gleaning ideas from his travels, he was inspired to create a neoclassical garden at his house on Montagu Street. The plan he drew up included a driveway designed as a long, box-lined allée, rows of tall Italian cypress trees, a new Gothic Revival folly house that doubles as a garden shed, and a series of geometrically shaped "rooms" divided by gravel paths and hedges.

Today, the garden has been fully reclaimed from its parking lot days. There is Confederate jasmine growing on walls made of old brick, Victorian-era cast iron urns, friezes, statues, and heirloom "Noisette" roses blooming in old-fashioned paisley-shaped beds. Clipped box provides structure, the tall cypresses add height, and the many crape myrtles lend their sculptural grace to the urban oasis.

OPPOSITE: *The crape myrtle was first imported to America by botanist André Michaux along with mimosa, gingko, parasol tree, and tea olive; all have become Southern favorites.*

ABOVE: *The structure of the garden resembles Italianate ones but includes plantings typical of South Carolina, such as azaleas, camellias, crape myrtles, and Noisette roses.*

ABOVE: *Between the main house and the carriage house, old bricks found on the property are used as edging for the beds and "tuteur trellises" are placed for climbing plants.*

RIGHT ABOVE: *Heirloom Noisette roses were first developed in South Carolina in the early 1800s by John Champneys and Philippe Noisette.*

RIGHT BELOW: *An 1823 Gothic Revival carriage house with quatrefoil windows faces a formal garden with a circular bed of boxwood hedges in the center.*

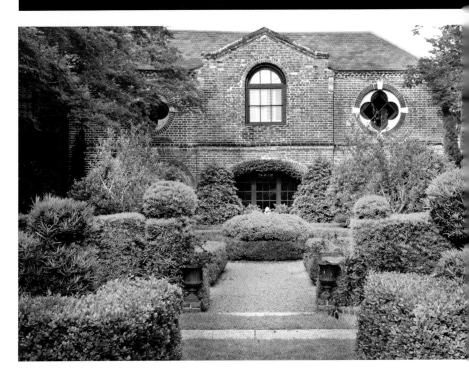

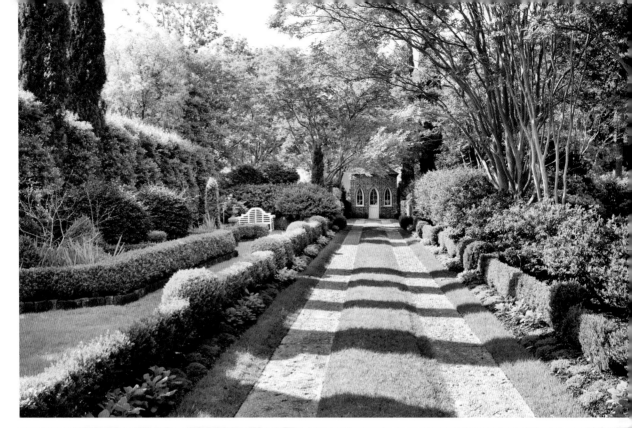

ABOVE: *The long driveway has been planted as an allée, providing a sense of drama. It leads to a small brick Gothic-style folly, made by Doctor Johnson to match an old carriage house on the property.*

BELOW: *A frieze of a winged Greek goddess lines one of the jasmine-covered brick walls. The walls were built to replace the chain link fences that once enclosed the property.*

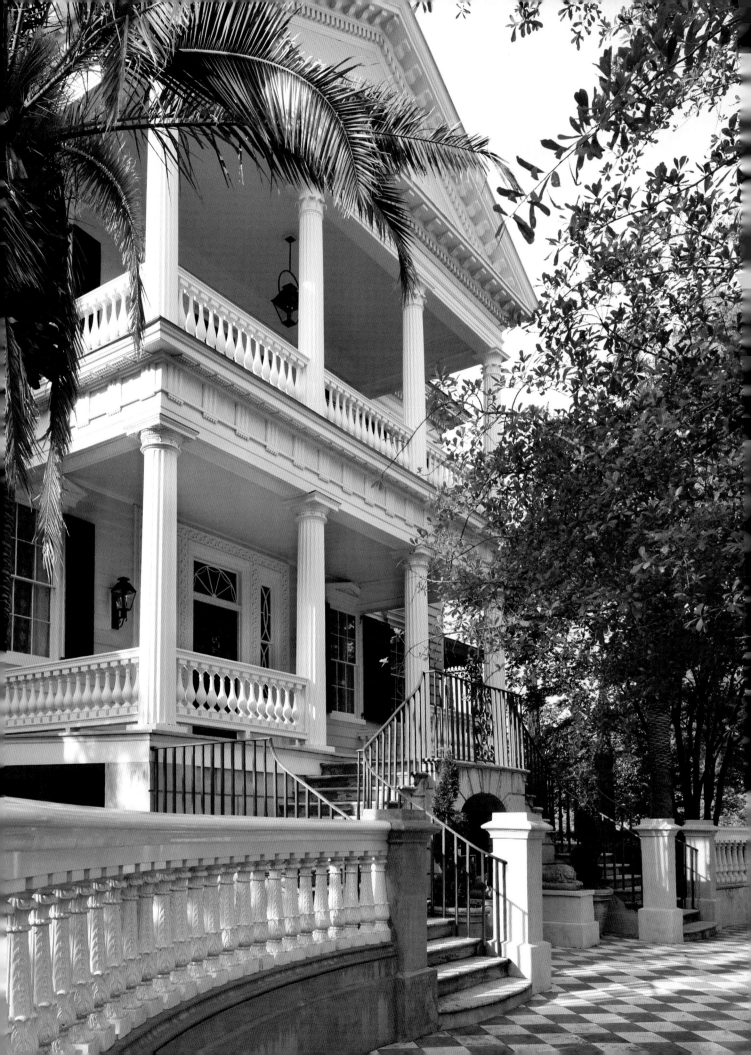

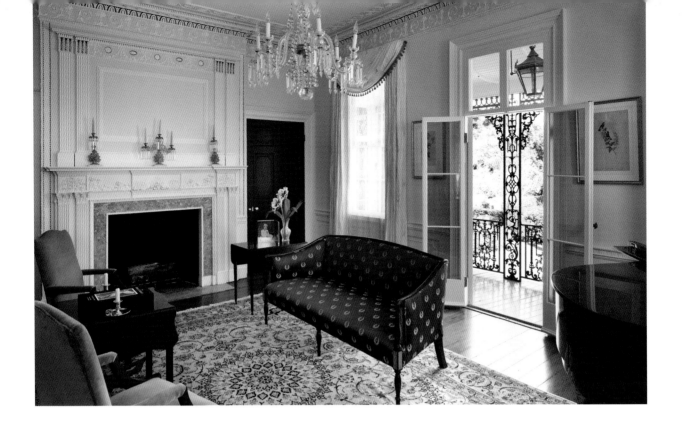

GAILLARD-BENNETT HOUSE

In 1802 Theodore Gaillard built an imposing Georgian house in the Harleston Village neighborhood, which was then a sparsely populated, rural area filled with marshes and tidal creeks. Gaillard was a planter and East Bay factor, descended from a family of French Huguenots who had fled Languedoc in 1687 and established lucrative rice and indigo plantations to the north of the city.

Gaillard, who had an unqualified admiration of Adam-style neoclassical plasterwork, embellished his rooms with fine examples of the plasterer's art, adding intricate detailing on mantels, cornices, and ceilings throughout the house. The design motifs he chose ranged from hunting scenes, shells, floral swags, and urns and were taken from pattern books, then made by plasterers in molds and applied to surfaces. The results included a drawing room that is said to be "one of the finest Federal interiors in Charleston" due to its rich layering of plaster details as well as its sense of harmonious proportions.

The Gaillard house passed through many hands, including those of General Jacob Read and Washington Jefferson Bennett, the son of Governor Thomas Bennett. It was recently purchased by Steve and Mary Caroline Stewart who have undertaken a remarkably intensive renovation of the property. Working from old photographs of the house, a striking checkered marble sidewalk was re-installed, the grounds were enlarged and landscaped with parterre gardens and lawns, and a Gothic Revival–style tack house was rebuilt from scratch. Inside the house, twenty-six thousand pieces of plaster moldings were redone by artisans who repaired fissures and mended broken pieces, "sculpting" them back to match the originals in painstaking fashion.

OPPOSITE: *The Gaillard-Bennett House had a Greek Revival double-portico added on to it in the 1830s. The black and white sidewalk was restored with Bardiglio and Carrara marble brought from Italy.*

ABOVE: *The drawing room has embellished cornices and a neoclassical overmantel designed in the style of Robert Adam, who dominated interior design in the eighteenth century.*

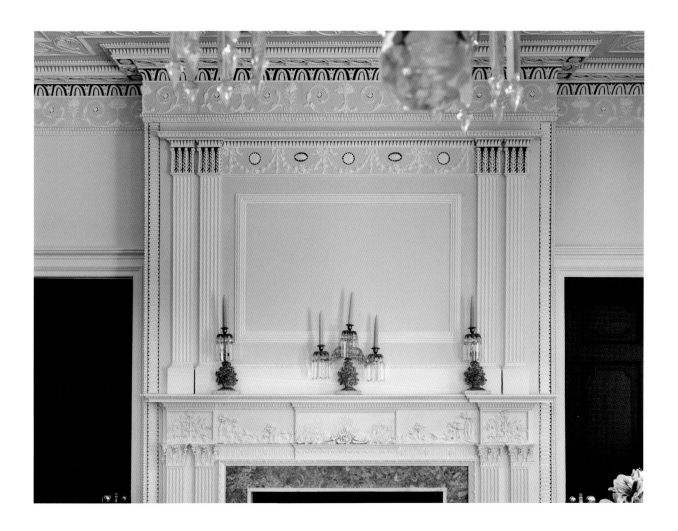

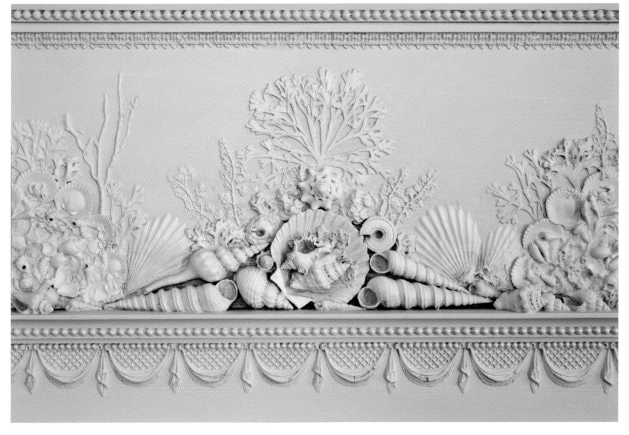

OPPOSITE ABOVE: *The over-mantel joins to the ceiling with an intricate series of molded plas-terwork designs. The mantel itself carries an exuberant fox-hunting scene that appears on many Charleston fireplaces.*

OPPOSITE BELOW: *Seashells and fronds of seaweed made of composition plaster were applied to the center tablet of the drawing room mantel.*

LEFT: *The expansive grounds were landscaped into an open, park-like setting with a croquet lawn and a reflecting pool utilizing a black urn as a fountain.*

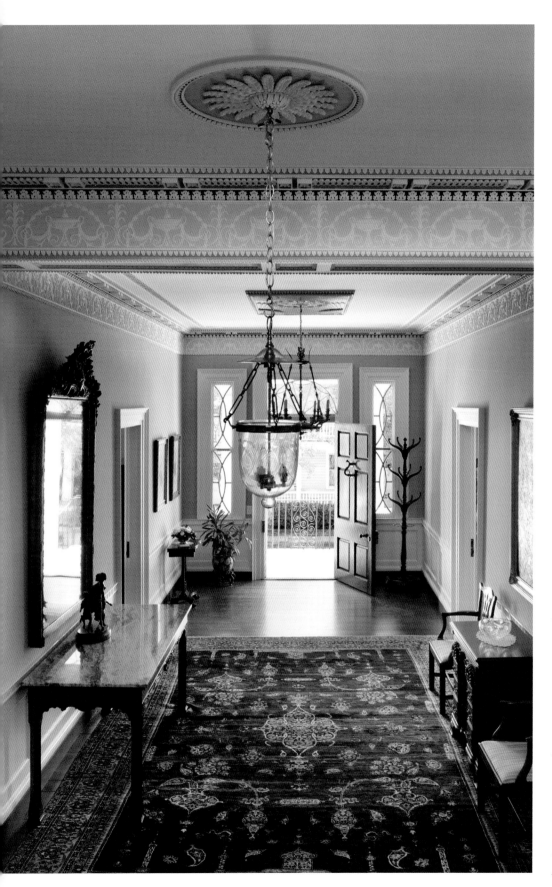

LEFT: *A wide center hall has low wooden wainscoting with a carved chair rail. The door leads to the portico from which General Robert E. Lee gave a postwar address to a gathering in 1870.*

OPPOSITE ABOVE: *Hand-painted Chinese silk covers the walls in the dining room. A large mahogany table was made for the Stewarts by a local craftsman; the large pier glass is an antique found at auction.*

OPPOSITE BELOW: *A seating area in an upstairs bedroom has heavy silk, embroidered drapery, and doors with faux wood grain painted by a local artist.*

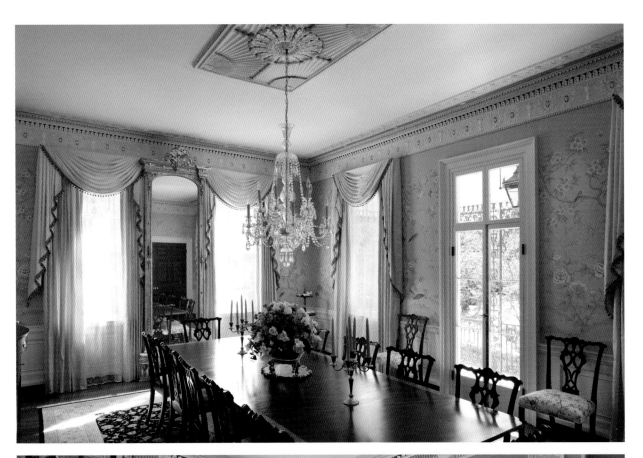

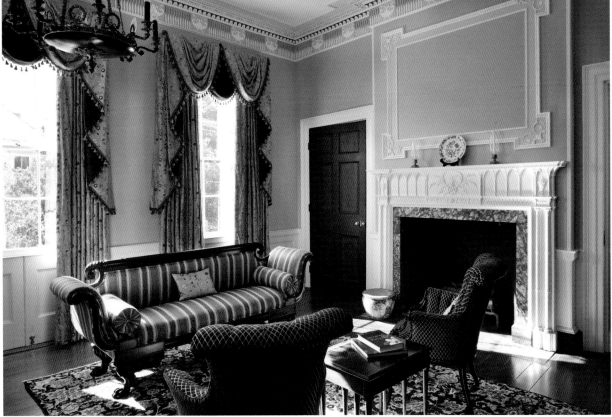

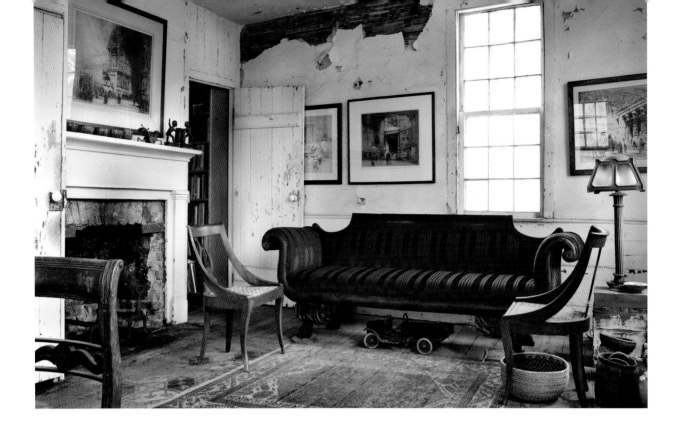

MARTZ AND WADDELL HOUSE

A vine-covered, wooden 1851 Greek Revival, the Martz and Waddell House was once a two-story "tenement" building that housed free blacks in the neighborhood of Radcliffeborough. Radcliffeborough had begun in 1786 when Thomas Radcliffe, a land speculator, purchased a suburban tract north of Calhoun Street and began developing it. When Charleston's population was booming in the antebellum period, developers such as Radcliffe saw the opportunity to build rows or groups of houses as rentals or for resale. Free people of color purchased homes or built them themselves, creating a neighborhood of artisans and entrepreneurs, many of whom owned their own businesses, including carpentry, tailor, and ironsmith shops.

In 1979, architect Randolph Martz and historian Gene Waddell purchased the duplex house and its backyard kitchen dependency and began renovating them, preserving as many of the original traces as possible. They removed a wall on the second story that had separated the tenement house into twin apartments, creating instead one large drawing room with plenty of light and air. And they intentionally left the house with its peeling paint and rough wood floors, along with a hole in the ceiling that happened during Hurricane Hugo, all of which increase its sense of character and age.

In addition, Martz and Waddell followed in the footsteps of the "old Charleston" school of interior design sensibility, one in which homes are not "decorated" in any formal or professional sense. Instead, they used an eclectic assortment of inherited and secondhand furnishings that they admired, collecting possessions for their interest and sentiment rather than for fitting into any preordained scheme. A reverence for tradition and the ability to see beauty in imperfection have kept this house from the creeping blandness of newness and provides a strong link to the past.

OPPOSITE: *Coral vines completely cover the wooden Greek Revival "tenement" house, which is a residence that was built for renting out, usually with more than one unit.*

ABOVE: *An Empire sofa has been newly reupholstered in "Lincoln assassination red." The etchings are by William Walcot, a noted artist and architect of Moscow.*

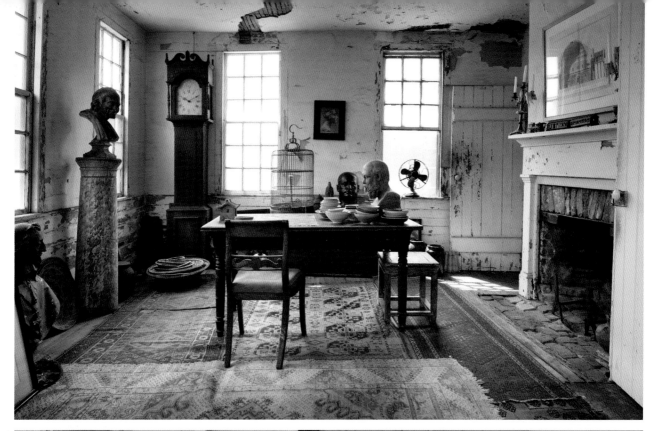

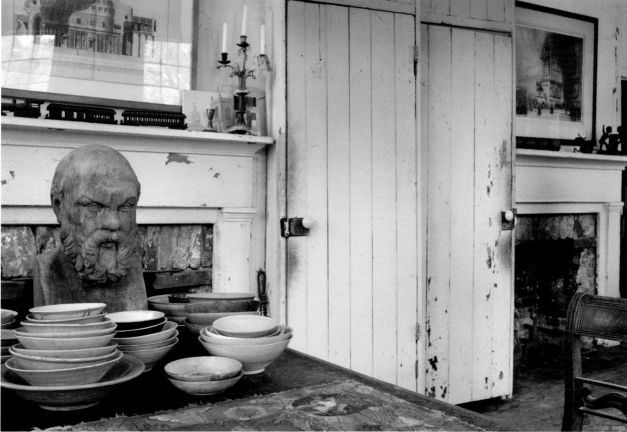

ABOVE: *The many neoclassical busts atop columns give a sense of grandeur to the gently crumbling room. Martz is the tenth generation owner of his family's grandfather clock.*

BELOW: *Randolph Martz removed the wall that originally divided the two apartments to create one large drawing room with twin fireplaces. The bust of Socrates was found at a flea market.*

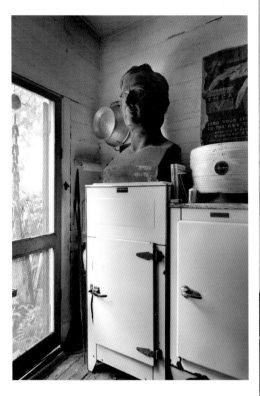

ABOVE: *A makeshift kitchen was created in a back room; the original kitchen was in a separate building. The 1920s electric icebox belonged to Martz's grandmother, who was the first in her neighborhood to own one.*

RIGHT ABOVE: *Chinese propaganda posters combine with a collection of masks on the narrow kitchen steps made of heart-pine wood.*

RIGHT BELOW: *An assortment of baskets was brought back from Africa by Gene Waddell. The basket-making tradition still followed by local Gullah artists today came to South Carolina by way of West Africa.*

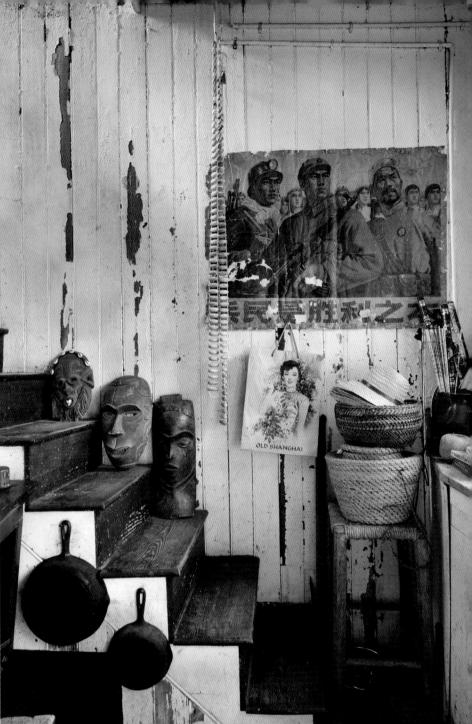

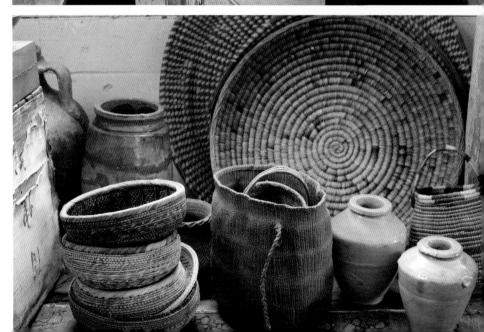

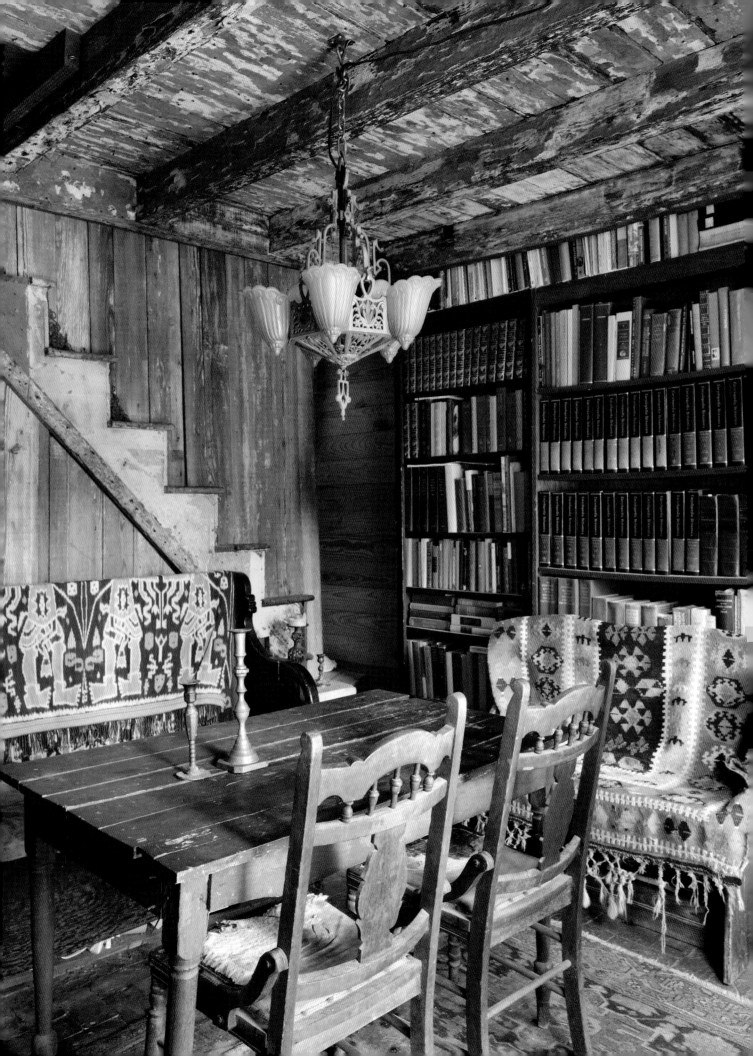

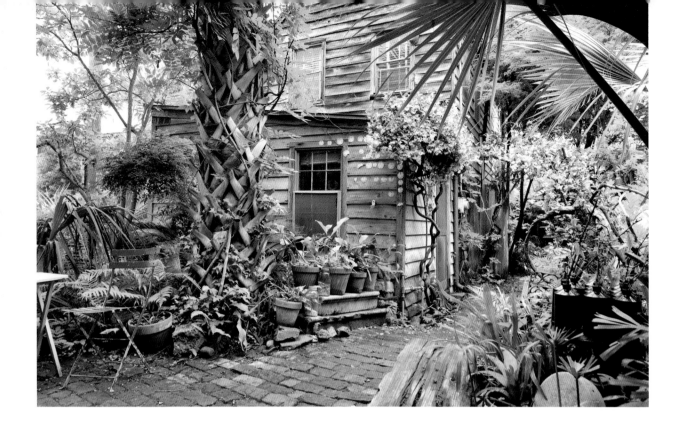

MARTZ AND WADDELL COTTAGE

A falling-down, two-story dependency came with the Greek Revival house Randolph Martz and Gene Waddell acquired in 1979. It had been built in 1851 to serve as living quarters for servants on the upper floor, with a kitchen and laundry on the first floor. By 1861 it had been divided in half vertically in order to house two families, with small twin interior staircases on each side.

Since the 1700s these dependencies, located behind the main houses in enclosed courtyards, had been configured in simple fashion as one room with a central chimney containing back-to-back fireplaces, with living quarters above. Sometime in the past, the Martz and Waddell outbuilding had a kitchen wing and a bathroom wing added to it; a sweet shop had also operated out of the first floor, selling candy, liquor, and other provisions.

It took Randolph Martz three years to turn the deteriorated building into something habitable, eventually transforming it into a comfortable cottage-like dwelling. Drawing upon his architectural training, as well as the knowledge gained from his eight-year association with Charleston architect Herbert deCosta Jr., he took down the dividing walls and replaced the rotting wooden floor with a brick one. He salvaged materials such as weathered boards, cast-off fireplace mantels, and old tiles, rehabilitating the building while keeping its aged look.

Herbert DeCosta, a third generation African American builder and preservation leader, has been credited with keeping alive the traditional building arts that had been passed down by the slaves who built Charleston with their expert craftsmanship in carpentry, blacksmithing, and masonry. Today, this humble vernacular building stands as part of the history of black Charleston.

OPPOSITE: *An art-nouveau lighting fixture hangs above the table in the dining room. The small staircase was enclosed with vertical boards around the zigzag pattern of the painted stringers.*

ABOVE: *Between the two buildings is an overgrown garden with a canopy of palms and banana plants. Randolph Martz patched missing clapboards with weathered boards he found floating in the surf at Folly Beach.*

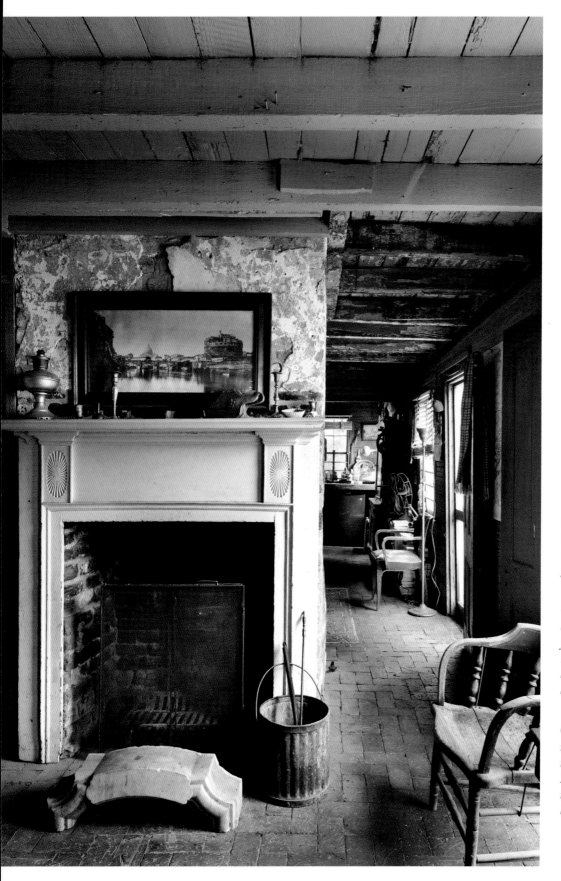

LEFT: *A Creole-style mantel was salvaged from a diminutive house built by French refugees fleeing Haiti in the 1800s.*

OPPOSITE ABOVE: *One central chimney provides for the four fireplaces of the house. The original brickwork has been left exposed, as were the many layers of colored plaster.*

OPPOSITE BELOW: *The bathroom, with its old-fashioned tub, is a later addition to the building. Randolph Martz laid the floor using brown-glazed Waccamaw bricks.*

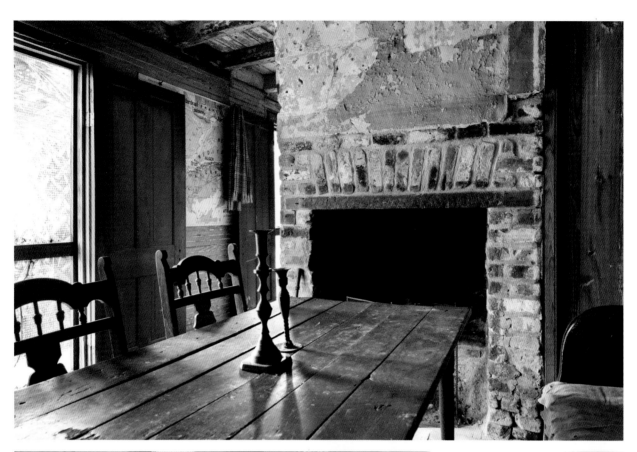

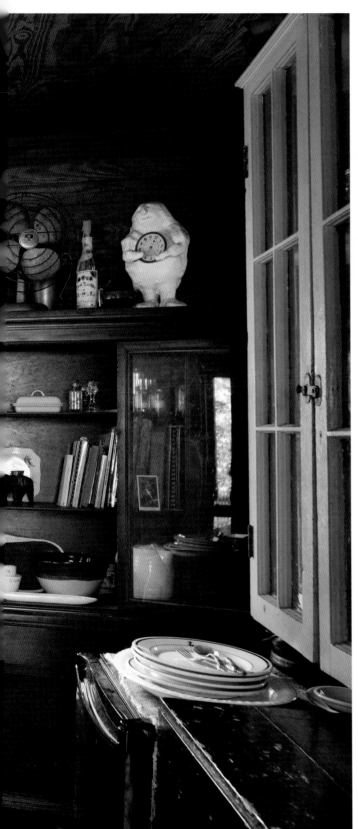

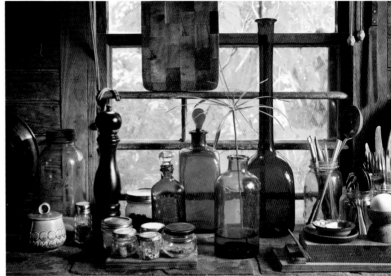

LEFT: *In the part of the house that had once been a sweet shop, a more modern kitchen was created with cabinets that were found on the street.*

ABOVE: *Glazed tiles, placed on the kitchen counter, are the oldest found in South Carolina and came from the rubble of a house that had been destroyed in an earthquake.*

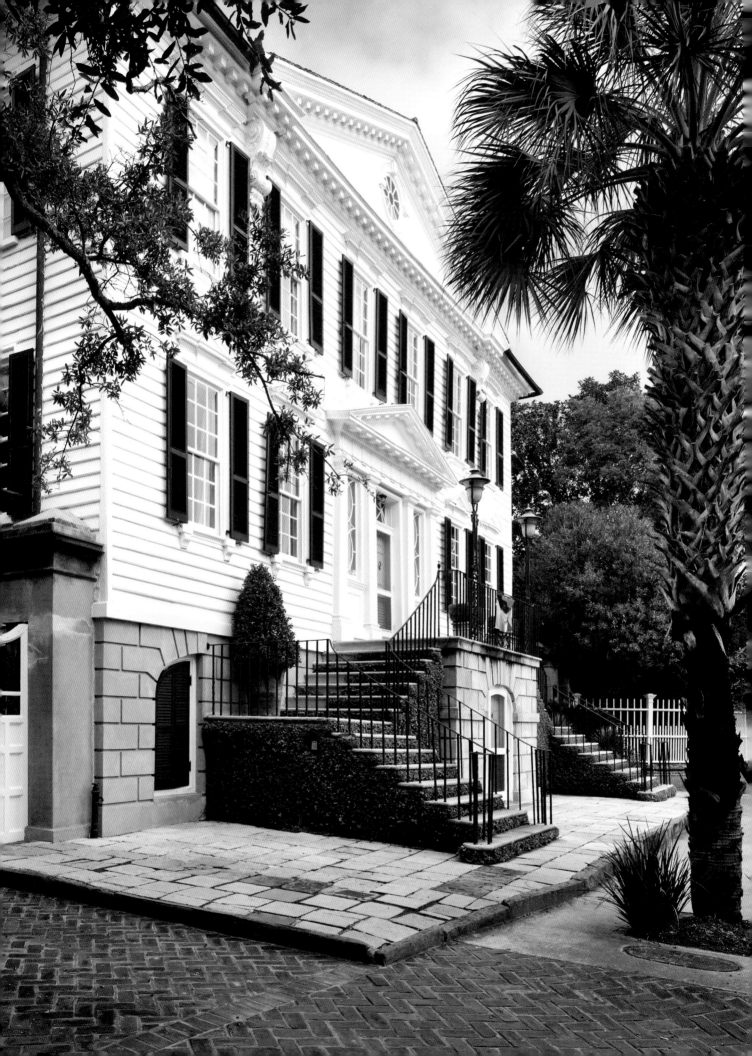

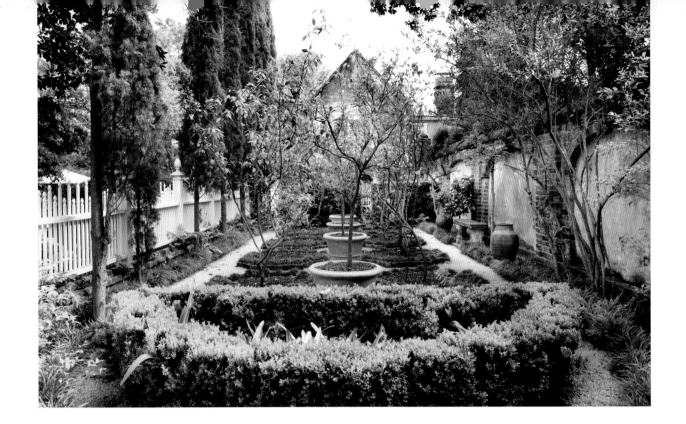

WILLIAM GIBBES HOUSE GARDEN

One of the first Charleston gardens noted landscape architect Loutrel Briggs was commissioned to design was the one for Mrs. Washington Roebling's fine Georgian house on the South Battery. After acquiring the historic William Gibbes house in 1928, Mrs. Roebling asked Briggs to restore the grounds and create a new garden based on the historic traditions of earlier Charleston gardens.

Briggs had recently arrived in Charleston from his practice in New York City at a time when many wealthy Northerners were buying up city townhouses and Lowcountry plantations that had been neglected since Reconstruction and were in deep disrepair.

Basing his Gibbes House design on the discovery of the "bones" of an earlier eighteenth-century parterre

garden that had been on the property, Briggs planted a formal French-style rose garden beside the 1772 dwelling. Other features included a long axial walk that ended at the focal point of an old summerhouse that sat hidden at the back of the garden, and the creation of a series of large and small "rooms," using hedges as walls.

For Roebling's garden, Briggs used the materials that would become part of his trademark designs, such as old Charleston bricks for walls and steps and a restricted repertoire of about thirty plants, including the camellia, boxwood, crape myrtle, and Jessamine vine. In years to come, his limited palette would be repeated in garden after garden throughout Charleston, uniting the garden landscape of the city as well as the look of each individual garden.

OPPOSITE: *Constructed in 1772 by planter and merchant William Gibbes, the house once had a long wharf on the Ashley River channel in front of it, with stores, warehouses, and a coffeehouse.*

ABOVE: *A newly planted orangerie was added to the garden by the current homeowners. Citrus trees were frequently grown in South Carolina during the early colonial era.*

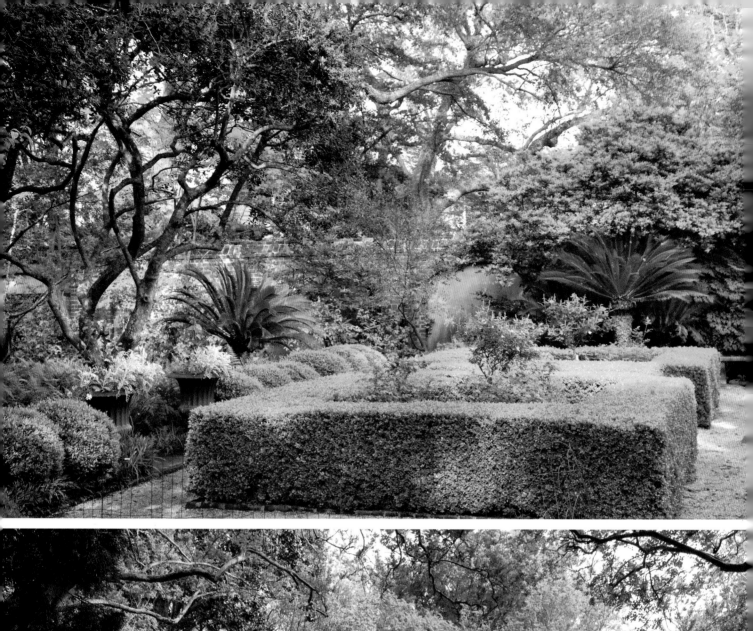
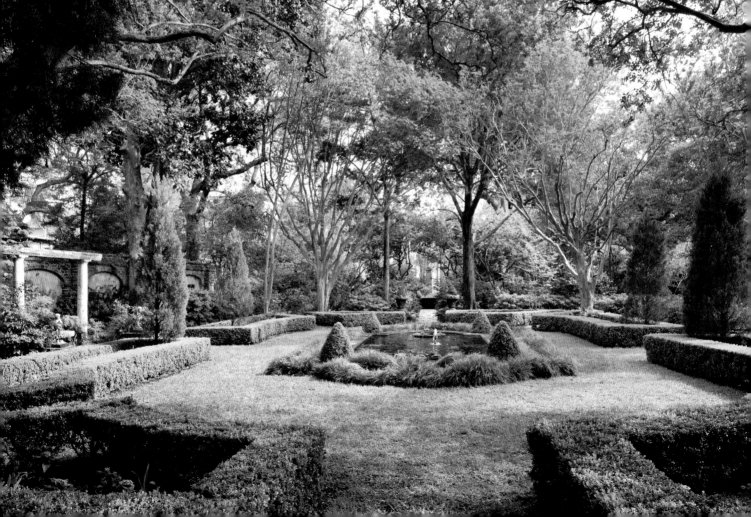

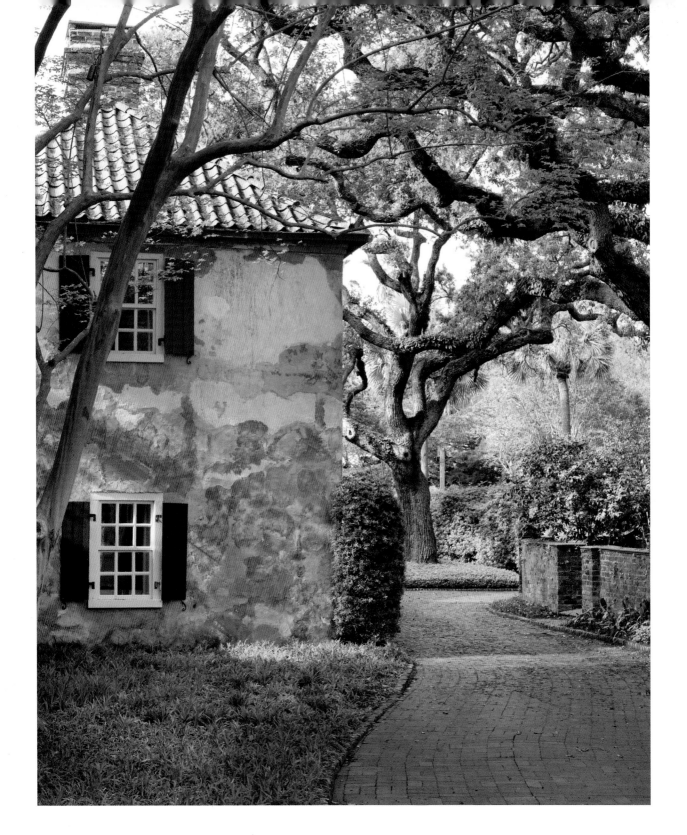

OPPOSITE ABOVE: *Loutrel Briggs unearthed remnants of a formal garden with four parterres dating from the late 1700s and restored the plot as a rose garden.*

OPPOSITE BELOW: *In the "Court of Myrtles," Briggs created one of his formal "rooms," by enclosing a grassy lawn lined with box parterres and adding crape myrtles for the beauty of their bare trunks in winter.*

ABOVE: *The pink kitchen house, of Belgian block with tile roofing, predates the main Gibbes house and has survived along with the original stable.*

RIGHT ABOVE: *"Pink Perfection" camellias have been grown in the South since the early 1800s when David Landreth, a Philadelphia nurseryman, began offering them in his Charleston office.*

RIGHT BELOW: *A Victorian-era cast iron planter is placed in front of a weathered garden wall. The brick walls were constructed in the 1830s with blind arches that face the interior.*

OPPOSITE ABOVE: *A limestone reflecting pool with a fountain in the center is surrounded by four cone-shaped topiary trees and a fringe of grass.*

OPPOSITE BELOW: *Covered with ornamental vine, a roofless, brick summerhouse with curvilinear gables is thought to be part of the original 1770s garden.*

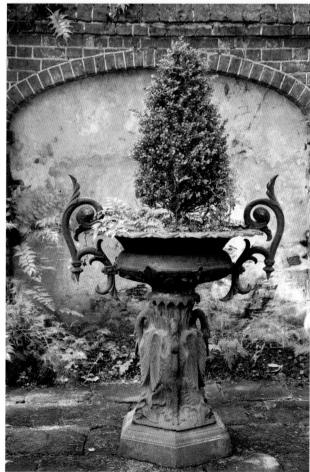

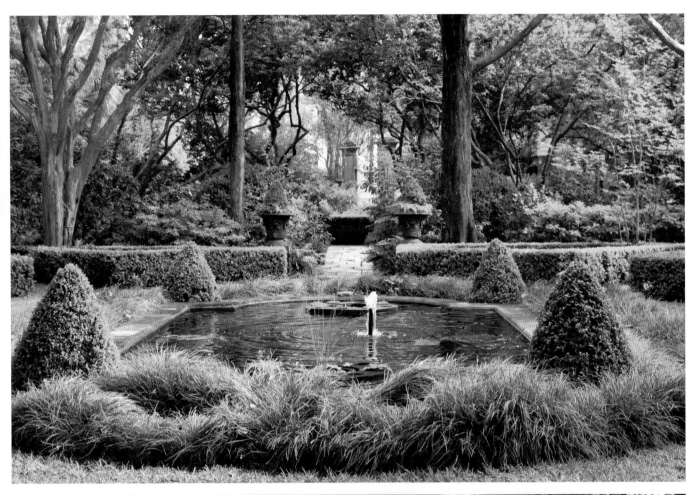

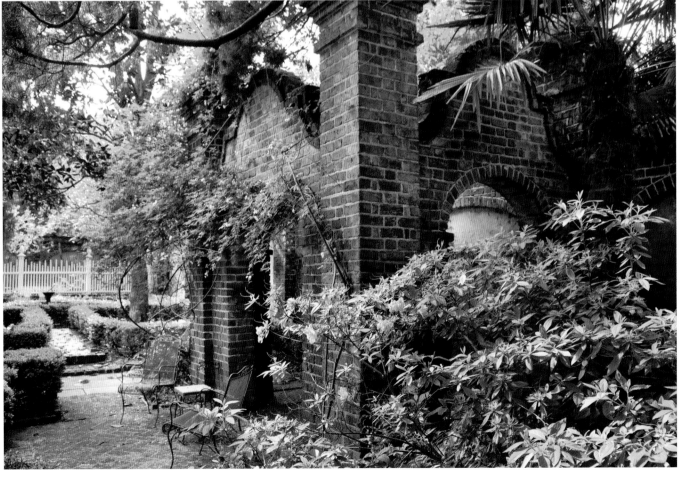

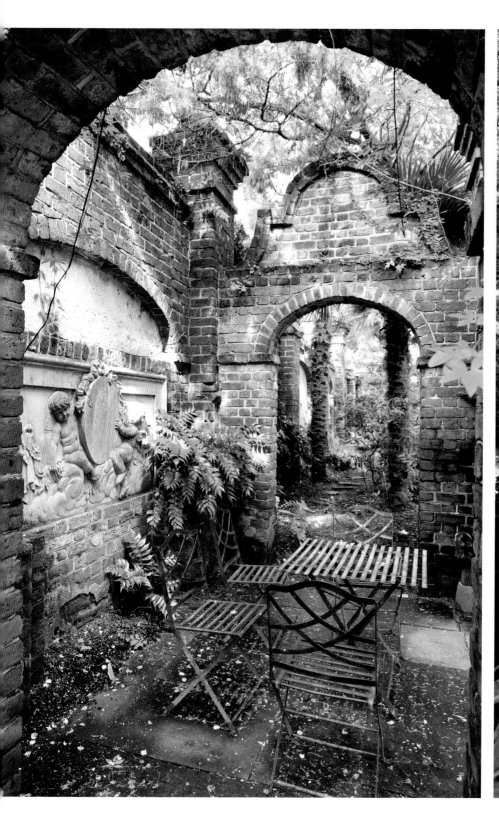

On the wall of the summer house, or tearoom as it is also called, is a limestone frieze from Europe that dates from 1850.

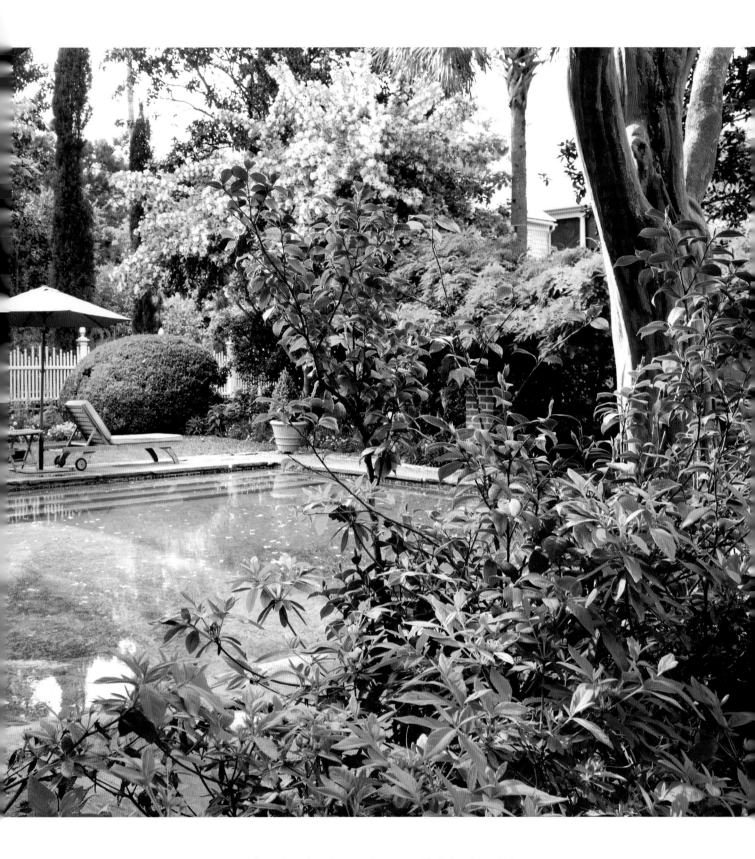

A square-shaped swimming pool was added in the 1980s, surrounded by pomegranate trees and a colonial-style picket fence by Loutrel Briggs.

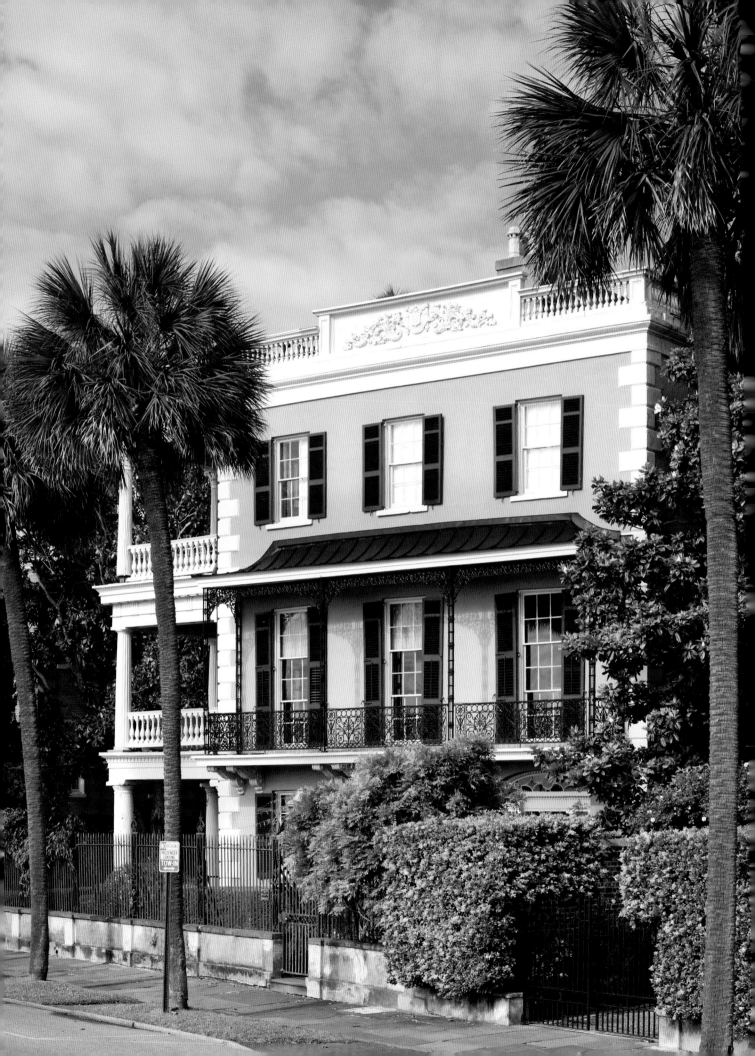

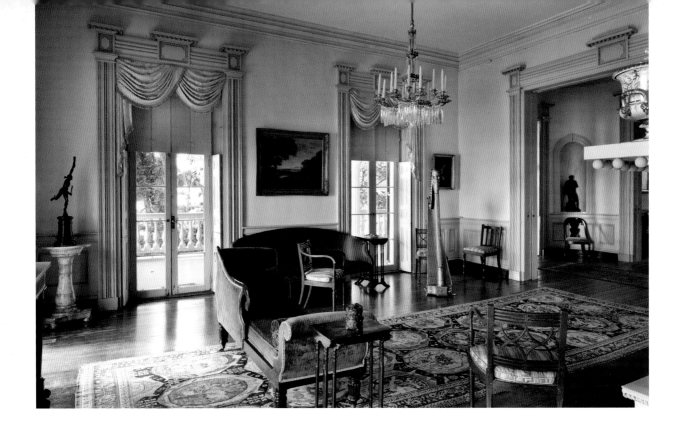

THE EDMONDSTON-ALSTON HOUSE MUSEUM

This "double house," which commands a panoramic view of Charleston harbor and the Battery's waterfront promenade, was built in the 1820s for Charles Edmondston, a Scottish-born merchant and wharf owner.

Falling into debt in the 1830s, Edmondston was forced to sell the house to prominent rice planter Charles Alston, son of the owner of a Waccamaw River plantation. Alston immediately remodeled the house, updating it with Greek Revival details and further enhancing it with a third-level piazza with Corinthian columns, a fancy cast iron balcony, and a roof parapet with the Alston coat of arms emblazoned on it.

The Alston house is said to have been the place where General P. G. T. Beauregard watched the bombardment of Fort Sumter in 1861 after having given the order to fire the cannons that signaled the start of the Civil War. Later that year, General Robert E. Lee sought refuge in the house, fleeing a wide-spreading fire that threatened his safety where he was staying in a Charleston hotel.

By the end of the war, Union quartermaster and general Rufus Saxton seized the house and occupied it for a time. Saxton was appointed commissioner for the Freedmen's Bureau, working during Reconstruction to reorganize the South into a society of small, independent producers to replace the plantation system.

On May 29, 1865, Charles Alston received a parole from President Johnson after swearing allegiance to the United States and the house was returned to him. The home, still remaining in the Alston family today, contains many of their personal belongings that have survived for more than one hundred fifty years, including fine portraits, an extensive library, and an original print of the Ordinance of Secession.

OPPOSITE: *The Edmondston-Alston is a Charleston "double house;" it was built on the ruins of the old Fort Mechanic, one of the earliest defenses of the city.*

ABOVE: *The family's social diversions took place in the second-floor drawing room where the piazza doors could be thrown open to catch breezes from the harbor and allow guests to circulate.*

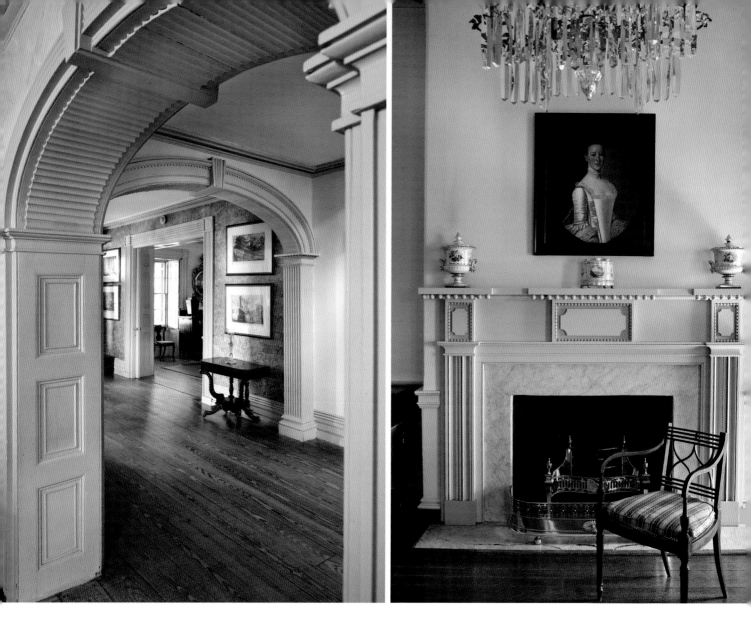

ABOVE LEFT: *The arched doorway with a center key was added during the Greek Revival remodeling of the house. The hallway walls are painted faux marble on paper, scored to resemble blocks.*

ABOVE RIGHT: *An eighteenth-century portrait of Susannah Maybank Reid painted by Jeremiah Theus hangs above the fireplace in the east drawing room. The mantel is trimmed with small ornamental wooden balls in a Steamboat Gothic motif.*

OPPOSITE ABOVE: *Above the sideboard in the dining room is a heavily carved girandole from 1810. It is encompassed by a deer at the apex, acanthus leaves at its sides, and a pair of twisting snakes at its base.*

OPPOSITE BELOW: *The "entre-salle" on the second floor divides the east and west drawing rooms and has curved walls with niches containing bronze vases and sculptures.*

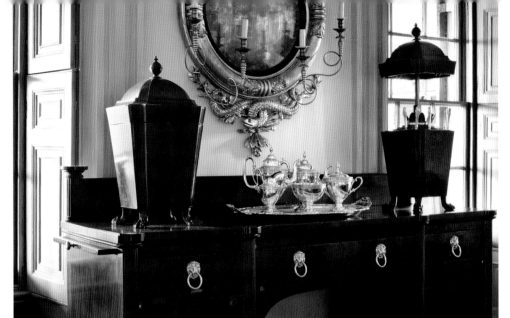

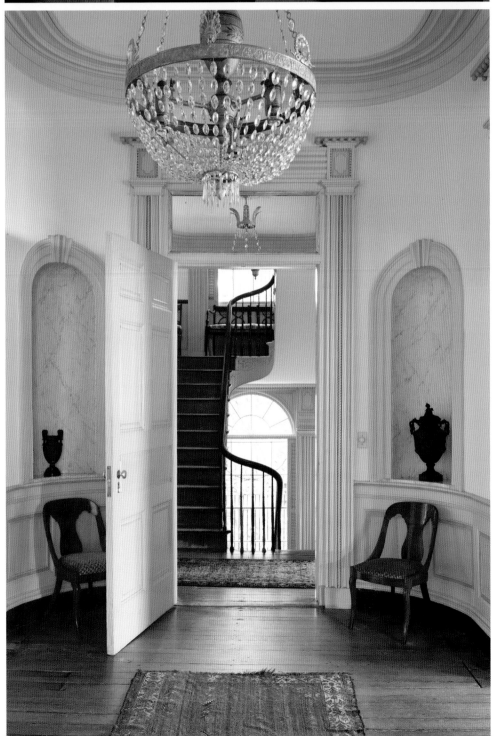

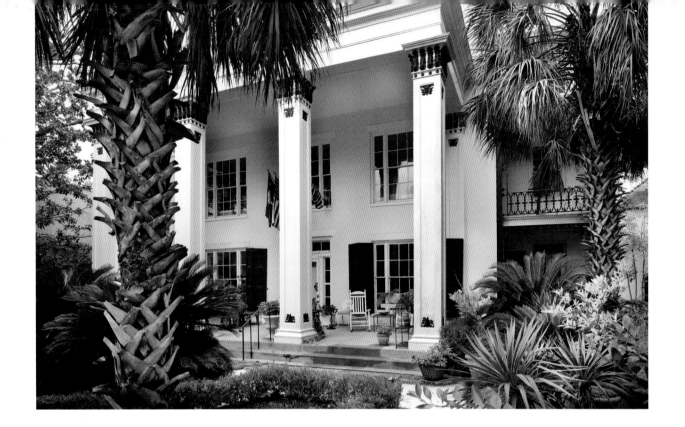

GEORGE REYNOLDS HOUSE

One of the most interesting and romantic buildings in Charleston, the George Reynolds House was built in 1847 as a Greek Revival, with Tuscan and unusual Egyptian Revival elements. The temple-like house differs from most of Charleston's houses; it sits far back from the street, facing a large forecourt garden with ancient magnolias, palm trees, and a large lotus-filled oval pool. Lacy cast iron balconies on square towers at either side look down on lushly planted grounds, which include a brick-paved court, twin gate houses, and a carriage house that is one of the oldest buildings still standing in the city.

Not much is known about George Reynolds, the man who built the house. He is said to have been either a carriage maker or a banker and a founder of the Magnolia Cemetery. Nor is the architect known; it might have been Russell Warren, who designed similar houses in Charleston and had a penchant for Egyptian detailing. Warren is believed to be the architect of the famed Nathaniel Russell House in Charleston, as well as many eminent houses in his native New England.

The Ansonborough neighborhood where the house is situated consisted of many fine old houses that had deteriorated by the 1950s. The city initiated the Ansonborough Rehabilitation Project in 1958, with pioneering preservationists and artists buying and restoring more than one hundred antebellum homes that were threatened with demolition. Charlestonians have long been foremost in recognizing the beauty and cachet of old houses and in seeking to preserve them.

Now the home of Doctor Marshall and Phyllis Wakat, the elegant Reynolds house is filled with art and fine antiques the couple have brought back from their travels around the world; many of the furnishings are consonant with the period of the building's construction. There are portraits and landscape paintings from England, French mirrors and chandeliers, and Chinese porcelain figurines.

OPPOSITE: *A yellow rose climbs on the brick wall of the garden.*

ABOVE: *The colossal columns of the George Reynolds House have Egyptian Revival detailing. The house is only one room deep; the grand two-story tall portico creates the illusion that the house is much larger than it is.*

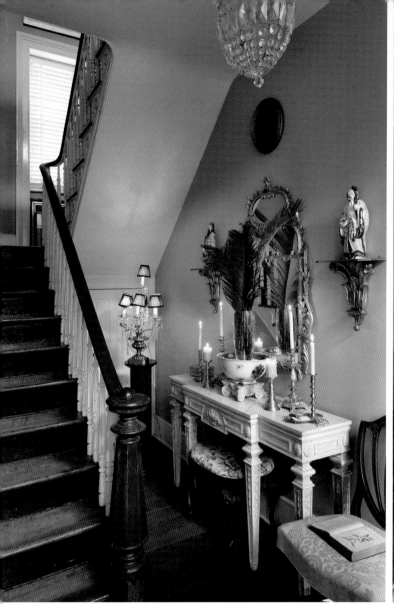

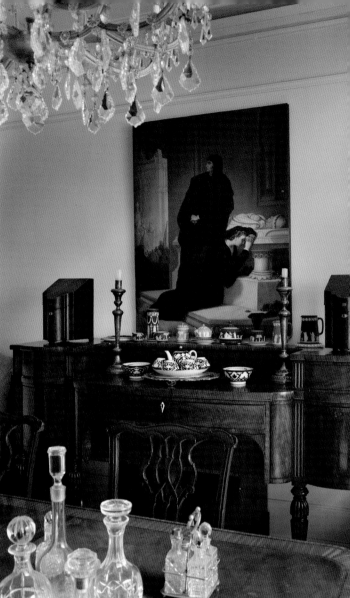

ABOVE LEFT: *In the front hallway, Chinese ancestor figures signifying prosperity and long life sit on Georgian wall brackets above a Regency-style table.*

ABOVE RIGHT: *On a handsome sideboard in the dining room are pieces of Russian china with a cotton boll pattern. Above it, a Victorian-era woman wearing black grieves.*

OPPOSITE ABOVE: *A gilded French mirror from the early 1800s and a painting by Theodoor van Thulden, a pupil of Rubens, decorate the formal dining room. Corner cupboards house an overflowing china collection, including many pieces of Wedgwood.*

OPPOSITE BELOW: *Shelving in one of the tower rooms is crammed with books and an interesting assortment of vases from around the world. The tall window looks out onto a small grove of live oak trees.*

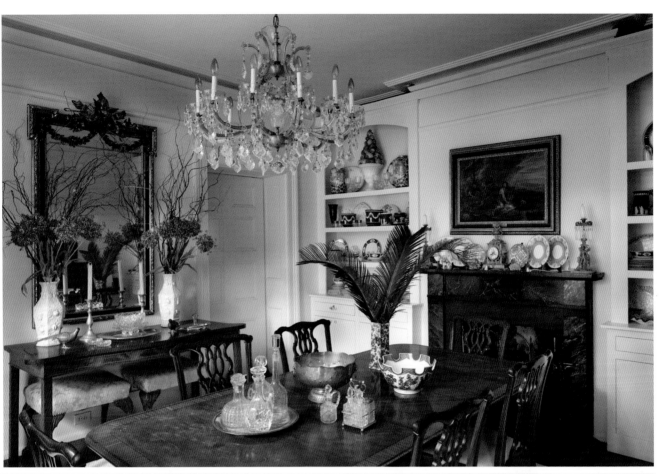

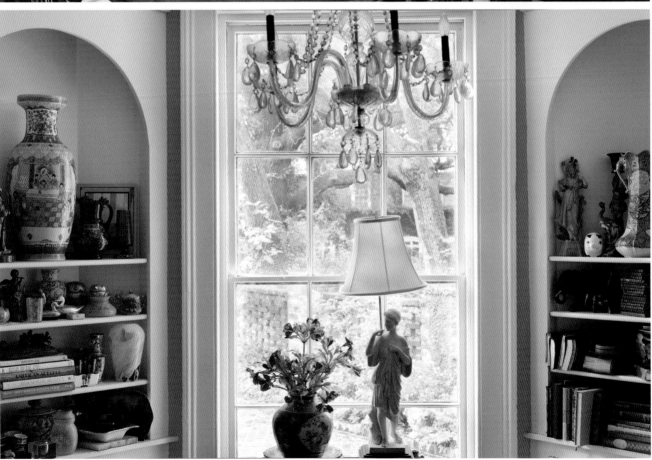

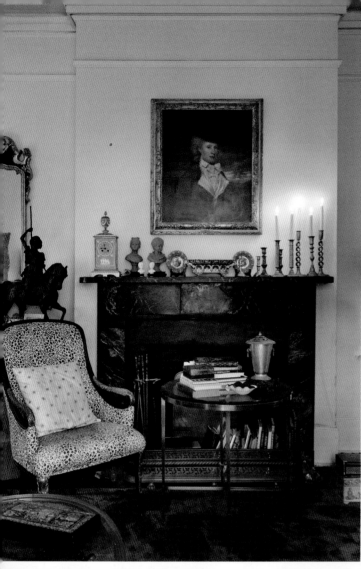

ABOVE: *Above a black marbleized mantle in the sitting room is a portrait of an English lady in riding habit by Gilbert Stuart, acquired by the couple on a trip to London.*

BELOW: *On the front portico, a marble-topped table with an ironwork base holds a still life of plants and sculptural objects.*

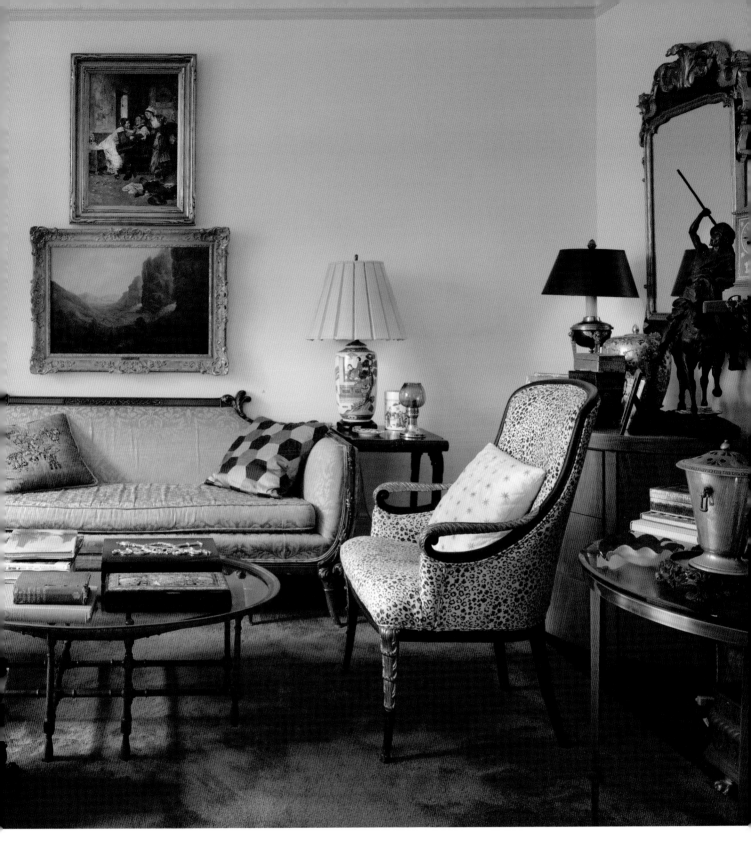

The sitting room has a Prince of Wales sofa, a pair of leopard print upholstered chairs
from the early 1900s, and "famille verte" vases made into lamps.

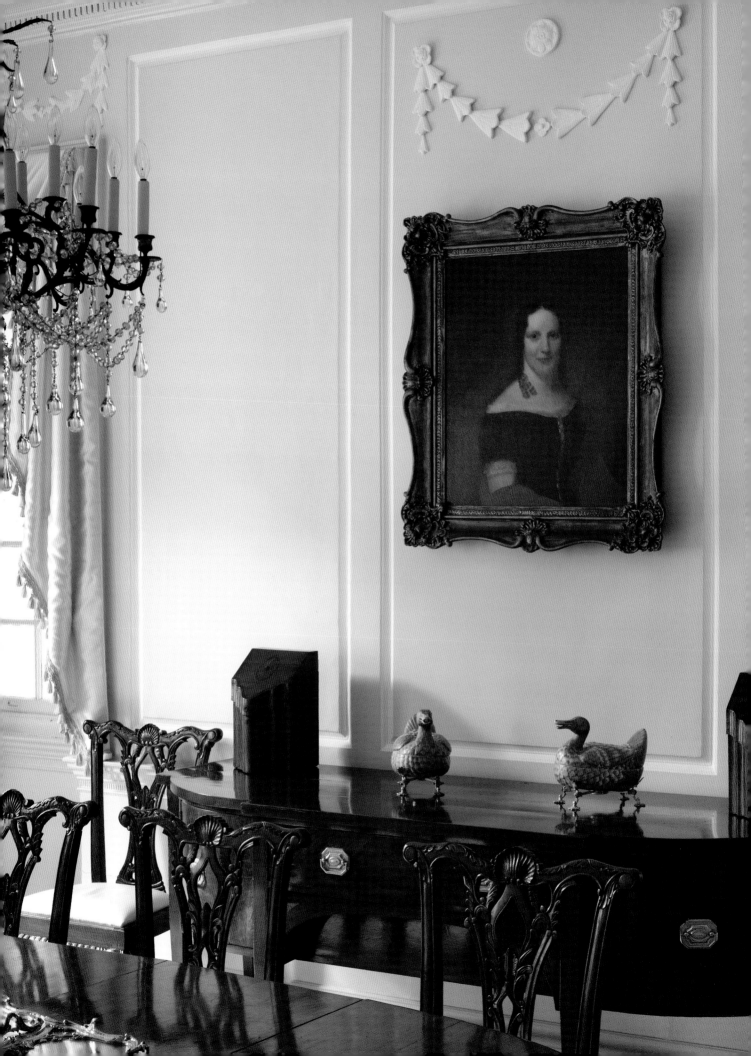

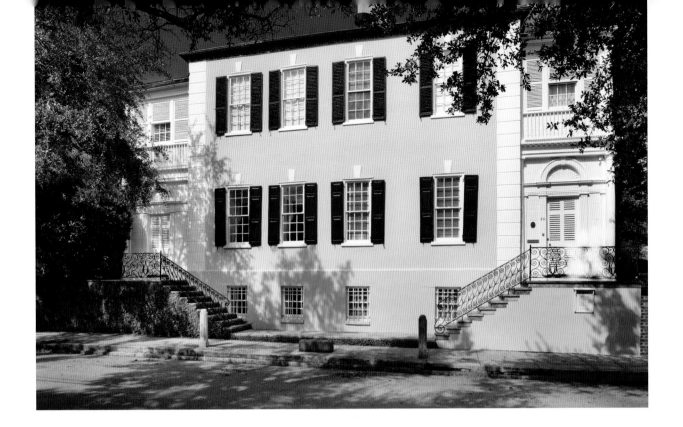

WILLIAM RHETT HOUSE

Among the oldest of Charleston houses, the William Rhett House was built circa 1712 by Colonel Rhett, the famous pirate fighter who helped capture Stede Bonnet, the so-called "gentleman pirate" who was hanged at the tip of Charleston peninsula in 1718.

Rhett's house stood on a twenty-acre site that was originally part of Jonathan Amory's 1690s "Point Plantation," a large, marshy tract that sat beyond the old walled part of the city. Rhett, who had been born in England, was captain of a merchant ship, sailing a circuit between London, Barbados, Africa, and Carolina. In addition to fighting pirates, he also defended Charleston's port, driving off a French fleet in 1706.

After many years, the venerable brick house gradually fell into decline, along with its surrounding neighborhood of Ansonborough. In 1941 it was rescued by the Kittredges of New York who restored the property, including its rare rococo "pulled plaster" ornamentation from the mid-1700s. In addition, they hired Innocenti & Webel, the renowned landscape designers of many of Long Island's plutocratic estates, to create formal gardens for the grounds.

Today, the house is owned by the Drury family, furnished with pieces that have been in their family for generations. There is a portrait of Mrs. Drury's ancestor, the South Carolina Governor Thomas Bennett, and one of his daughter-in-law, Sally Rutherfoord Bennett from Virginia. There are Duncan Phyfe chairs from Governor Bennett's collection and a dining room table "that has heard many interesting conversations" including ones when General Robert E. Lee sat at it and orchestrated plans during the Civil War.

OPPOSITE: *Sally Rutherfoord, daughter of the governor of Virginia, married Governor Thomas Bennett's son around the time this portrait of her was painted. The dining room table has been in the Drury family for many years.*

ABOVE: *Piazzas on both sides of the William Rhett House were added in the early 1800s; the front steps with wrought iron scrolls were added even later. Hitching posts and a carriage block remain from the 1800s.*

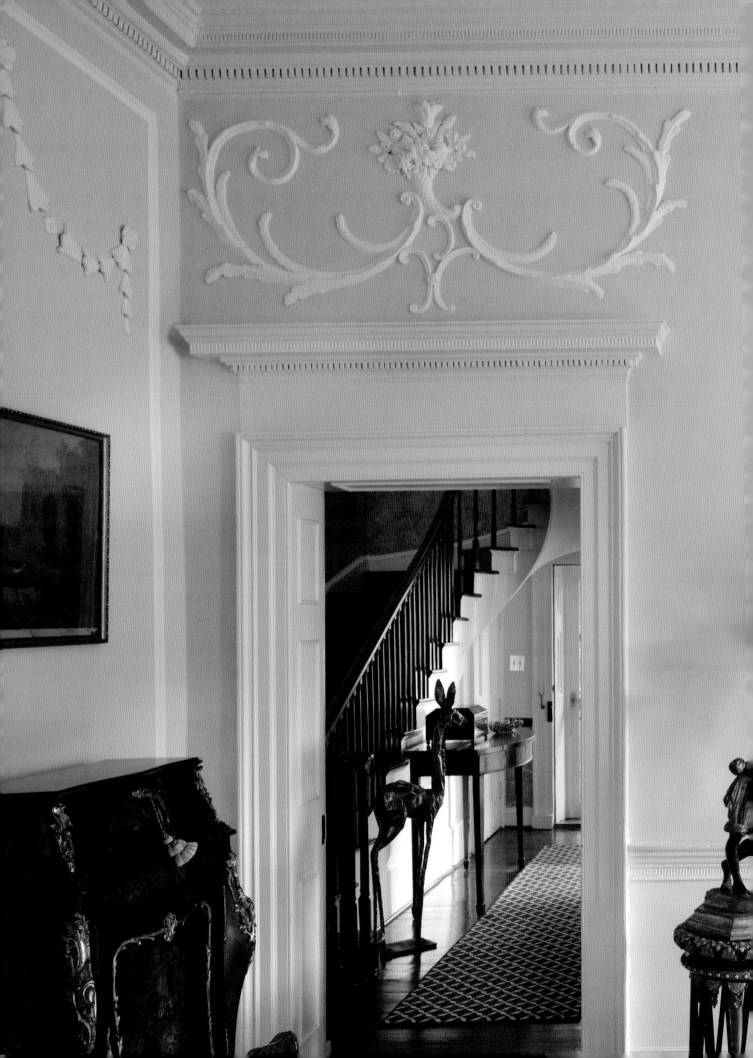

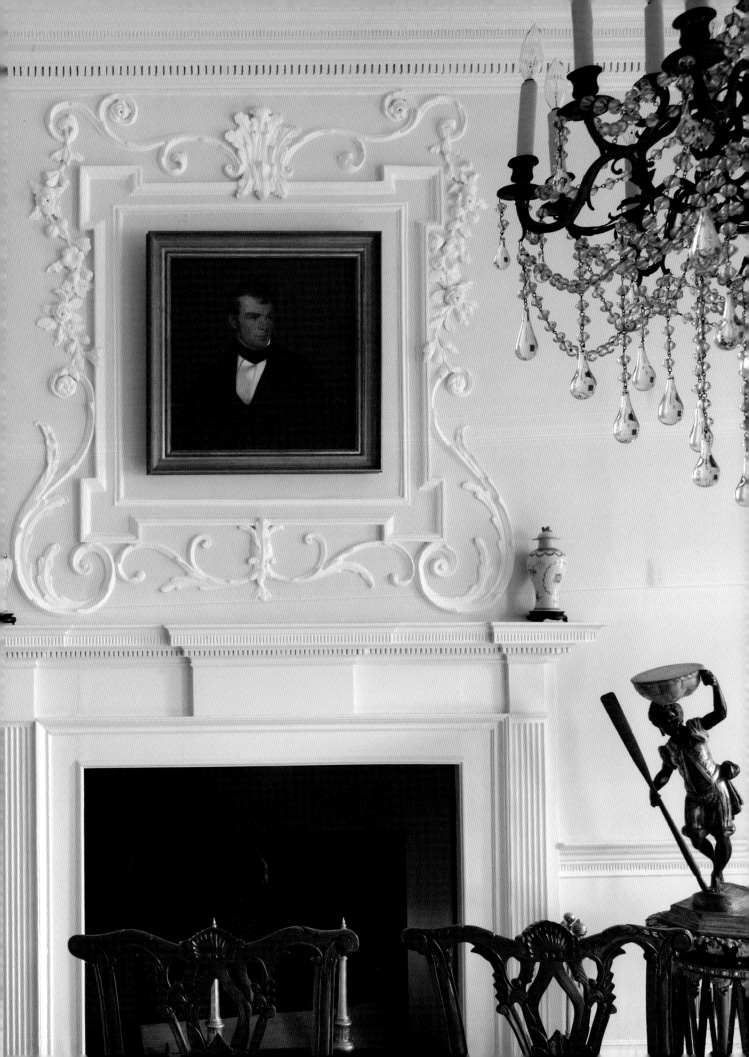

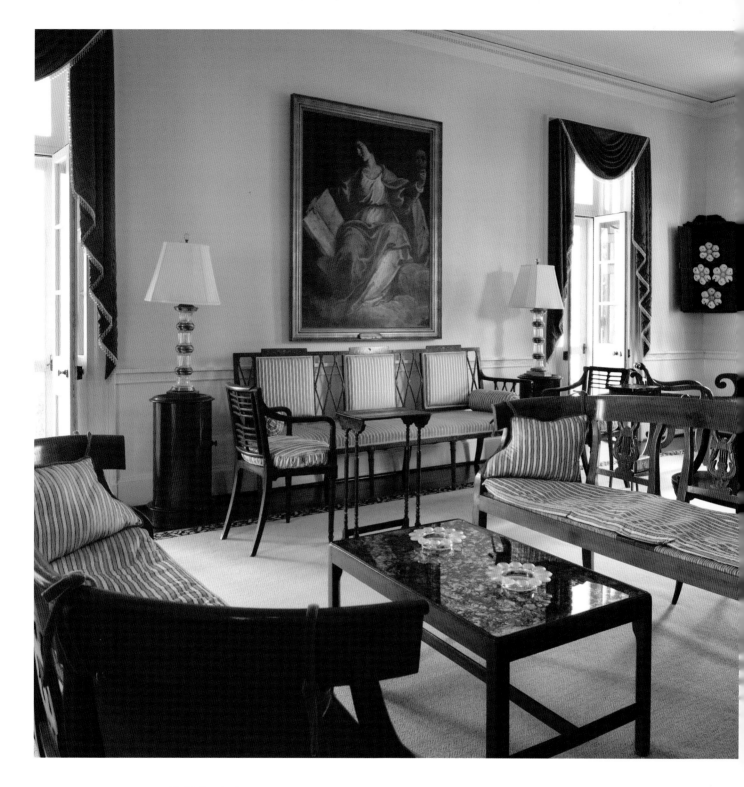

ABOVE: *The living room contains Charleston-made pieces along with Duncan Phyfe chairs from New York. The chairs were painted black during the mourning period after the Civil War.*

OPPOSITE ABOVE: *In the 1700s, small rooms like this were used as intimate "receiving" rooms. A set of the Drury's maroon-edged plates are displayed in a bookcase.*

OPPOSITE BELOW: *When rococo style was the fashion, many Charlestonians had a predilection for chinoiserie, such as this Chinese cabinet with its motifs of the "land of Cathay."*

PRECEDING OVERLEAF: *A portrait of Henry Clay Gregory, a Bennett relation, done by Thomas Sully hangs above the dining room fireplace, and is encircled by robust, rococo plasterwork.*

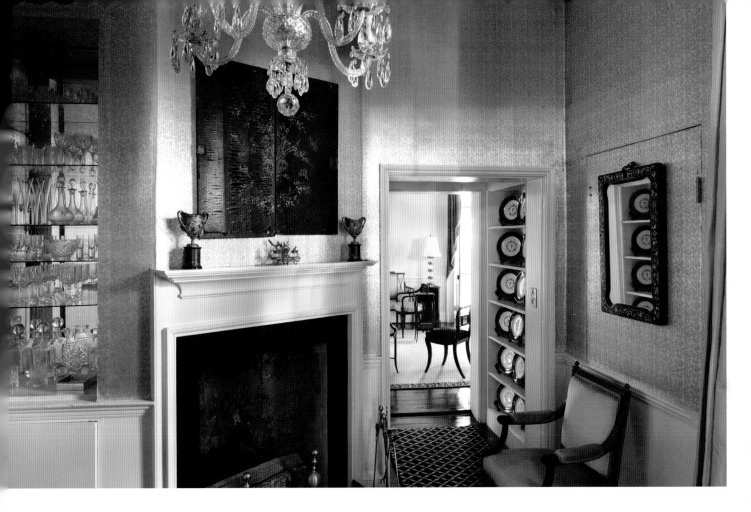

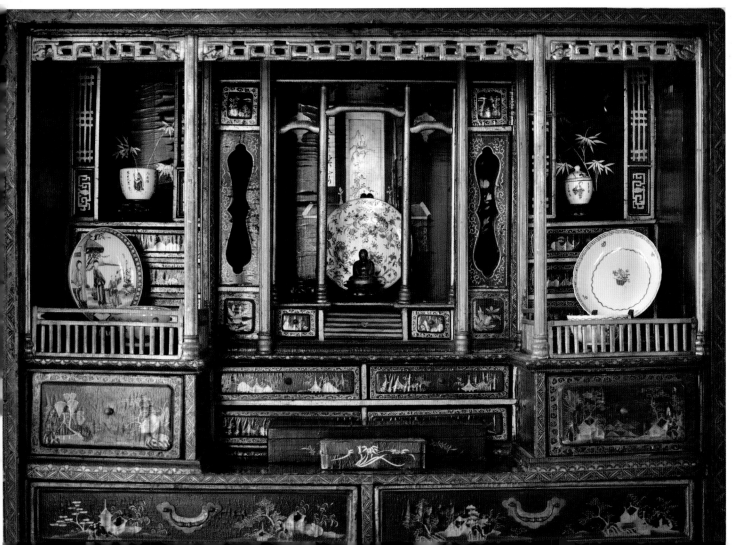

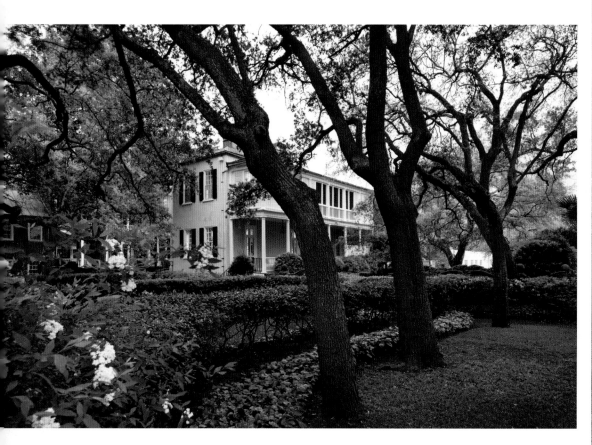

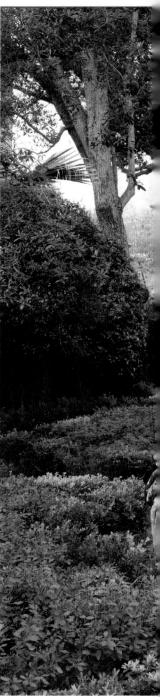

ABOVE: *Called the "oak forest," there are twelve live-oaks forming a canopy that creates privacy for the house. One of the largest gardens in the city, it contains five "rooms," each with a different motif.*

RIGHT: *In 1980, the Drurys paved a court of the garden with old brick. The four statues represent the four seasons, all are centered around an armillary sphere. An ancient carriage house can be seen beyond the vine-covered walls.*

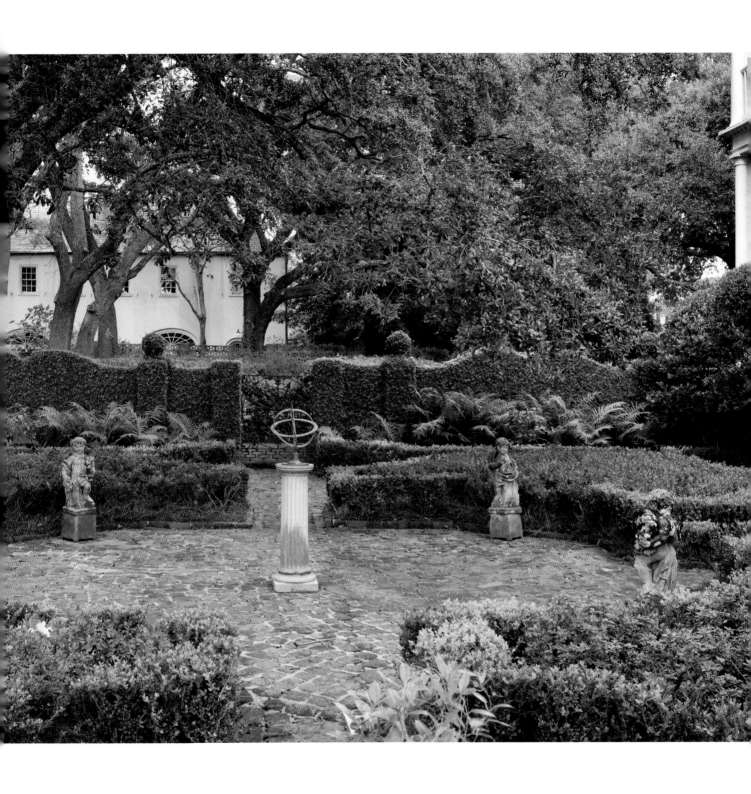

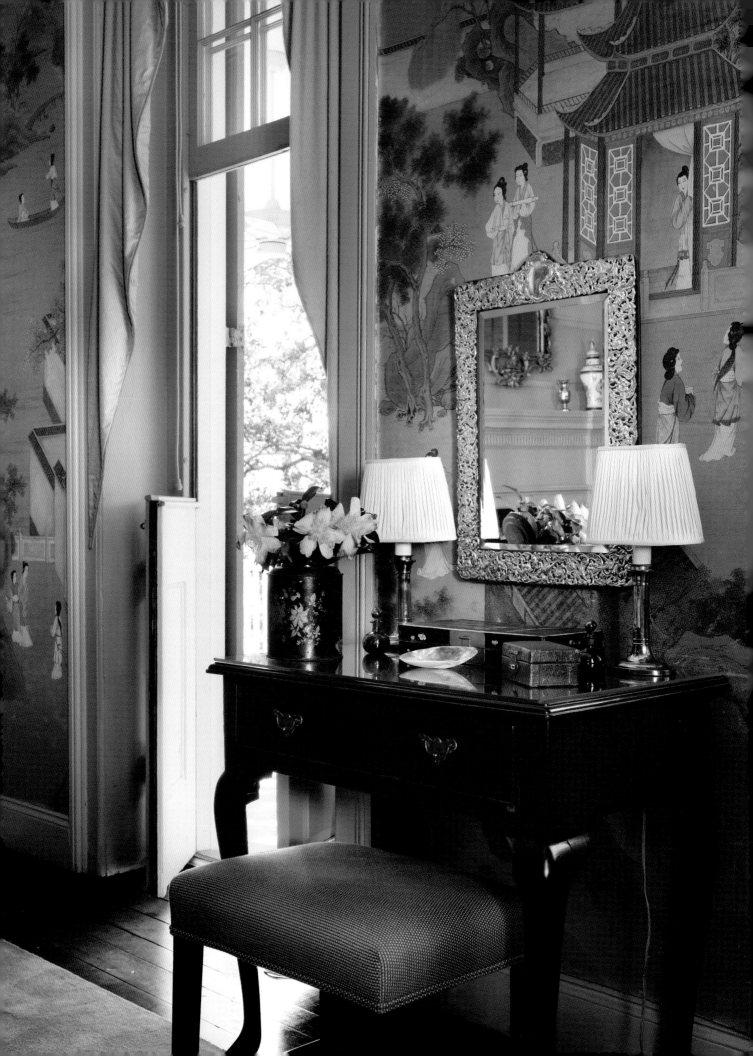

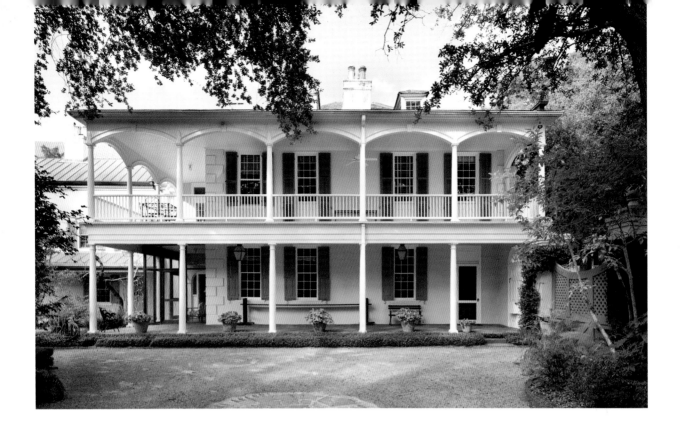

THOMAS ROSE HOUSE

Constructed circa 1735, the Thomas Rose House is a rare survivor of the great fire of 1740, which destroyed more than three hundred buildings and several wharves in the old walled section of Charleston.

After his wife inherited one of the original lots of the "Grand Modell" city plan, Thomas Rose sent a letter to his brother in England, requesting him to find four masons who would indenture themselves to him for four years in order to construct a house in Charleston. At the time, the Rose House was located in what was then a commercial, working-class neighborhood, with many of the city's merchants and artisans operating shops out of their homes, selling rum, guns, sugar, clothing, wine, and other goods.

The "double house" of brick covered with oyster plaster was built according to a classic "merchant house plan," with a large room on the first floor used as a counting house for the Savage family, who purchased the house as soon as Rose had completed it. On the second story

was a long drawing room running the full width of the house, which was the site of balls, teas, and other cosmopolitan exchanges within Charleston society.

Altered over the years by various owners, the house was restored in 1929 by the Whitman family who hired local preservation architect Albert Simons to modernize it, while keeping its colonial-era character. Albert Simons' aesthetic taste in the many renovations he undertook throughout Charleston in the 1920s and '30s shaped much of the present day "look" of historic homes. It was his conviction that a restored house should still look rooted in time and place.

The Henry P. Staats family purchased the house in 1942, also acquiring a dilapidated house next door to it and razing it, creating a large space for a garden. Loutrel Briggs planted it with luster leaf holly, camellias, magnolias, and sweet bays. The house is privately owned by the Staats' granddaughter Cathy Forrester, and is open to public tours several times a year.

OPPOSITE: *A dressing table that belonged to Juliette Staats is placed next to a full-length window opening onto the upper piazza.*

ABOVE: *Architect Albert Simons removed the Victorian details on the piazzas and replaced them with traditional Charleston colonial-style elements.*

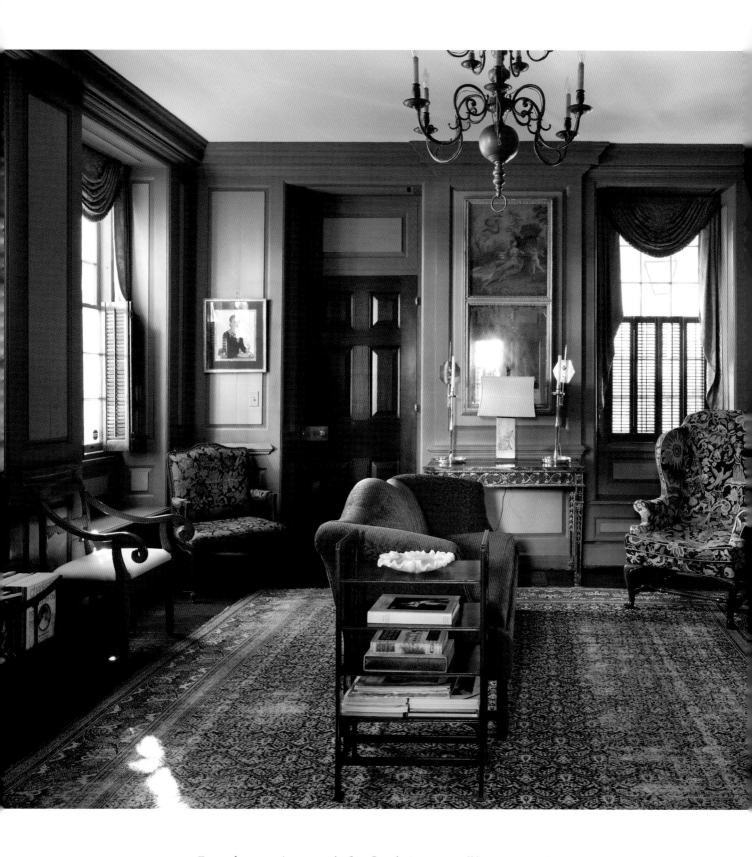

Formerly a counting room, the first floor living room still has its original Georgian paneling of cypress wood along with an eighteenth-century needlepoint wing chair.

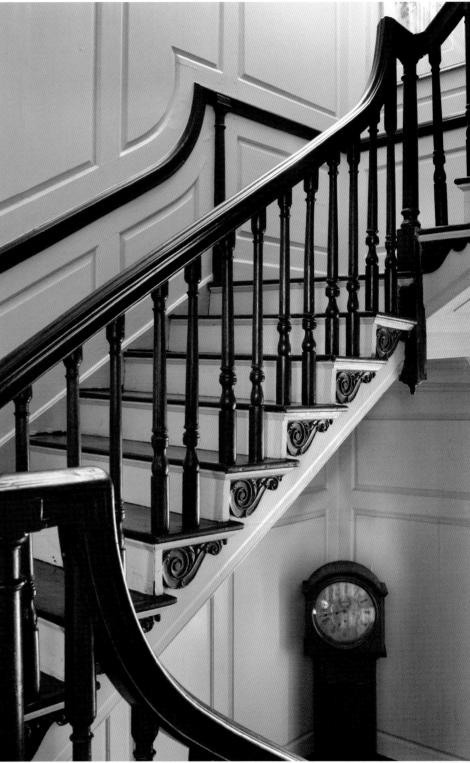

The three-story staircase at the center of the Thomas Rose House has
sophisticated carved brackets of black walnut.

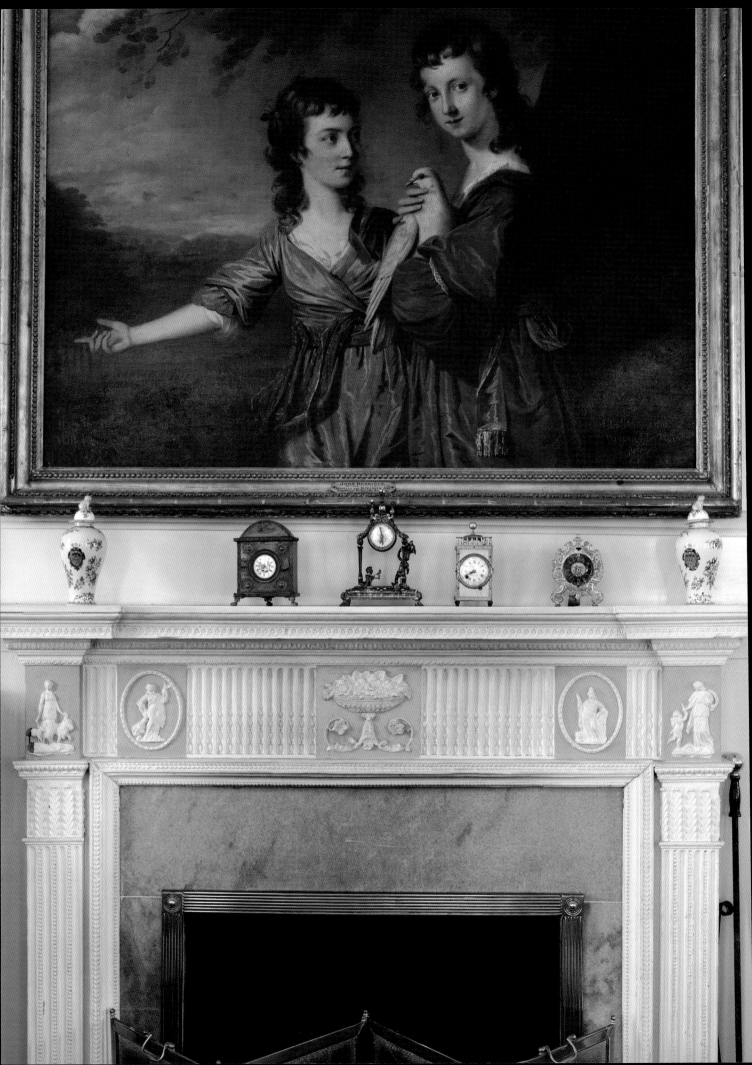

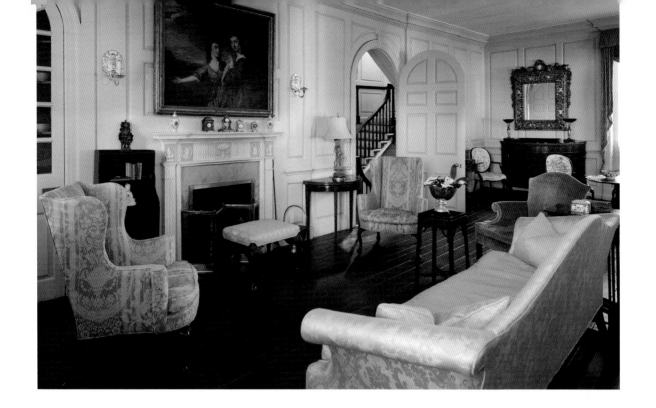

OPPOSITE: *A carved wood, Adam-style mantel was added to the fireplace of the salon in the early nineteenth century by the Savage family. Above it hangs a painting by John Berridge.*

ABOVE: *Furnished gracefully with Hepplewhite, Sheraton, and Chippendale pieces, the second story drawing room represents a historic Charleston interior.*

BELOW: *Chinese scenic wallpaper was popular in Charleston in the eighteenth and nineteenth centuries. This hand-painted silk was put up in the 1960s and the Ming-style fretwork canopies were added to the beds in the 1980s.*

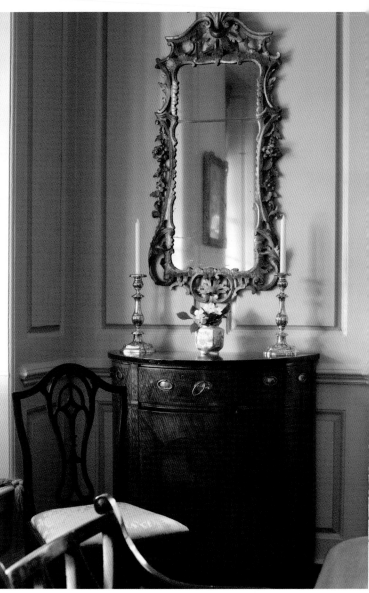

LEFT: *Camellias from the garden have been taken into the drawing room and placed in a bowl on an eighteenth-century kettle stand.*

RIGHT: *The original chestnut paneling of the dining room was painted by Juliette Staats in the 1940s, according to her interpretation of what eighteenth-century paint colors would have been.*

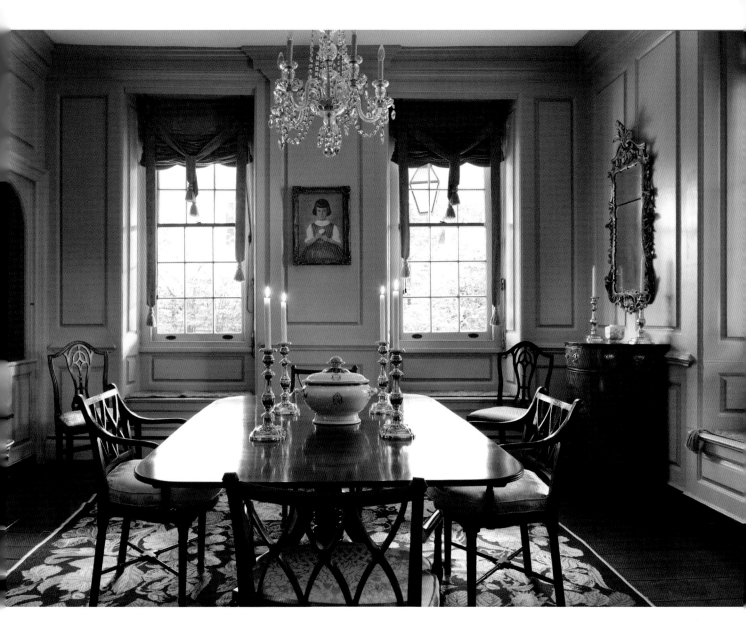

The portrait in the dining room is of Cathy Forrester at age five. Her grandmother, Juliette Wiles Staats, was considered Charleston's quintessential hostess and helped to establish Historic Charleston in 1947.

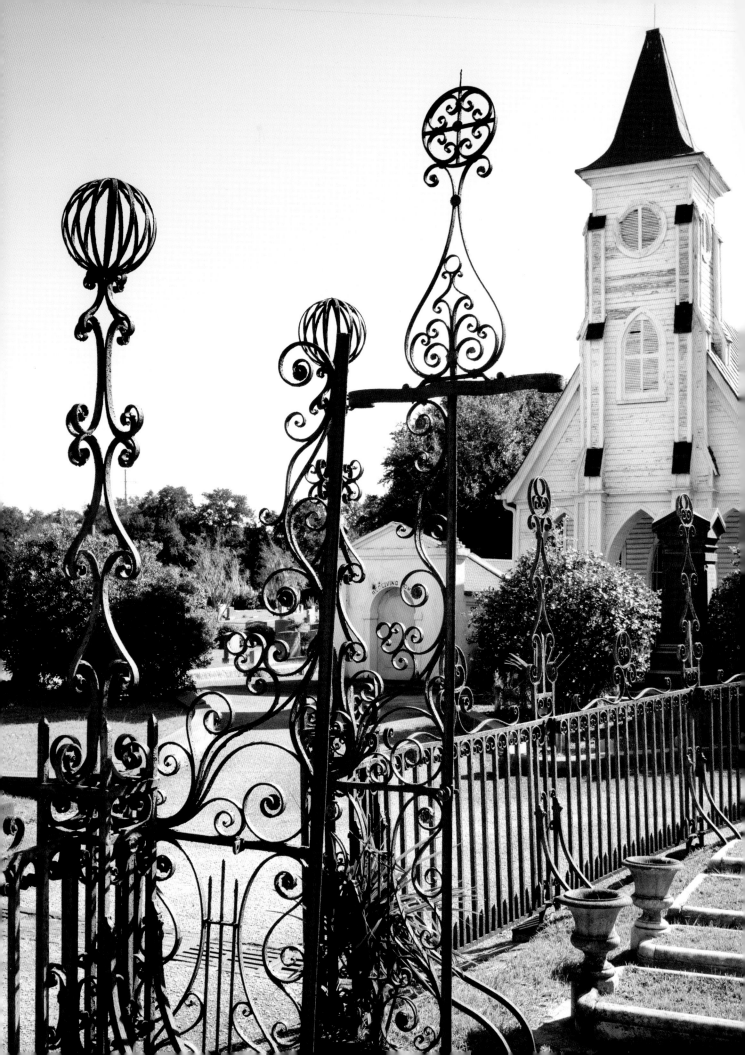

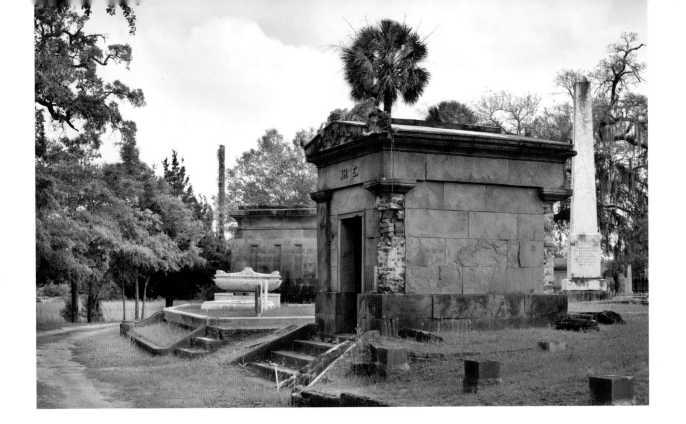

MAGNOLIA CEMETERY

"Out in the old cemetery on the edge of the lagoon, where the distillation of the past was perhaps clearest…" said Henry James of his visit to Magnolia Cemetery, on the outskirts of Charleston. The cemetery was officially opened in 1850 with much fanfare, religious ceremonials, and music, as well as orations delivered by Charlestonian artist Charles Fraser and poet William Gilmore Simms, who wrote his poem "The City of the Silent" for the occasion. Quickly becoming a popular spot for picnicking as well as a tourist draw, the cemetery reflected the Victorian era's fascination with death and mourning.

The Magnolia complex, which contains several separate sections, was created on the banks of the Cooper River and covers ninety-two acres of land that was once a rundown rice plantation called "Magnolia Umbra." The meandering grounds, planned by the eclectic architect Edward C. Jones, were laid out with trees, winding drives, small ponds, circular paths, and man-made lagoons according to the fashion of the national Rural Cemetery Movement of the time.

A repository of historic Charleston, Magnolia Cemetery has numerous examples of eloquent funerary art, including monuments and mausoleums that were designed by some of the city's foremost architects. It is the resting place of many notable figures in South Carolina's history, including past governors, senators, congressmen, generals, and more than 2,200 Confederate soldiers who died in the Civil War, including the inventor, commander, and crew of the H. L. Hunley Confederate submarine.

OPPOSITE: *In the German-American Bethany Chapel section, founded by Lutherans in 1856, master ironworker Christopher Werner created a wrought iron fence with distinctive crosses in an ornate style.*

ABOVE: *The crumbling "White Mausoleum" reveals handmade bricks beneath its stone facing. Obelisks were one of the most pervasive of cemetery art forms in the mid-nineteenth century.*

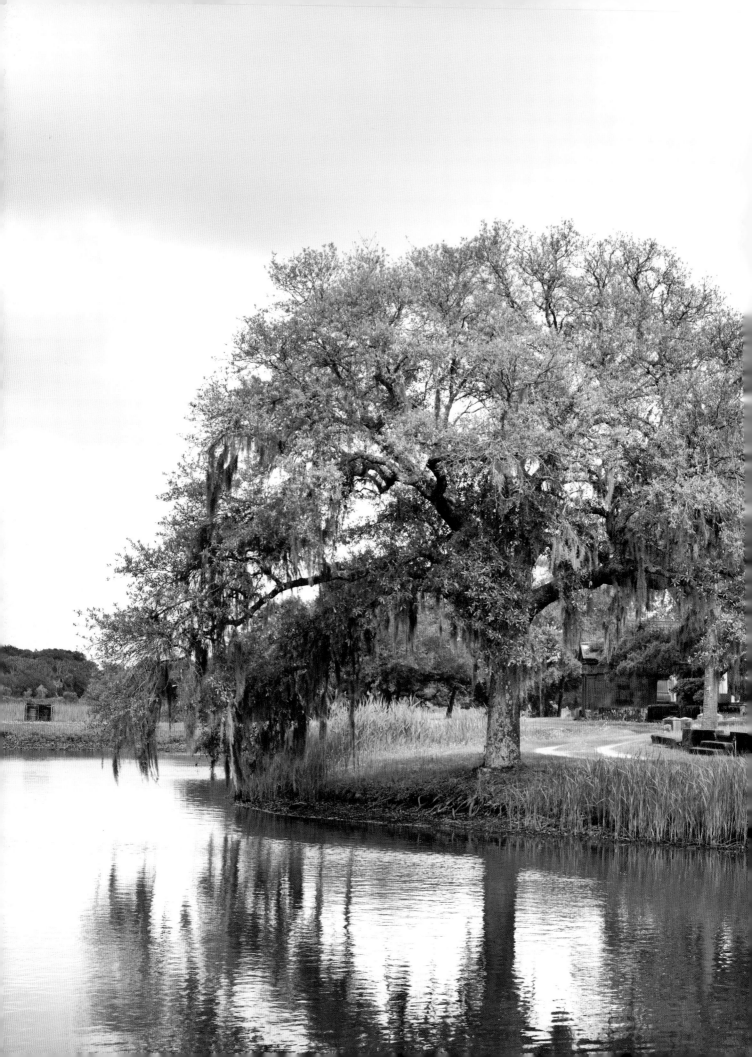

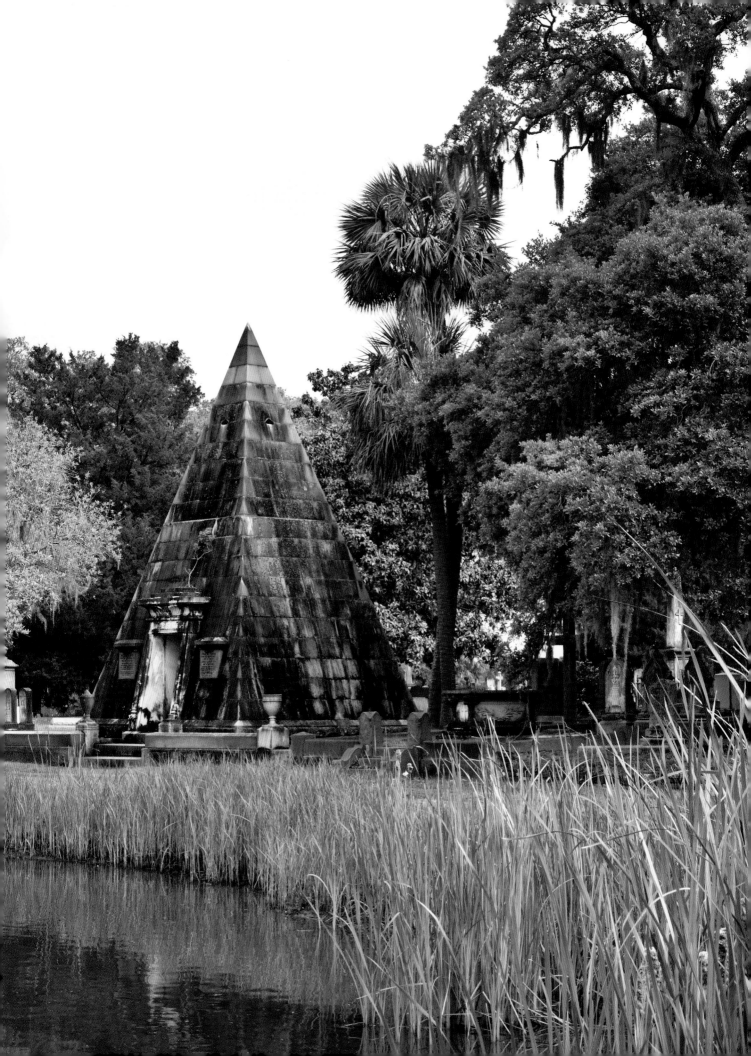

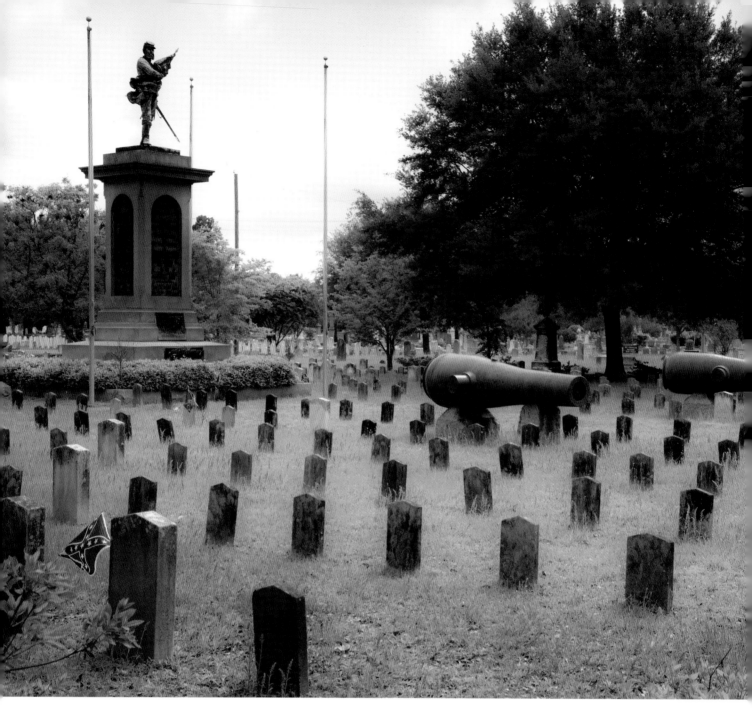

ABOVE: *Civil War cannons guard the graves of Confederate soldiers, including many who died at Gettysburg and were re-interred in the Soldiers Grounds. A bronze statue depicting a marching soldier overlooks the markers.*

OPPOSITE ABOVE: *The "Receiving Tomb," the place where the dead were held while their burial sites were being prepared, is one of the original cemetery structures.*

OPPOSITE BELOW: *Designed by Tiffany Studios, which created stained glass windows and gravestones for cemeteries, this stone carving of an otherworldly figure was made for the grave of Charlotte Witte.*

PRECEDING OVERLEAF: *A pyramid mausoleum houses a number of members of the William Burroughs Smith family. The Egyptian Revival was a style popular in cemeteries and with Freemasons in the 1800s.*

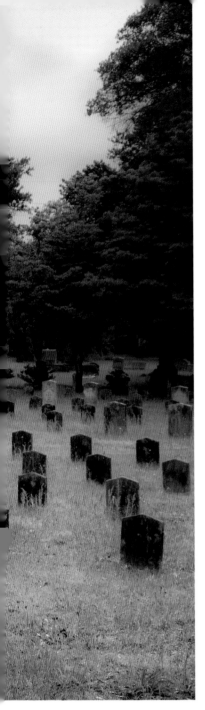

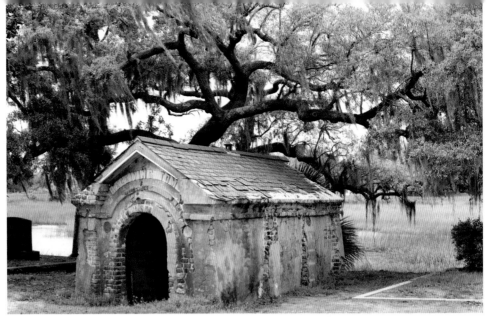

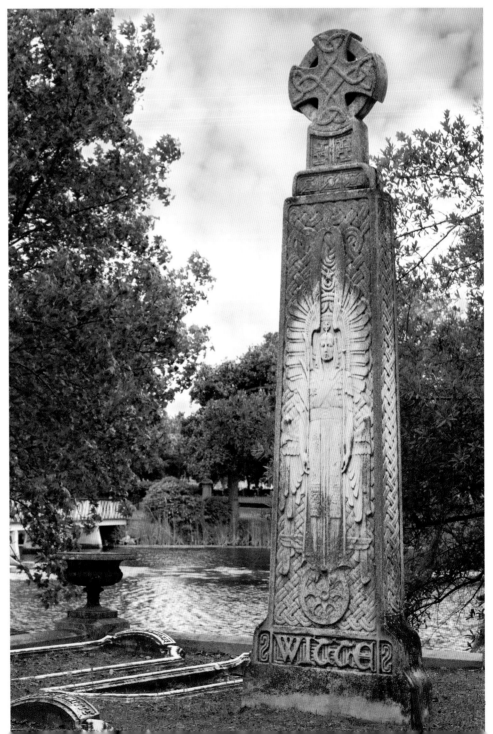

The Lowcountry

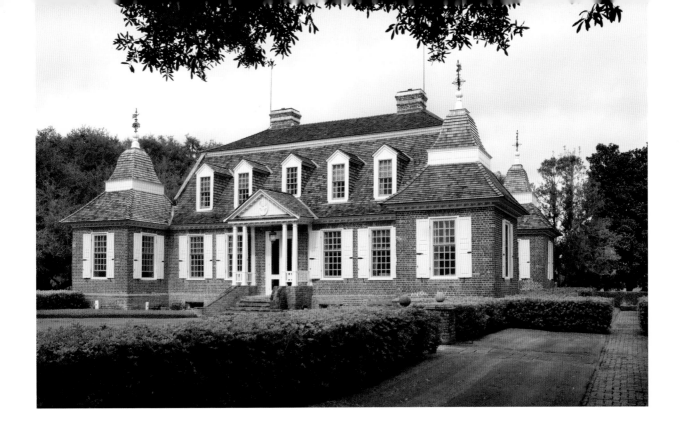

MULBERRY PLANTATION

Named for the mulberry trees on which silk worms feed, Mulberry began in the early 1700s with hopes of becoming a silk producing plantation. However, the plantation was more successful in growing indigo and rice, with rice being cultivated from colonial days into the early twentieth century.

Built circa 1714 by Thomas Broughton, an Indian trader and one time Royal Lieutenant Governor of South Carolina, the house was located on what was then the frontier and set high upon a bluff overlooking the Cooper River. A mélange of styles, the house is architecturally eclectic and unique. It has been called everything from Jacobean to French Huguenot to Dutch to early Georgian, and is evidence of the colonial syncretism of the time.

Constructed of English bond brickwork, Mulberry has a quaint "jerkin-head" gambrel roof and four small pavilions, or flankers, at each corner of the house,

each with a bell-shaped cupola and weather vanes atop them. These pseudo-military flankers serve as reminders of the fact that the house once served as a fortified stronghold during the Yamasee War.

After the abolition of slavery, the house became abandoned by 1909. In 1915, it was purchased by avid duck hunter Clarence Chapman from New York as a winter retreat. Chapman selected the English architect Charles Brendon to restore the house and also hired Loutrel Briggs to design the grounds as a series of connecting gardens on three separate levels. From the high point of the house, several paths meander down a slope to a camellia garden and walkways extend to the river and an old canal.

Privately owned, the house is the third-oldest plantation house in South Carolina and has easements placed by the Historic Charleston Foundation in order to preserve the property.

OPPOSITE: *The lower garden has a gate with mulberry finials and a reflecting pool that was part of the garden plan laid out by Loutrel Briggs.*

ABOVE: *Mulberry's design has similarities with sixteenth-century French "tower houses" sometimes found in Virginia and the West Indies. The pediment has carved sprigs of mulberry within a horseshoe; the weather vanes are topped with crowns.*

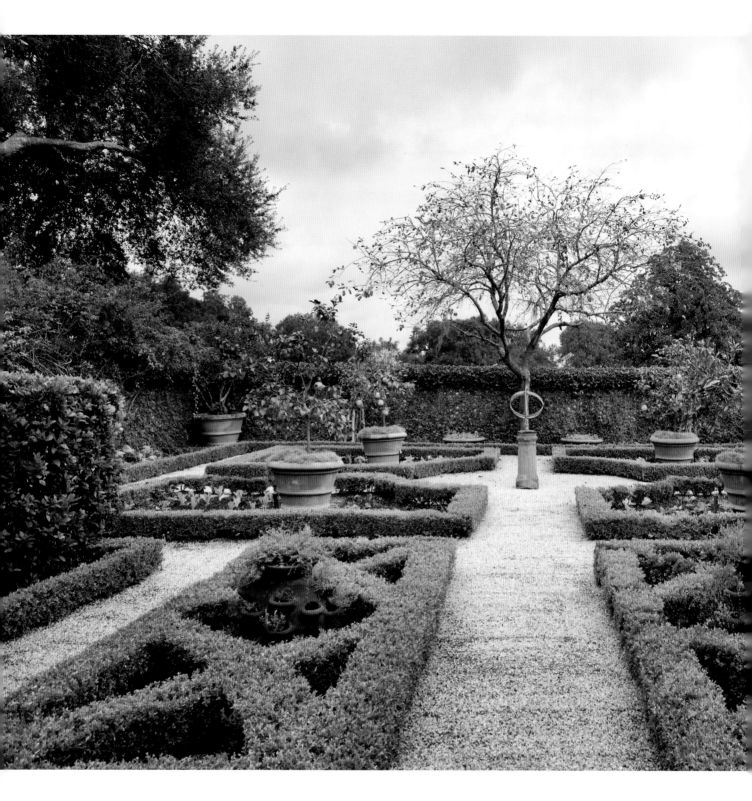

The laundry-drying yard of the plantation was landscaped into a traditional parterre garden where vegetables and citrus trees are now grown.

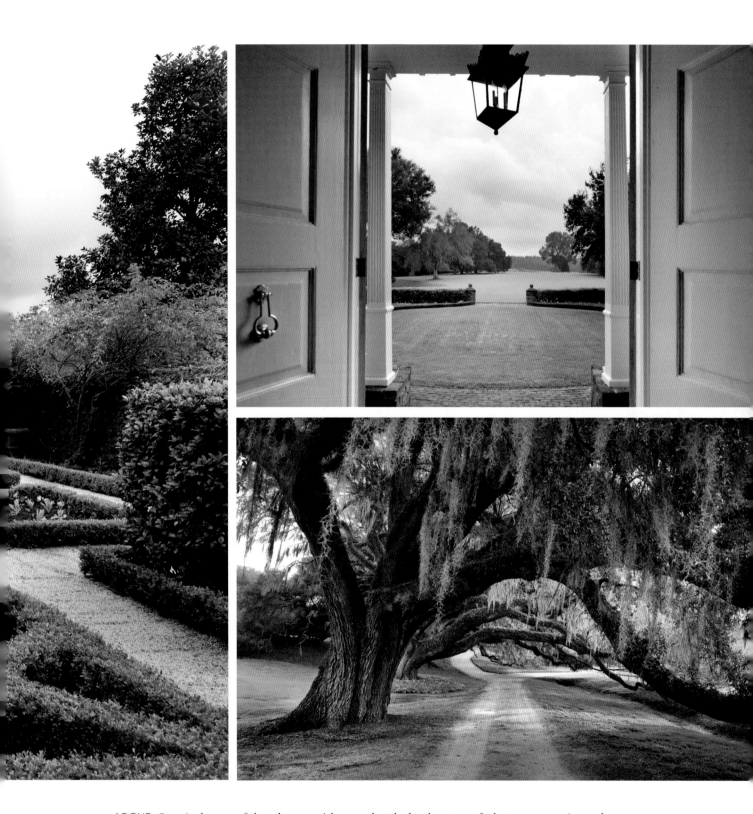

ABOVE: *Gone is the row of slave houses with steep thatched palmetto roofs that were once situated on the great lawn, as painted by Thomas Coram around 1800. Their design was reminiscent of African building practices.*

BELOW: *Spanish moss and resurrection ferns grow abundantly on the ancient live oaks leaning across the drive to the main house.*

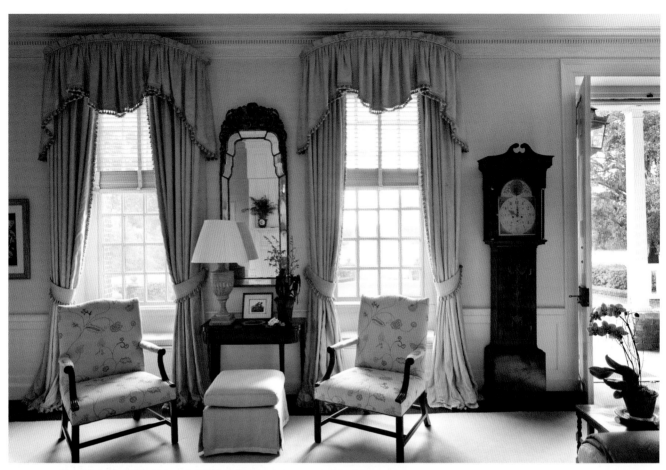

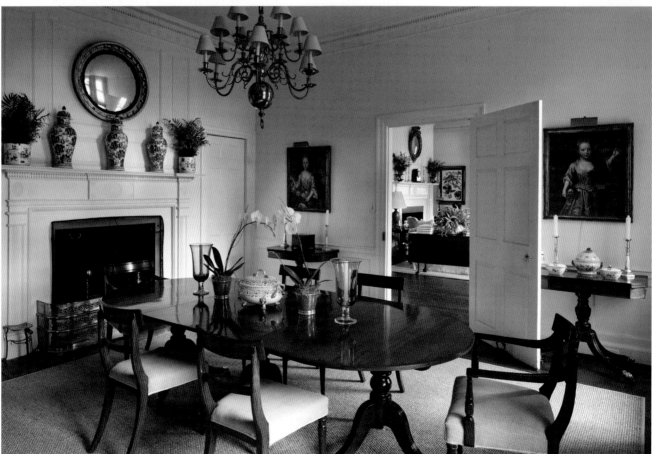

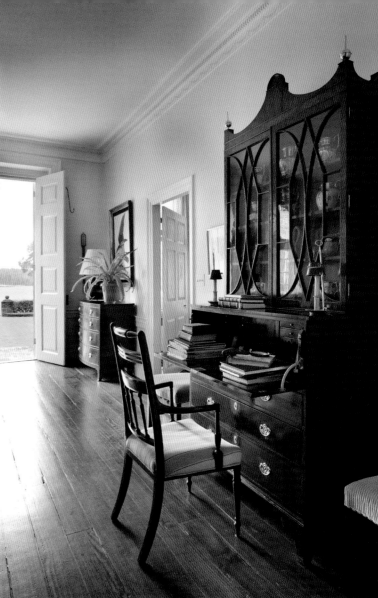

OPPOSITE ABOVE: *In the living room, tall windows are formally dressed. The grandfather clock, Chippendale armchairs, and other furnishings of the house have been passed down owner-to-owner since the Chapmans' time.*

OPPOSITE BELOW: *The dining room was remodeled with late eighteenth-century woodwork as the prosperity of the plantation increased.*

LEFT: *A portrait of Thomas Broughton's grandson, Alexander, is by Jeremiah Theus, a painter who lived in Charleston from 1740 and traveled to nearby plantations to fulfill commissions. It hangs above an English wine cellaret.*

RIGHT: *The entrance from the front portico went directly into what was once a large "dining hall." The secretary dates from the 1770s and holds ephemera illustrating the history of the house.*

ABOVE: *In one of the "curious corner rooms" inside the towers, a small library is comfortably furnished and has a cypress mantle that is original to the house.*

BELOW: *In an upstairs bedroom, a door with diamond-shaped panel and a fireplace mantle have been painted with blue milk paint. A canopied bed has the traditional carvings of rice plants on its posts.*

OPPOSITE ABOVE: *Mulberry has one of the few still intact plantation gardens that Loutrel Briggs designed. Briggs capitalized on the sweeping views overlooking the Cooper River with his placement of two brick terraces.*

OPPOSITE BELOW: *During the early days of settlement, the easiest and safest travel routes to Charleston were often in canoes dug out of giant cypresses. Each river plantation had a boathouse on its landing for the officer in charge of the boats.*

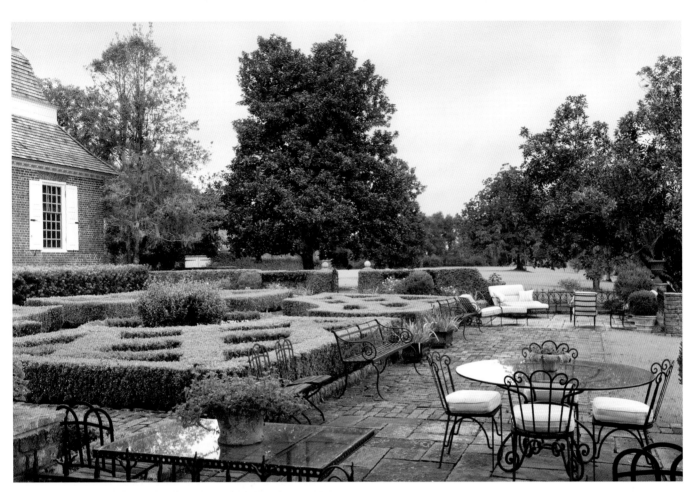

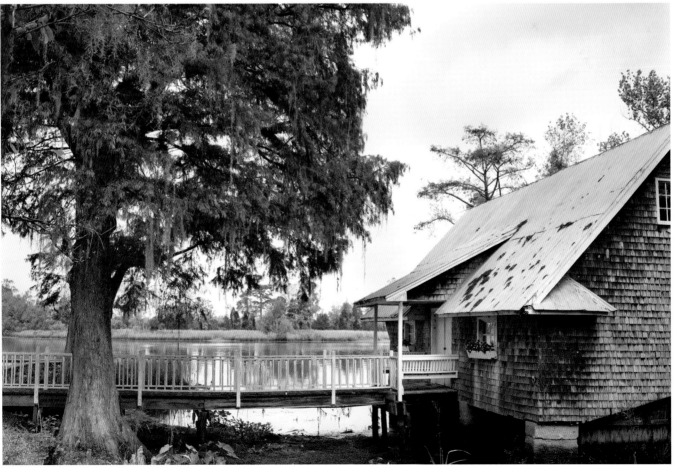

MIDDLETON PLACE GARDENS

Often described as the oldest landscaped garden in America, Middleton Place Gardens was begun in 1741 by Henry Middleton, who sent to England for an experienced gardener to design the grounds of his seven thousand–acre estate in a neoclassical, French style.

Determined to out-do his neighbors who were laying out simple four-squared parterres, Middleton's plans called for grassy turf terraces, a pair of butterfly-shaped lakes, ornamental canals, and shady groves with marble statues.

Into the creation of the garden went the labor of a hundred slaves over a period of ten years. Water buffalo were imported from Constantinople in the late 1700s to help work in the deep muck. The family's friendship with the French royal botanist André Michaux resulted in a house gift, the first camellias grown in the country, some of which survive today and have grown to the height of fifteen feet.

In the antebellum era, the second Henry Middleton expanded the gardens further, introducing the Asiatic azalea and filling his greenhouses with imported, exotic plants. In 1865 Union troops captured Middleton Place, burning the Jacobean-style main house, destroying the grounds, and eating the water buffalo.

Following the Civil War, the gardens disintegrated into a tangled wilderness. Determined to restore Middleton to its original splendor, descendants J. J. Pringle Smith and his wife, Heningham, labored for years, replanting and reworking them. The Smiths opened the former plantation gardens to the public in the late 1920s to great acclaim and the site has been an international tourist destination ever since.

OPPOSITE: *In 1786, French botanist André Michaux gave the Middleton family the first camellias ever grown outdoors in an American garden. Camellias, planted as an allée, have grown into a tunnel.*

ABOVE: *Built on the shores of the Ashley River, the remaining south wing of the house is set in an open expanse of greensward where sheep graze, helping to crop the grass as they have done for centuries.*

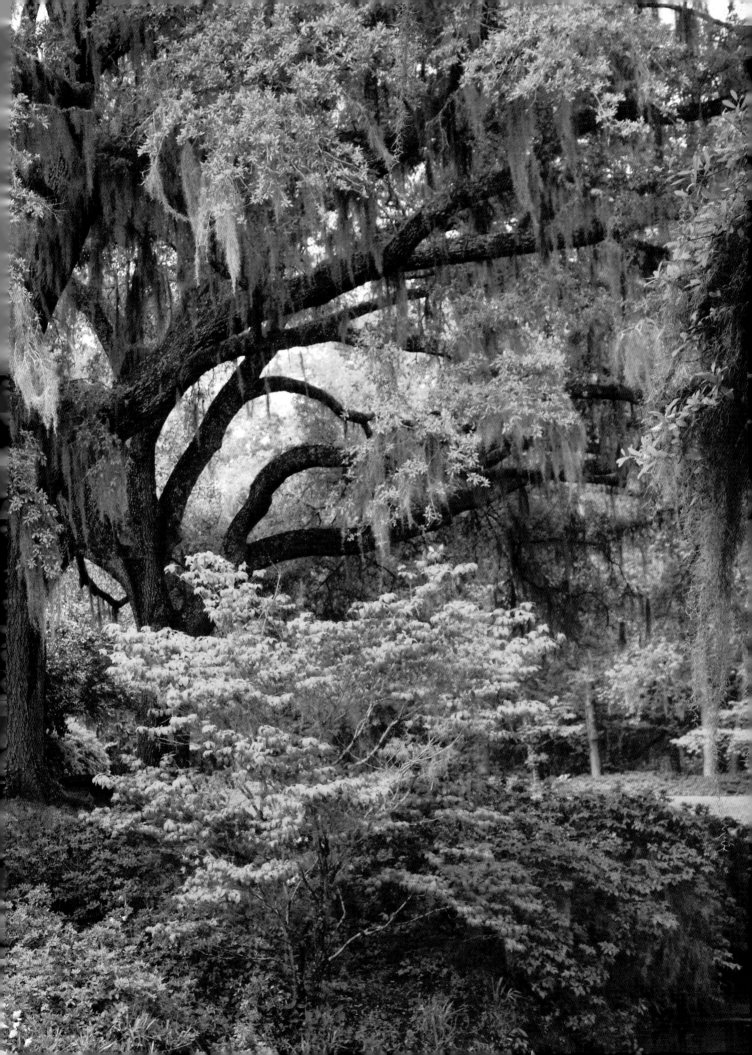

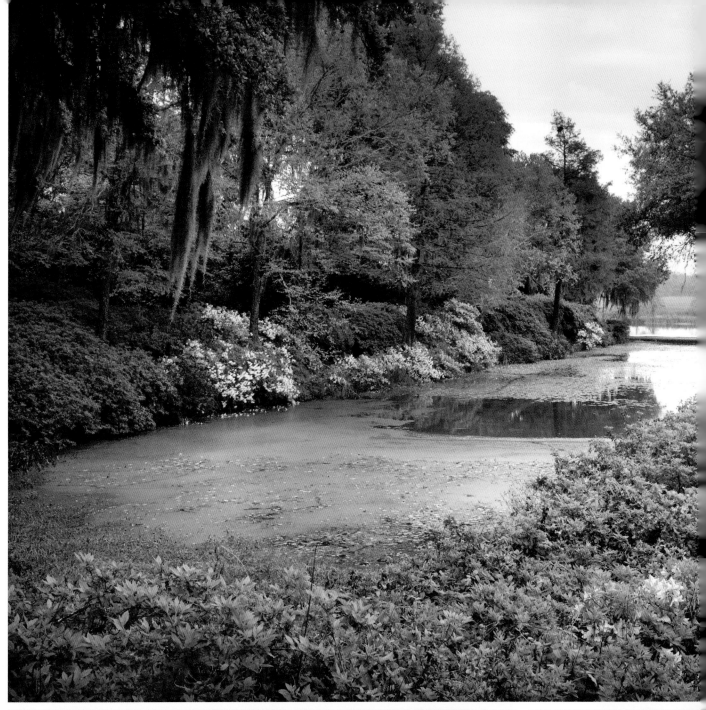

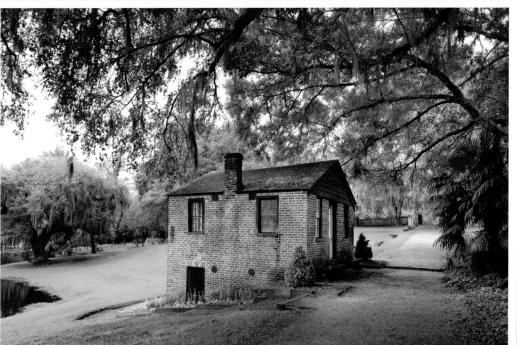

LEFT ABOVE: *Along the banks of an old canal, azaleas in all shades are packed close together with moss-draped live oaks overhead.*

OPPOSITE: *An upper room was added to the brick spring house with the intention of placing a billiard table in it. Instead, the space was converted into a chapel that served the plantation population.*

LEFT BELOW: *Ancient live oak trees bend down their long arms to the earth next to flooded rice fields where "Carolina Gold" rice was once planted by slaves.*

PRECEDING OVERLEAF: *A seated wood nymph lacing her sandal was sculpted by Rudolf Schadow in 1810. The statue was buried during the Civil War to hide it from marauders and survived unscathed.*

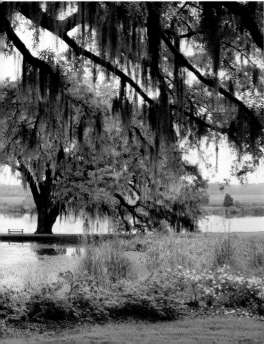

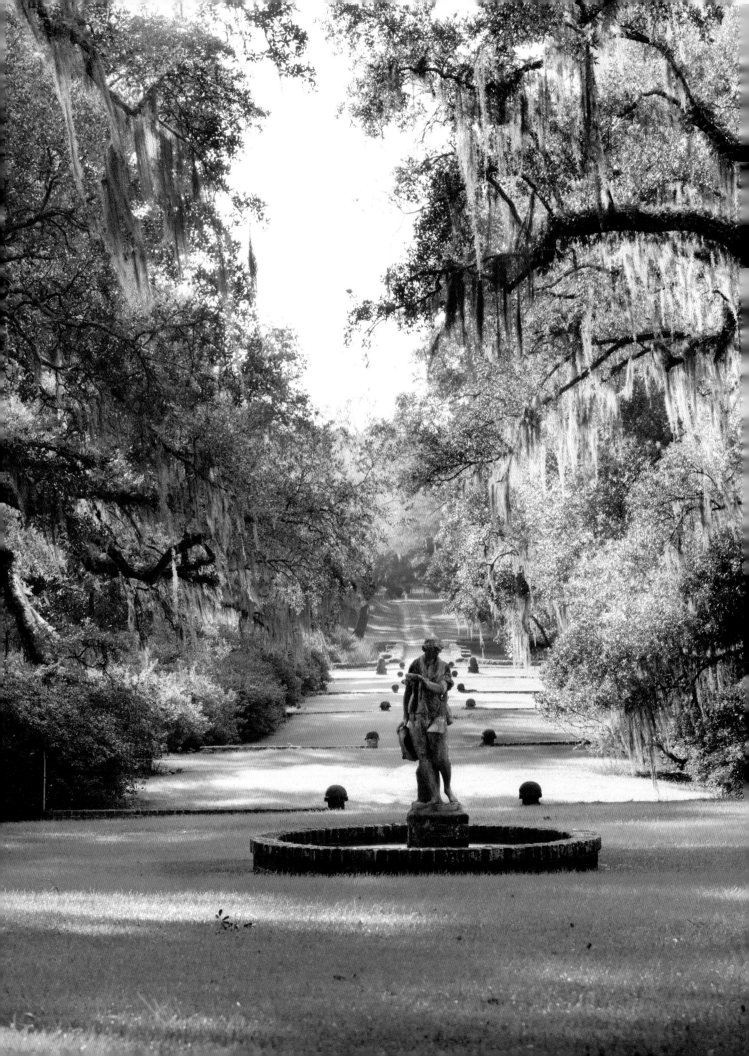

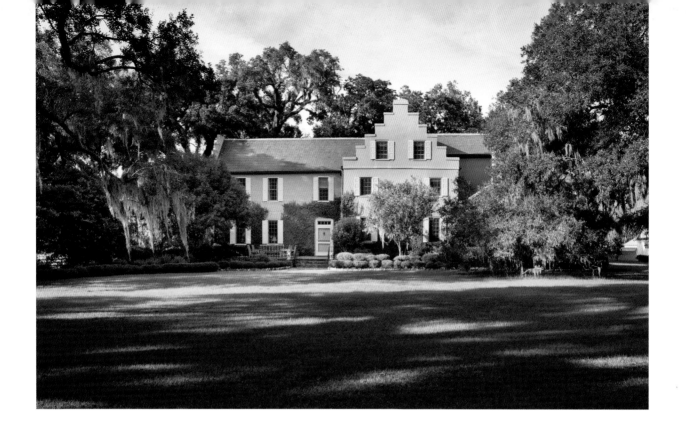

MEDWAY PLANTATION

Medway Plantation was begun in 1686, only sixteen years after the founding of the colony, by Jan Van Arrsen, who led a small group of Hollanders to South Carolina to settle after the Lords Proprietors granted him twelve thousand acres. The turquoise shuttered, pink-stuccoed plantation house is made of handmade bricks with stepped gables following a post-medieval Jacobean style borrowed from the Dutch.

After a fire, the core of the house was rebuilt circa 1705 by Edward and Elizabeth Hyrne.

The house was gradually enlarged to its present size, the last addition being a wing added in 1855 by Peter Gaillard Stoney. Stoney, who acquired Medway in 1833, set up a racetrack and fenced in large tracts as deer-hunting parks. He also started a brick making operation on the estate. Along with rice he produced

"Carolina Grey" bricks from the local river clay to supply Charleston and the building of Fort Sumter.

Located on the Back River, the house is surrounded by more than 6,700 acres of pine forests, ponds, and horse pastures. In 1929 the estate, which had fallen into dilapidation, was purchased by Sidney and Gertrude Legendre who restored it, adding salvaged cypress paneling to rooms as well as creating a formal garden. Gertrude Sanford Legendre, a socialite and carpet heiress, was noted for being a big game hunter and OSS spy during World War II.

Today, Medway is privately owned and is the oldest existing masonry house in South Carolina. A remnant of the former Goose Creek rice plantation society, it is a refuge for endangered creatures and home to many bird colonies, as well as a place for duck and quail hunting and horseback riding.

OPPOSITE: *Carriages used to come up this allée to the back entrance of the house; the main entrance faced the riverside. A statue serves as the focal point of the terraced avenue lined with ornamental "cannon balls" made of mortar.*

ABOVE: *Of stuccoed-brick, Medway is painted in historic shades of Barbadian pink and turquoise.*

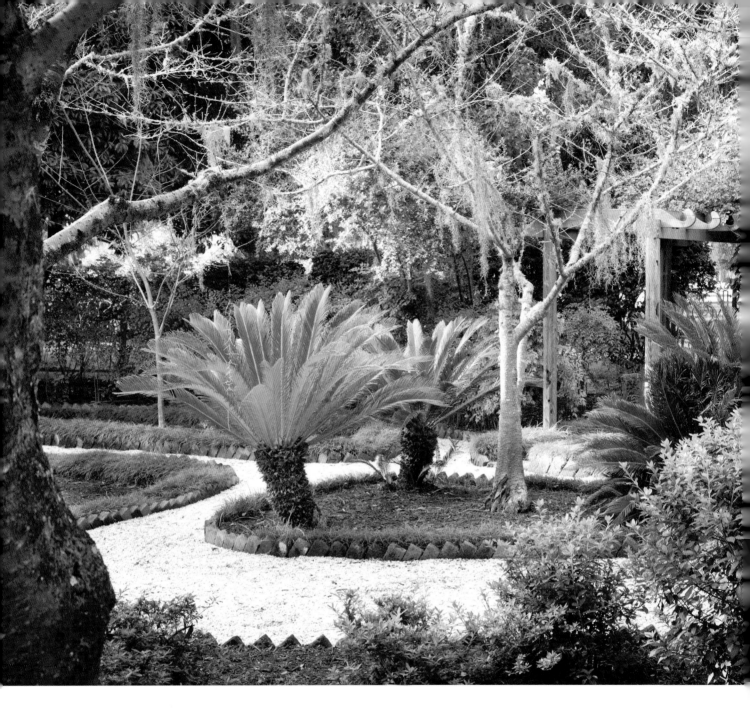

ABOVE: *Known as the "Grandmother's Garden," this enclosed garden with pea-gravel paths was planted by Louisa Stoney two hundred years ago. The old plantings have been redone in the same fashion over the years.*

OPPOSITE ABOVE: *The guest house, called "Cave of the Winds," is older than the main house and dates from 1686. It was originally the kitchen house of the old plantation.*

OPPOSITE MIDDLE: *A small library was referred to as the "gun room" for the gun and trophy collections that Gertrude Legendre kept on display here. The mantle, added in the 1930s, is of pecky cypress.*

OPPOSITE BELOW: *Serpentine brick walls surround a formal garden laid out in the 1930s by Ides van der Gracht, a noted architect who helped to design the Pentagon building in Washington.*

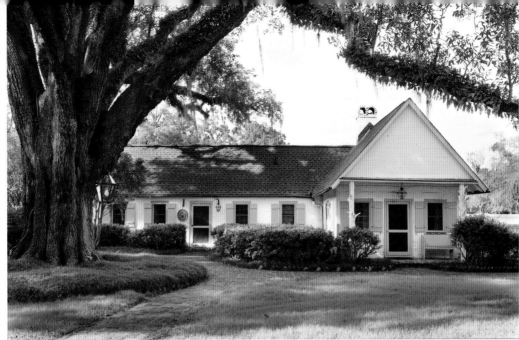

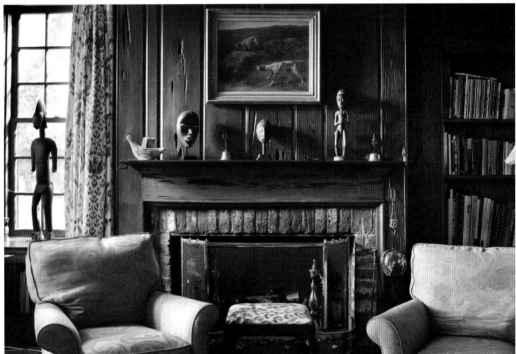

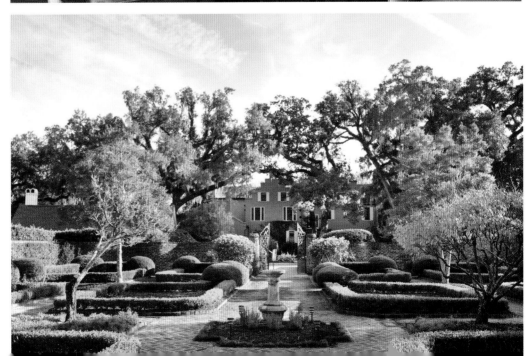

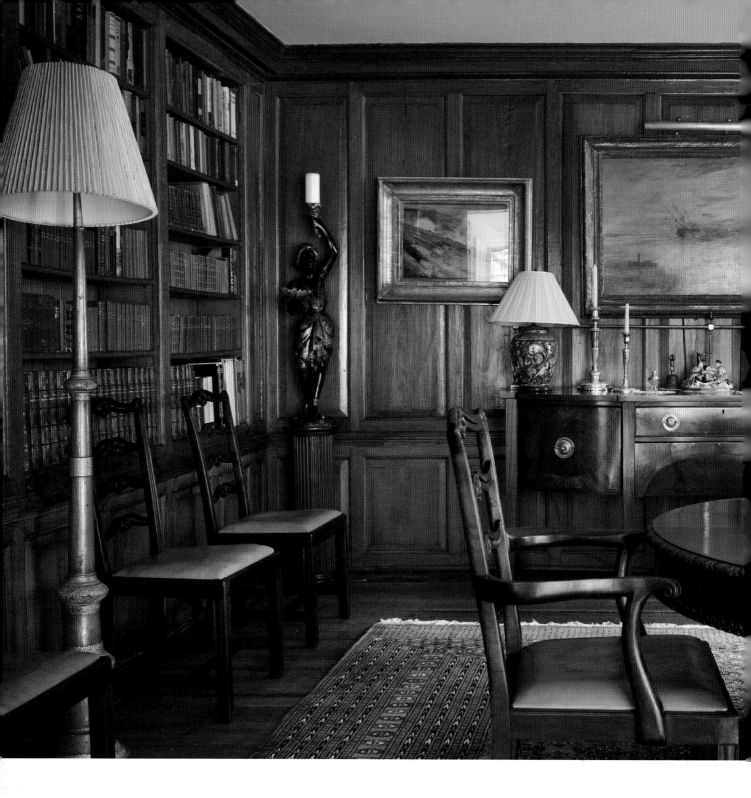

ABOVE: *In the 1930s the Legendres remodeled the dining room adding cypress paneling recycled from Pine Grove plantation. The table, sideboard and pair of blackamoors date from the Legendre days, as well as the tall lamps made out of horns.*

OPPOSITE ABOVE: *This long, pine-floored room was originally a large hall, the principal entertaining room in the house. Gertrude Legendre was famous for throwing lavish New Years' Eve costume balls, making her entrance on one occasion on the back of an elephant.*

OPPOSITE BELOW: *A collection of ancient pottery is displayed in a cypress cabinet with a carved shell back panel that was installed during renovation in the 1930s.*

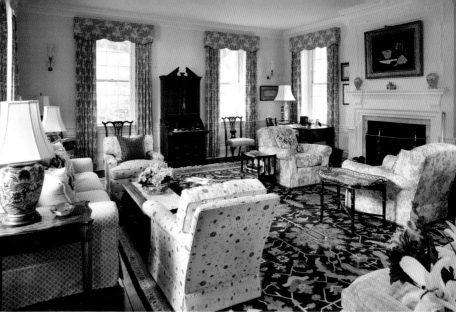
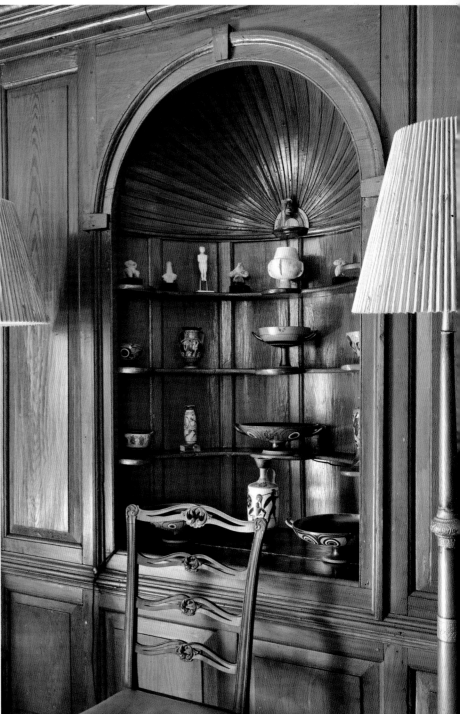

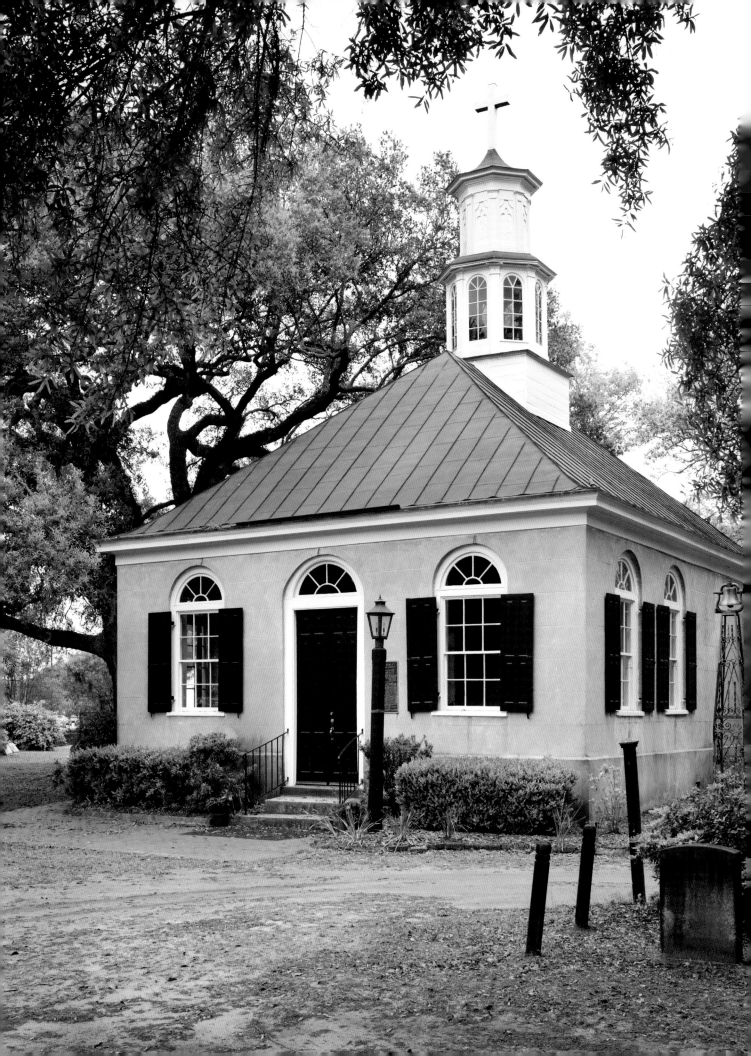

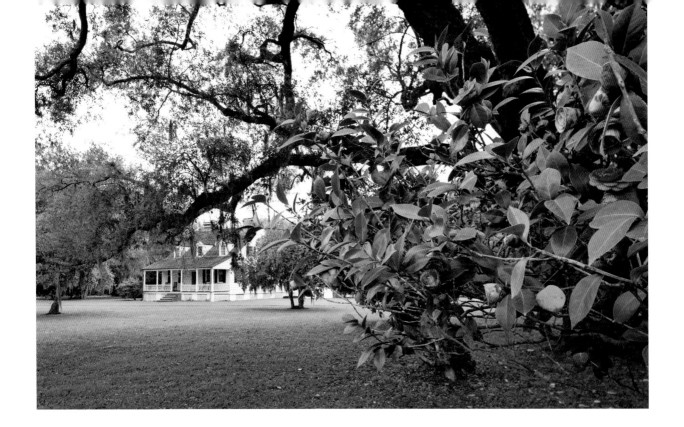

CHARLES PINCKNEY NATIONAL HISTORIC SITE
MOUNT PLEASANT, SC

The Charles Pinckney National Historic Site is a remnant of the large rice plantation that Charles Pinckney inherited from his father in 1782 and enjoyed until his debts and mismanagement forced him to sell the estate in 1817. Known as "Snee Farm" for the Gaelic word meaning bountiful, the plantation and country retreat was among the many properties owned by the Pinckney family. The family's long history in Charleston dates back to 1692 when Thomas Pinckney, an English privateer arrived on the *Loyal Jamaica* from the West Indies.

Called the "forgotten founder," Charles Pinckney was one of the drafters and a signer of the U. S. Constitution; he also served four terms as South Carolina governor.

His great aunt, Eliza Lucas Pinckney, was an agricultural innovator who developed the lucrative indigo trade in South Carolina from seeds she grew on the Wappoo family plantation, with help from her slave Quash.

The present house at Snee Farm was built of native cypress and pine in the 1820s and is an example of the vernacular tidewater cottages once common throughout the Lowcountry. Displays of archaeological finds on the property tell the story of the Pinckney family along with accounts of the enslaved Africans who lived and worked on the plantation, providing insight into the Gullah culture.

OPPOSITE: *In the eighteenth century, the nearby Christ Church was built in Mount Pleasant to serve Wando Neck rice plantations, including Snee Farm. The interior of the church was gutted and used as a stable by Union cavalry near the end of the Civil War.*

ABOVE: *The vernacular farmhouse at Snee Farm has a shed roof above its porch. Traces of a "handsome garden and pleasure grounds" have been found, along with artifacts such as crystal goblets and silver spoons with the Pinckney monogram.*

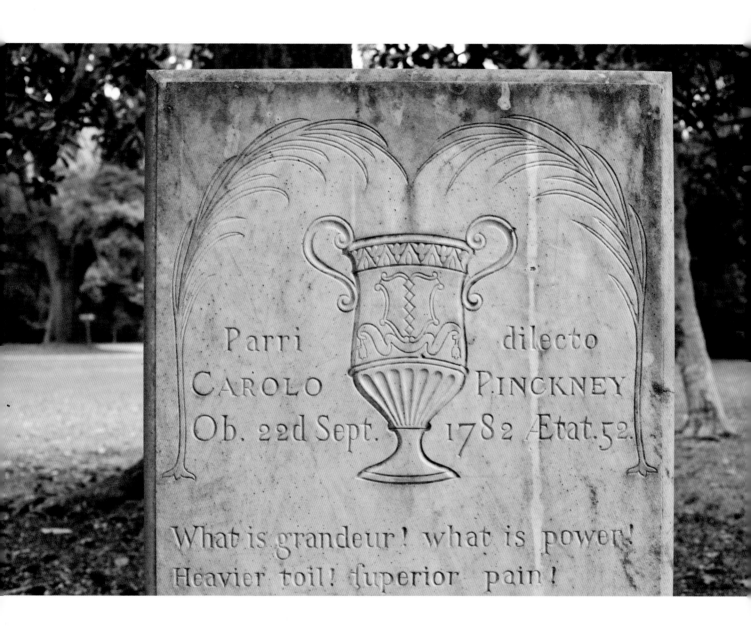

Parri dilecto
CAROLO P.INCKNEY
Ob. 22d Sept. 1782 Ætat.52.

What is grandeur! what is power!
Heavier toil! superior pain!

A replica of a marble cenotaph that Charles Pinckney commissioned for his
father has been placed under a live oak at Snee Farm.

The camellia, along with Spanish moss, is emblematic of the South's landscape and was one of the most treasured flower specimens in nineteenth-century gardens.

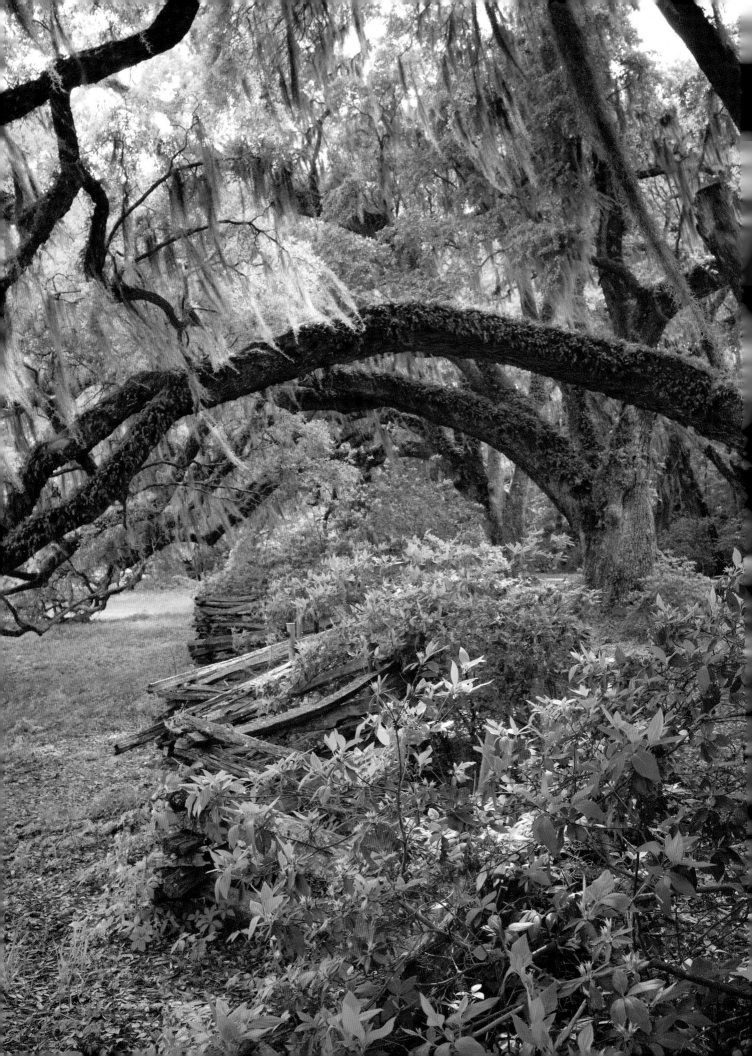

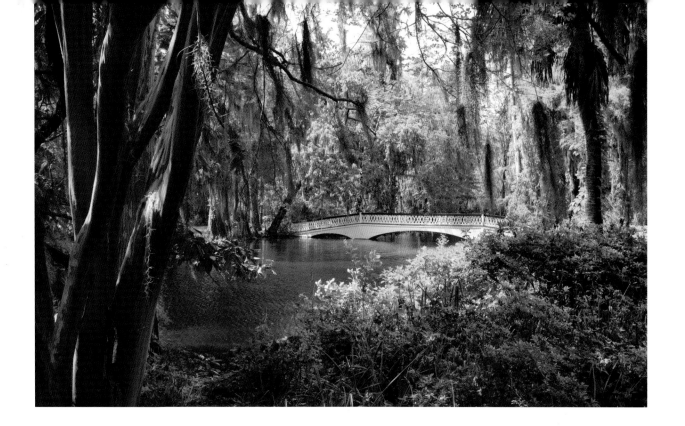

MAGNOLIA GARDENS

Magnolia Gardens gained national recognition in 1870 when Reverend John Grimke Drayton opened his family's ancestral plantation that dated back to 1676 as a tourist attraction.

Beginning in the 1840s, in order to improve his failing health, Reverend Drayton had worked outside in his gardens, re-landscaping the estate's original formal design into the new "picturesque" English Romantic style of the time. Drayton added winding paths and footbridges and introduced wisteria, dogwood, and azaleas of all colors into the woodland setting. He was also among the first in the country to cultivate 'Camellia japonica' outdoors.

In the Victorian era the gardens were written up in guidebooks and magazines as one of the three foremost attractions to visit in America, along with Niagara Falls and the Grand Canyon. Paddleboat steamers took visitors up the Ashley River to marvel at the spring displays of masses of flowering azaleas reflected in the mysterious black water of lakes that used to be rice fields. Today, Magnolia is the oldest "picturesque"-style public garden in the country, attracting thousands of visitors each year.

OPPOSITE: *Once an impenetrable jungle, the garden now has paths lined with hundreds of varieties of azaleas including some native ones, which have been growing quietly in American forests since antiquity.*

ABOVE: *The "Long Bridge," built in the 1840s, crosses a lake lined with bulbous-rooted cypress trees. The inland rice fields of the plantation were converted into ornamental lakes in the early nineteenth century.*

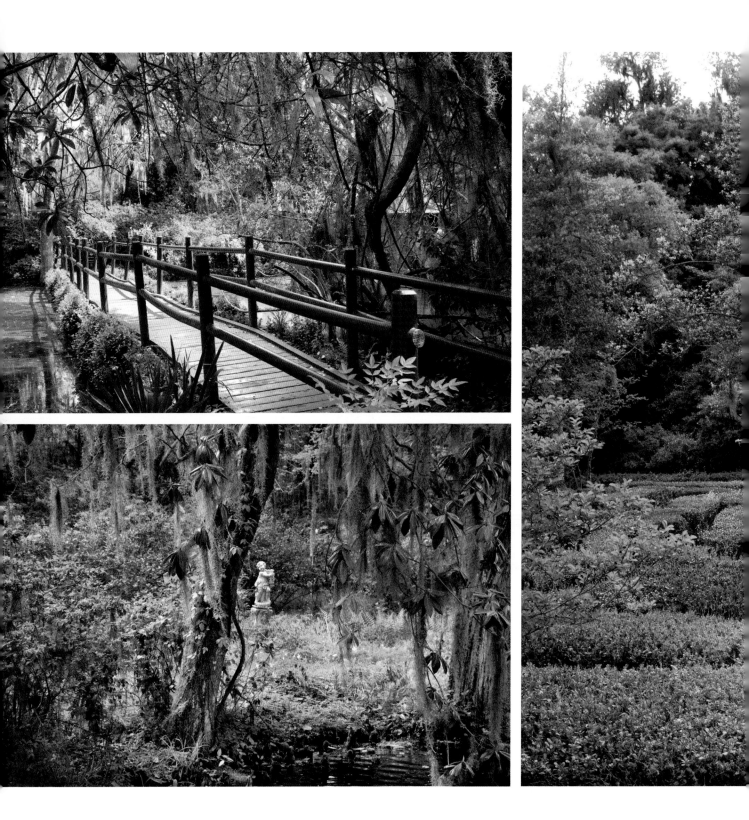

ABOVE: *Picturesque, romantic English landscape gardens planted in an irregular way frequently contained Chinese elements, such as a red-painted bridge.*

BELOW: *Vivid colors of the azaleas are "flung into contrast with the somber beauty of moss-draped live oak and dark, cypress-haunted water," as novelist DuBose Heyward wrote.*

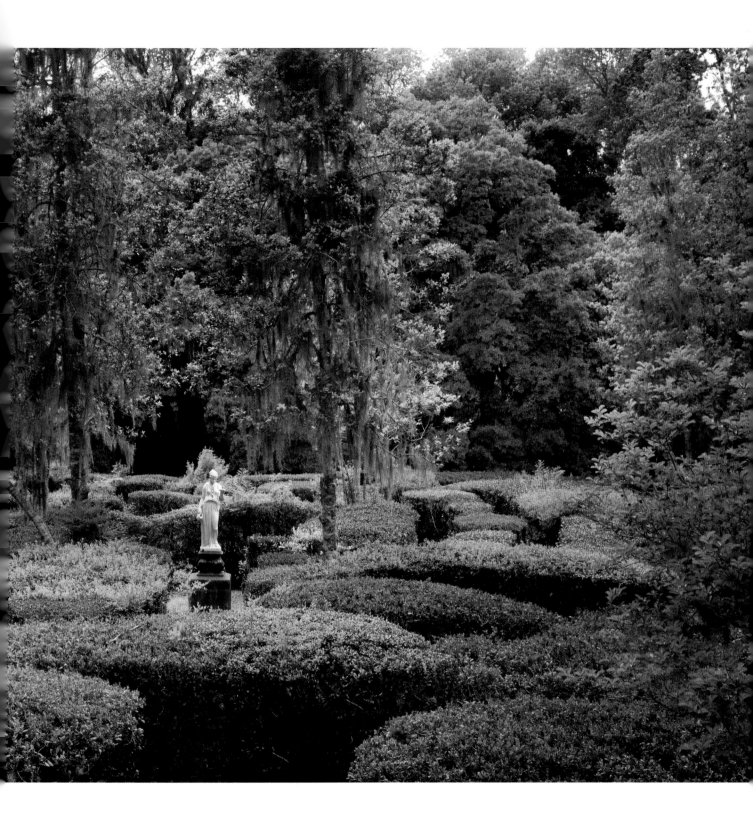

The maze, a replica of a famous one at England's Hampton Court Palace, is planted with hundreds of camellia sasanqua shrubs; there are more than one thousand cultivars of camellias grown at Magnolia, including "ancient" (pre-1900) ones.

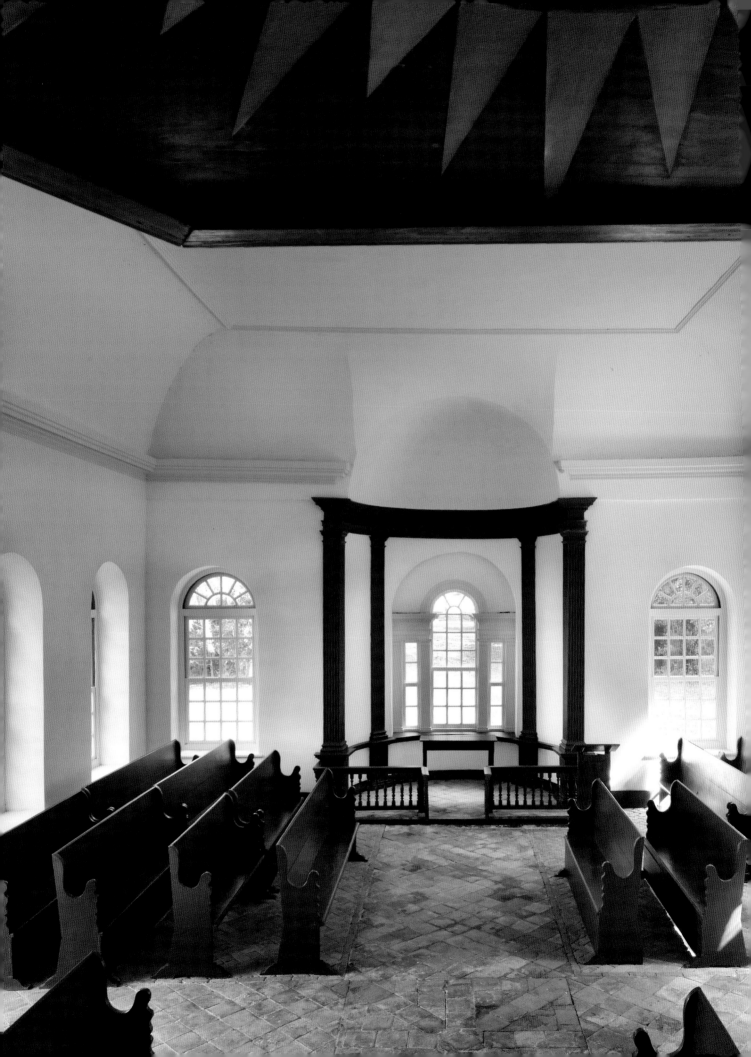

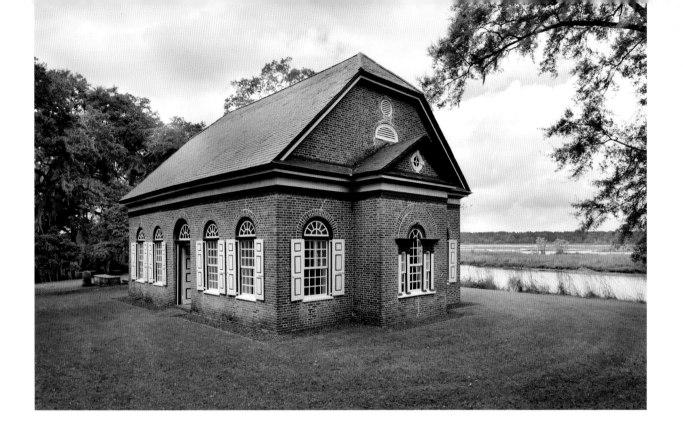

POMPION HILL CHAPEL · HUGER, SC

At the end of a long dirt road, a small red brick "chapel of ease" stands in solitude on a small bluff beside a branch of the Cooper River near Huger's Bridge. The chapel is located at Pompion Hill, which was part of a settlement of exiled French Huguenots, a number of which first arrived in Carolina in 1680 to begin cultivating grapes, olives, and silkworms, as King Charles II desired.

In 1763, the planters of St. Thomas and St. Denis Parish contracted with two masons to build an Anglican chapel that would be conveniently located near their plantations, saving them a trip downriver to church in Charleston on Sundays. One mason was Zachariah Villeponteaux, who would erect the building shell and

the other, William Axson, would "finish and adorn the Inside in a decent and compleat manner."

Villeponteaux, a member of one of the old Huguenot families, was renowned for the bricks he produced at his "Parnassus Plantation," including ones for St. Michael's Church in Charleston. Axson, a master carpenter, executed the fittings and woodwork, putting his insignia as a Freemason and other Masonic emblems on the walls.

Pompion Hill Chapel, first built of cypress wood and then of brick, survives, having been recently restored by the descendants of former parishioners and their friends.

OPPOSITE: *The red tile and herringbone-pattern brick floor was paid for by Gabriel Manigault, a Charleston architect, who was descended from a Huguenot family.*

ABOVE: *Villeponteaux designed the Pompion Hill chapel-of-ease with a rectangular layout and two doors opposite each other. It has Palladian windows and a "jerkin-head" roof covered in heavy slate.*

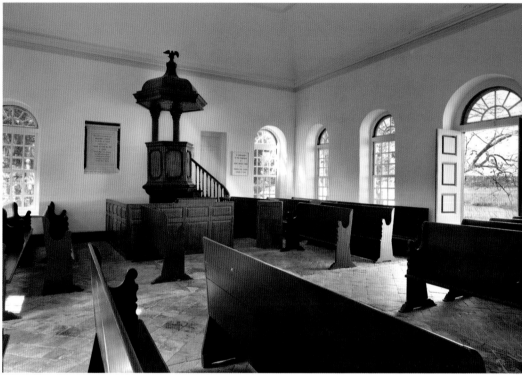

LEFT: *The oldest plantations, such as the nearby Middleburg from 1697, were built on marsh-free waterfronts for shipping and transportation.*

ABOVE: *A hexagonal pulpit is built of native red cedar, which was often used for coffins. The underside of its canopy bears an inlaid sunburst done in exotic woods.*

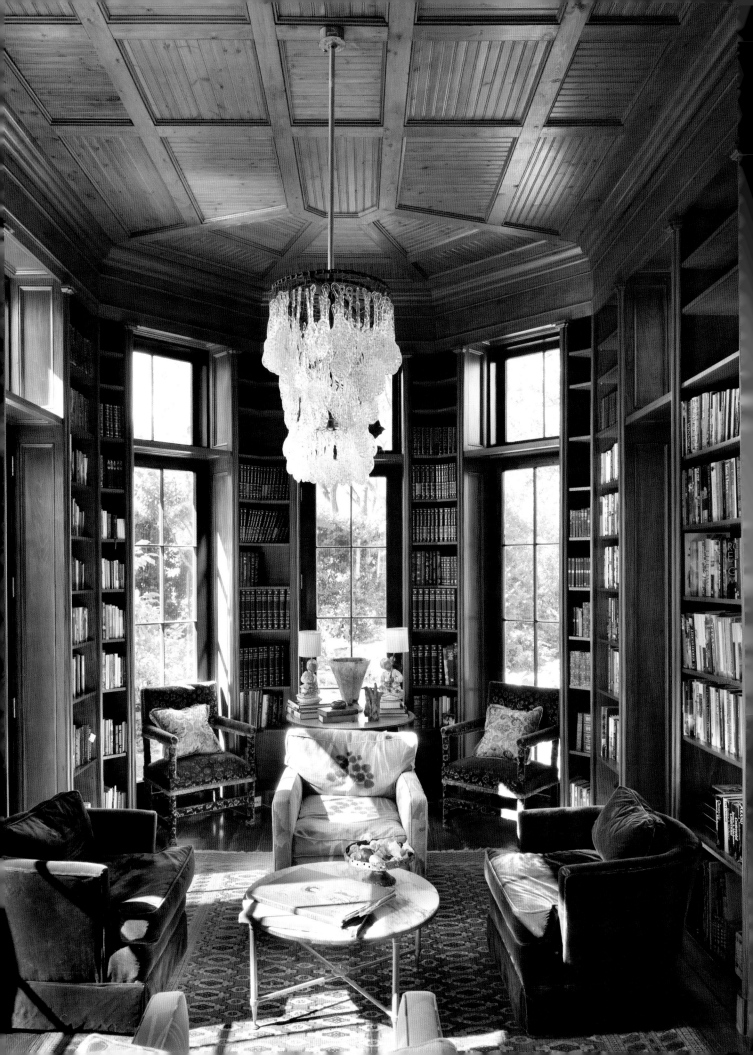

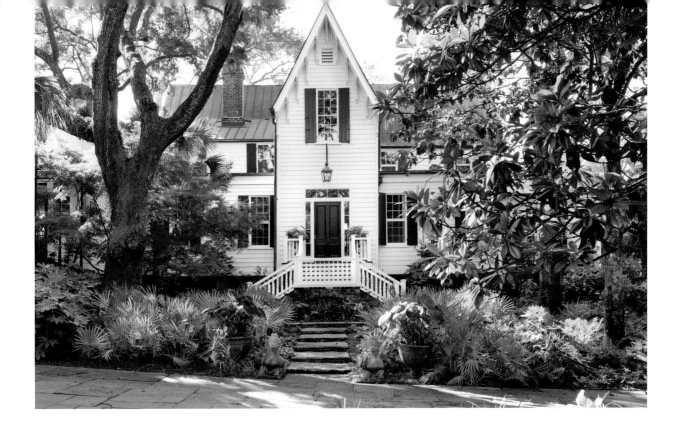

SOUTHWINDS · MOUNT PLEASANT, SC

On quiet Haddrell's Point in Mount Pleasant, the Carpenter Gothic house known as Southwinds, is set along the harbor, offering wide views of the water and the peninsula of Charleston in the distance. Haddrell's, or Old Woman's, Point was once home to canneries and the important rice mills that drew their power from tidal creeks. The area had first been settled in 1680 under the leadership of Captain Florentia O'Sullivan, an Irish soldier of fortune who had come to Carolina in 1669 as deputy to one of the Lords Proprietors.

Southwinds was originally a sea captain's home; later it served as a hospital during the Civil War. Built in a light-hearted version of the early Gothic Revival style popular for cottages in the 1840s and 1850s, the house has a steeply pitched roof, an ornamented central gable, pointed dormers, bay windows, and large porches. At the time, Mount Pleasant and Sullivan's Island were havens for rice planters seeking an escape from the summer "sickly season" of their swampy environs. Believing their "country fevers" to be related to stagnant water and air, they built summer houses close to the ocean, with the thought that healthful sea breezes and salt water bathing would help prevent disease.

Having sat derelict for many years when they found it, the present owners of Southwinds had it thoroughly restored, enlarging it with additions that remained faithful to the character of the original house. The older portion of the home was absorbed into a larger one that now includes new wings, including a wood-ceilinged library, a formal living room, and a large central kitchen space. Extensive gardens were created with a terraced lawn that runs down to a dock at water's edge. Porches and a brick patio take advantage of the harbor views; flowers and herbs now grow in abundance.

OPPOSITE: *Stained pine on the ceiling adds warmth to the library and reflects the taste of the Eastlake style popular in summer cottages of the Victorian era.*

ABOVE: *The Mount Pleasant home, with tin roof and decorated gable, was redesigned by the current homeowners to look like it had evolved over time.*

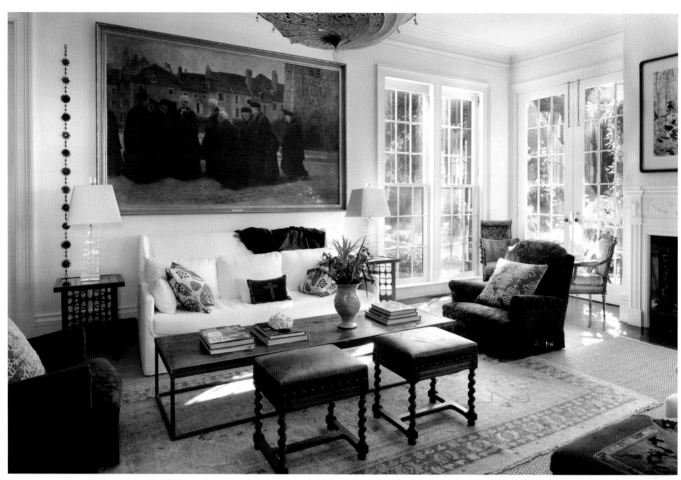

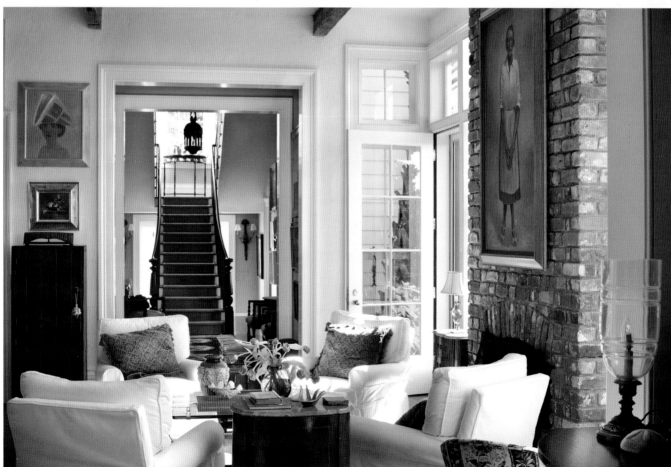

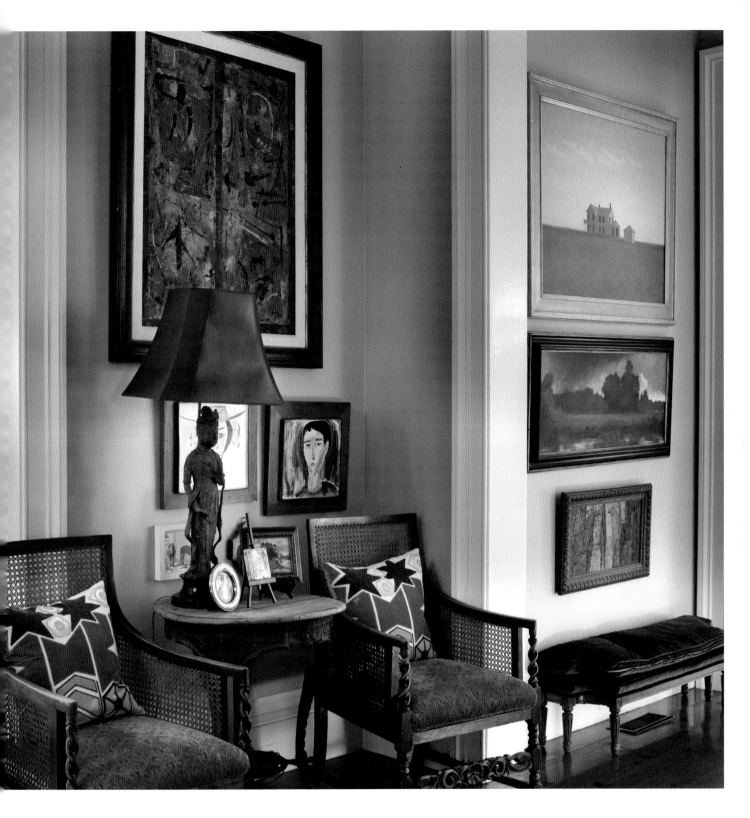

OPPOSITE ABOVE: *A living room with tall windows and French doors was created in one wing of the house. It's been furnished eclectically with blue velvet bullion-fringed armchairs and a Fortuny silk chandelier.*

OPPOSITE BELOW: *The kitchen's seating area is the center of the house and bridges the old structure with the new. On the wall is a full-length portrait by John Carroll Doyle of Daisy Bell Haygood, a family friend of the homeowners.*

ABOVE: *In the hall, an art collection "that appreciates all styles and media" is grouped with pieces playing off each other.*

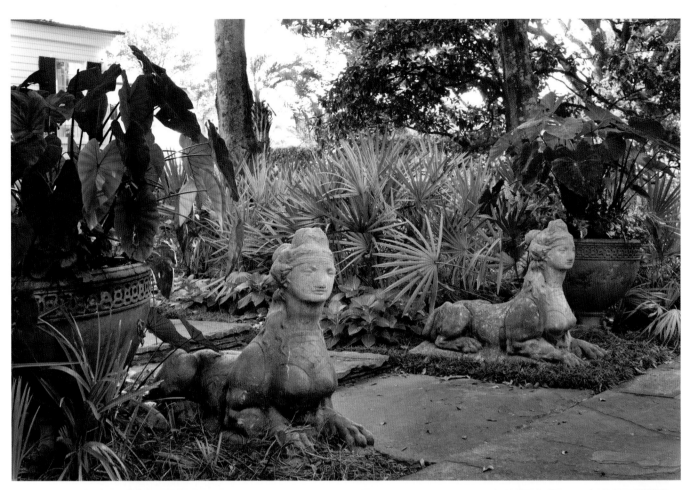

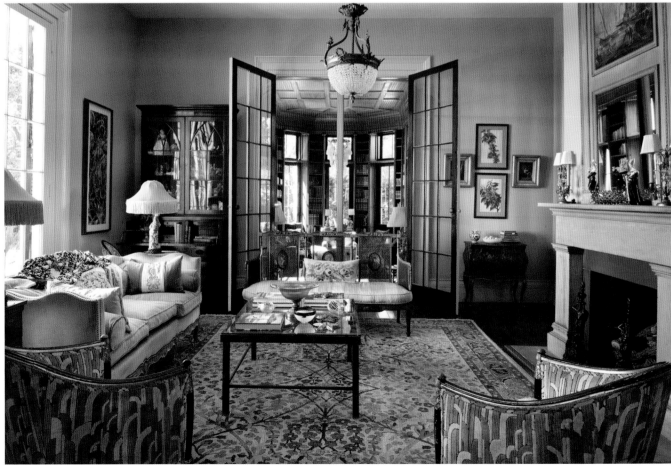

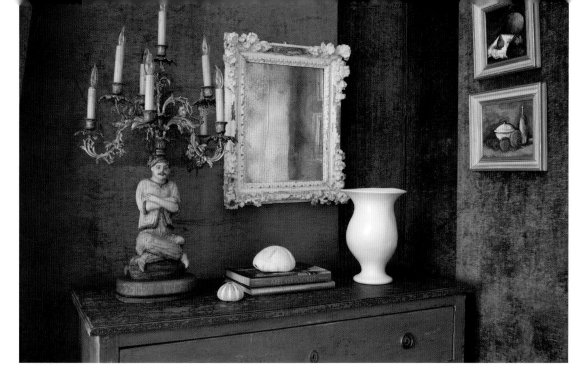

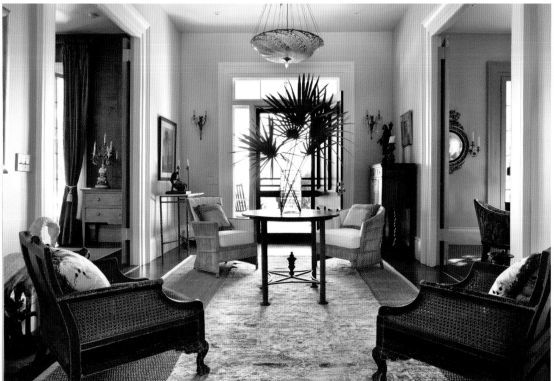

OPPOSITE ABOVE: *A pair of sphinxes guard the bluestone path leading to the front door. The garden is filled with luxuriant plantings, including palms and gray sabal palmetto; old magnolias and oak trees came with the property.*

OPPOSITE BELOW: *The original parlor of the house has the atmosphere of a home where things have been passed down in the family for generations, with a collection of furnishings from many different eras.*

ABOVE: *A still life on a chest in the velvet-walled dining room combines an Italian mirror with an Arabian figural lamp. Many of the items in the house are vintage or one-of-a-kind.*

BELOW: *An airy center hall, with its bamboo and Chinese red cane chairs, serves as a breezy seating area and leads from the front door to a back porch.*

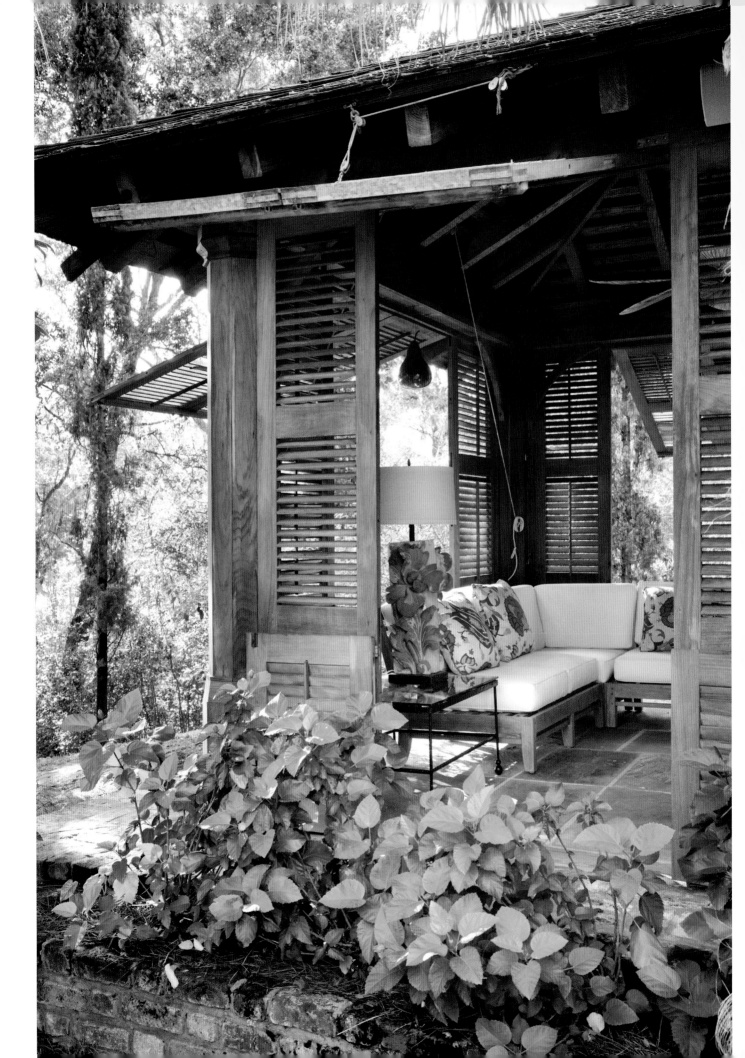

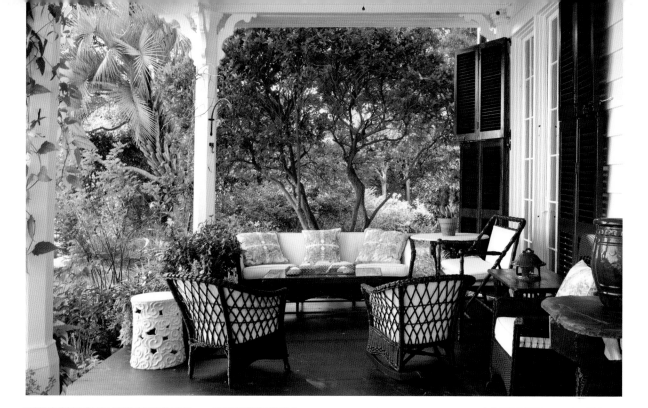

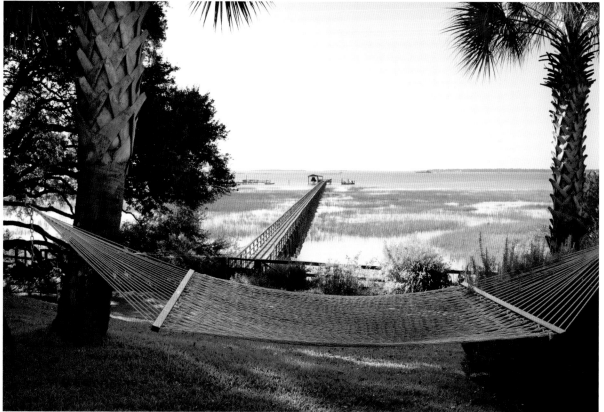

OPPOSITE: *Hidden away in the garden is a pool house that was "inspired by a Pawley's Island dock house combined with the open-air cottages of Thailand."*

ABOVE: *The back porch, which was part of the original house, has shutters and wicker furniture painted in classic "Charleston Green," a green so dark that it's almost black.*

BELOW: *A terraced lawn leads gently down to the family's dock at the edge of a coastal salt marsh with tall reedy grasses.*

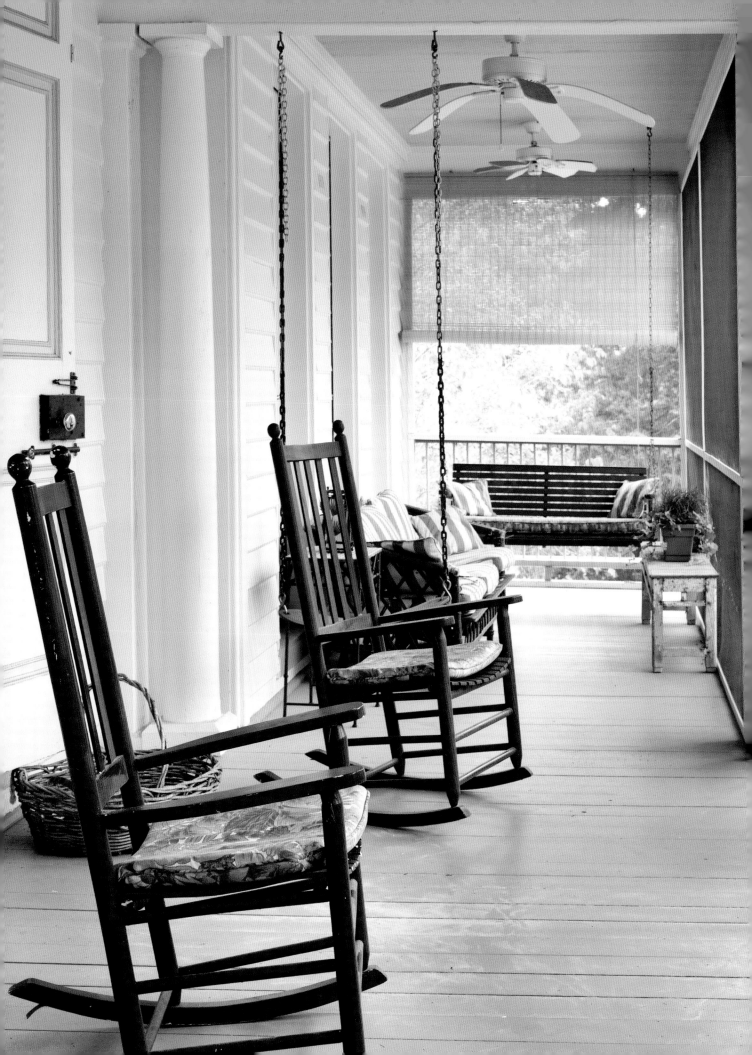

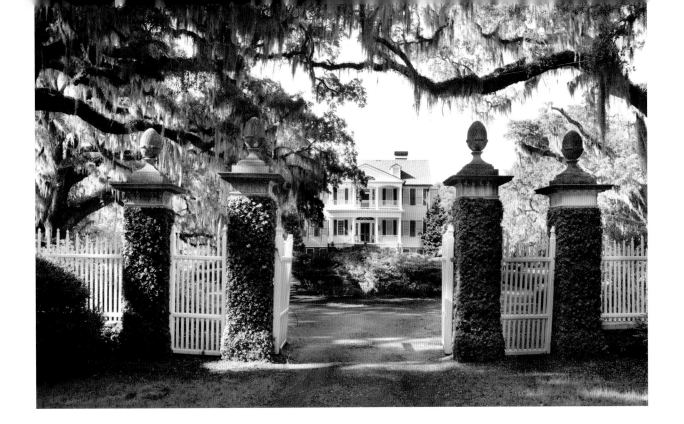

SEABROOK PLANTATION · EDISTO ISLAND, SC

William Seabrook began his planting career on inherited land when he was seventeen and soon became the wealthiest Sea Island cotton producer on Edisto Island in the early 1800s. The highly-prized type of cotton, with its long, silky fibers, thrived in the ocean climate of the islands below Charleston and was sent to the looms in England to be woven into luxury cloth.

Seabrook's namesake house was built in 1810 on the waterfront of a tidal creek for the convenience of shipping goods in and out. Designed by James Hoban, the house is "characterized by its simple dignity and beauty," with an imposing double-tiered front portico. Hoban, who later was selected to design the White House, had come from Ireland to Charleston in 1792. With his Seabrook design, he created the prototype for many Sea Island plantation houses, with two fronts to

each building, one facing the all-important waterway and the other facing the land road.

In 1861, the Confederacy suddenly ordered Edisto to be evacuated; Union troops landed on the island and occupied the deserted plantation houses, including Seabrook. The houses were not put to the torch, but their contents were destroyed or looted, with furniture and paintings taken back north by Union soldiers.

Since the 1940s, the plantation and its grounds have been renovated several times with the addition of outbuildings, including a folly and a large greenhouse for growing cut flowers. Like many old plantations, Seabrook was purchased by wealthy sporting enthusiasts from the North and used as a hunting lodge and winter estate.

OPPOSITE: *The screened porch with rocking chairs faces a garden filled with roses and camellias that goes down to the edge of Steamboat Creek.*

ABOVE: *The approach to Seabrook from its land side has picket fence gates with pine cone finials. The elegant dwelling is notable for hosting General Lafayette in 1825.*

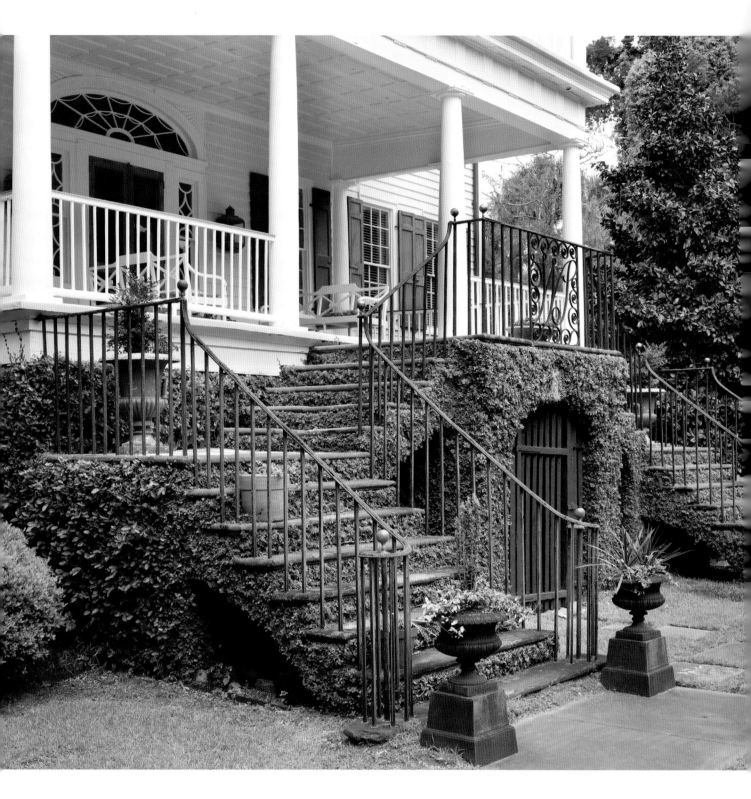

Double front steps rising to a portico are decorated with William Seabrook's initials molded into the ironwork.

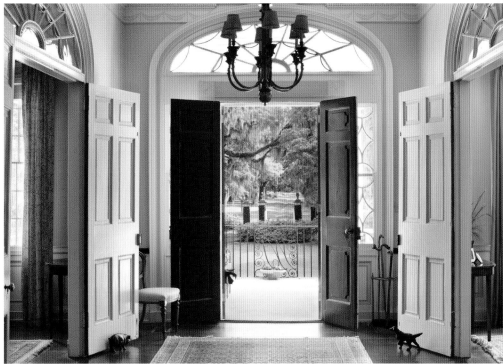

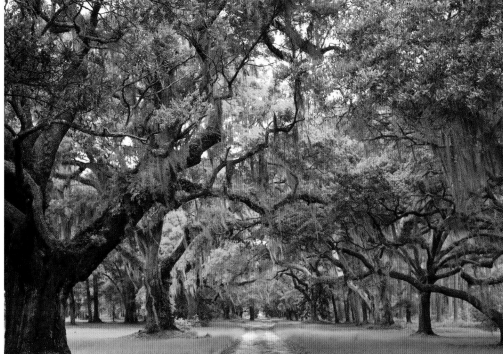

ABOVE: *A spacious center hall opens to formal gardens with wide, encircling lawns and a multitude of box-bordered walkways.*

BELOW: *A long, dramatic double drive leads to the house that is set atop a waterfront knoll. Magnificent live oaks, which often survive for centuries, define the Lowcountry landscape.*

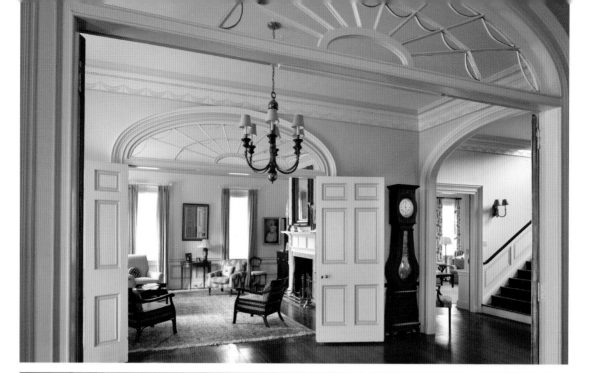

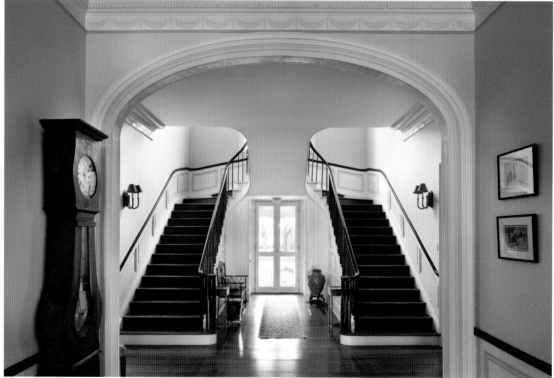

ABOVE: *The house has finely-detailed woodwork and semi-elliptical fanlights over the doors; used as a country retreat, its furnishings are comfortable and casual.*

BELOW: *An unusual double staircase is contained in the rear stair tower of the center hall.*

OPPOSITE ABOVE: *A two-story porch at the waterfront plantation, "Seabrook" overlooks a formal garden and faces Steamboat Creek. The house was designed with two fronts; this side greeted guests arriving by water.*

OPPOSITE BELOW: *Above the mantel in the library is a silhouette by Clay Rice of a Lowcountry scene. Rice is the grandson of noted artist Carew Rice, who started the family tradition of crafting portraits and landscapes in cut paper.*

OVERLEAF: *A small tower, or folly, was built by Donald D. Dodge in the 1930s to entertain his hunting guests.*

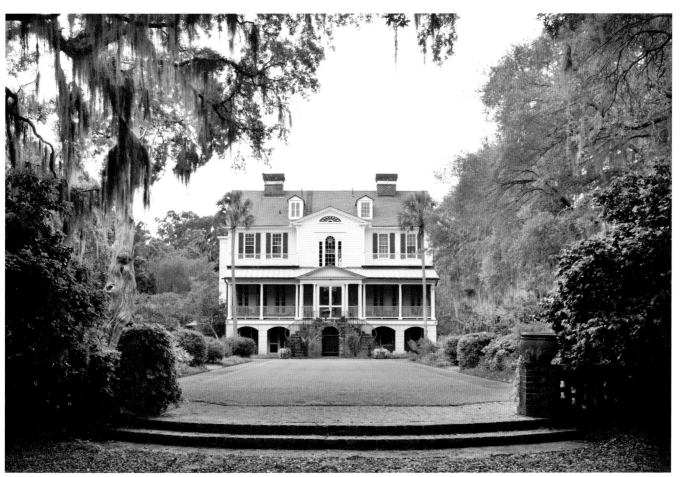

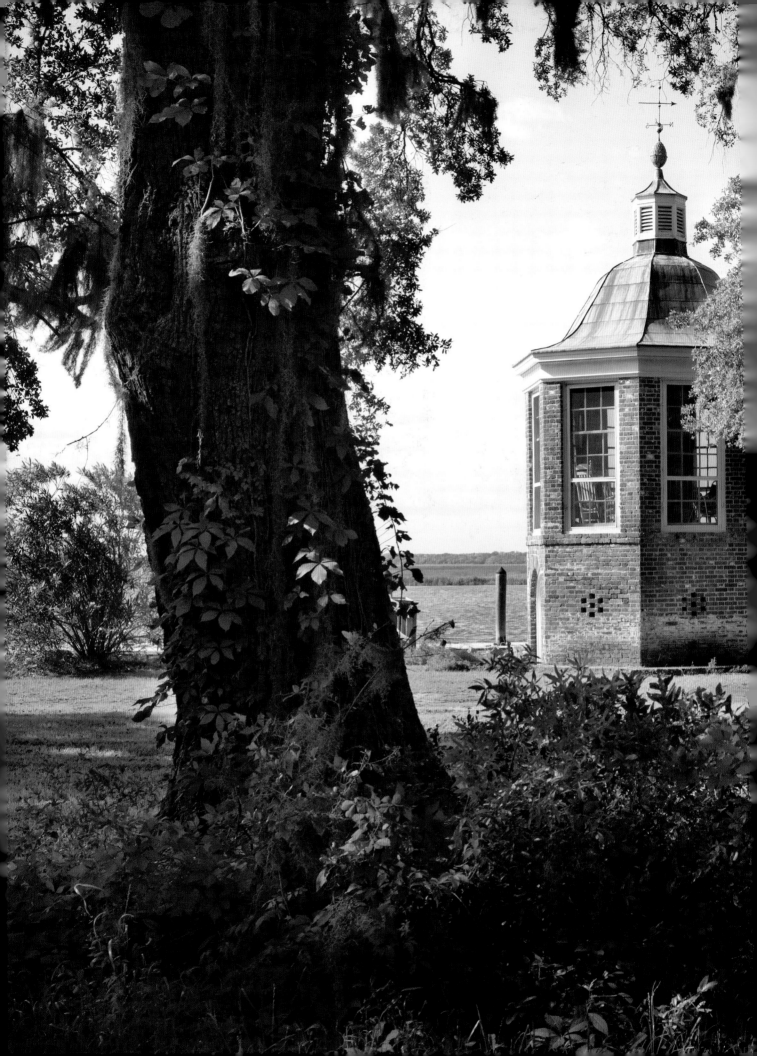

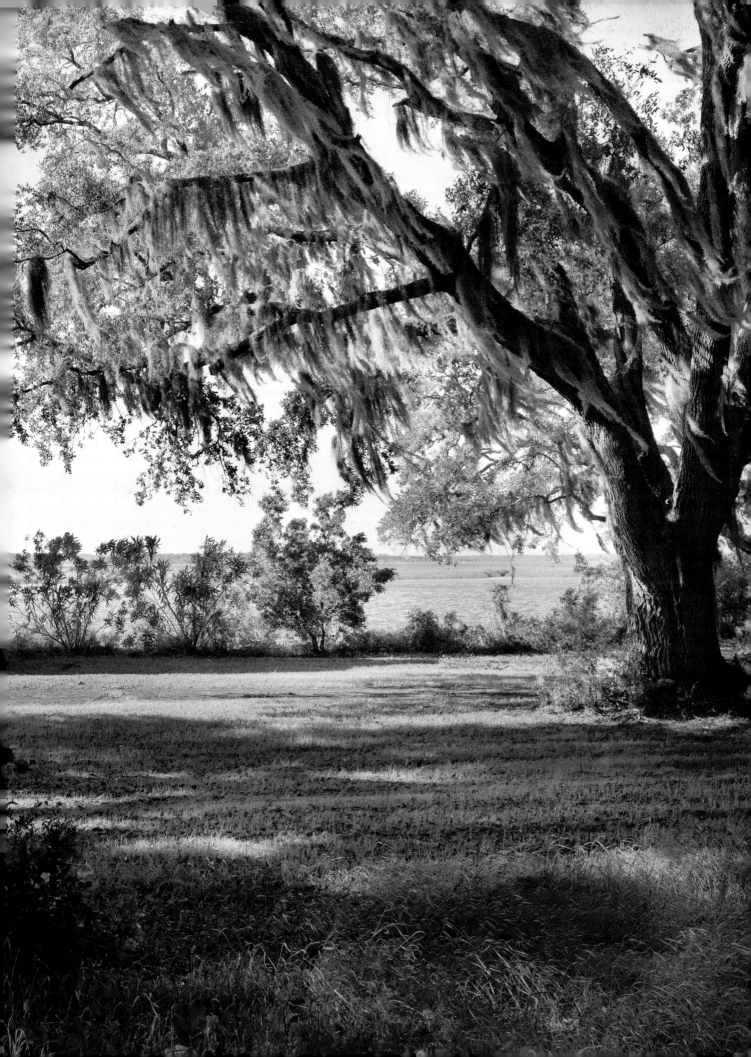

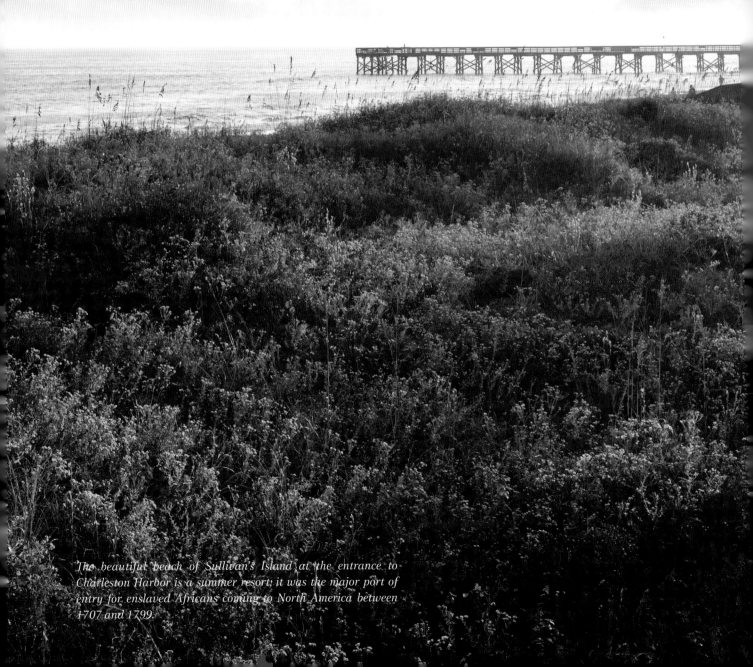

Acknowledgments

We would like to thank all the homeowners and museum curators who graciously allowed us into their houses and gardens to photograph. Special thanks to Phyllis and Marshall Wakat for being such enjoyable hosts, Ben and Cindy Lenhardt for their kind help, Peter Patout for scouting out the best locations as he always does, and Kitty Robinson, Joe McCormack, and Bob Hortman; also Tom Luciano as our furnishings consultant and Chip Hall for showing us a beautiful part of the Lowcountry. Big thanks to the team at Gibbs Smith, especially our excellent editors Madge Baird and Katie Killebrew. And of course, our deepest thanks to Edith, as always.

The beautiful beach of Sullivan's Island at the entrance to Charleston Harbor is a summer resort; it was the major port of entry for enslaved Africans coming to North America between 1707 and 1799.

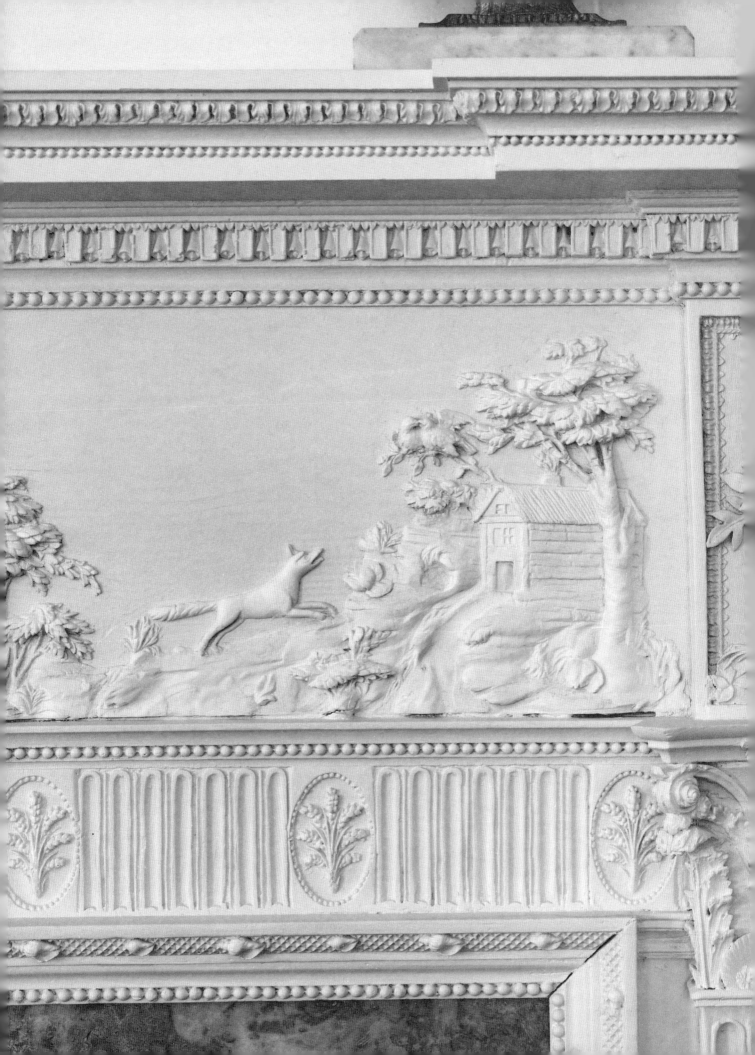